HIDDEN
HISTORY
of
KANSAS

Adrian Zink

THE
History
PRESS

Published by The History Press
Charleston, SC
www.historypress.net

Front cover: Shooting buffalo from a train on the Kansas-Pacific Railroad. The government encouraged destruction of the buffalo and "hunting excursion" trains such as these were promoted. 1871. *Courtesy of the Library of Congress.*
Back cover, inset: Cessna Aircraft Company worker Mina Weber takes a moment to touch up her makeup, using a sheet of aluminum as a mirror. Wichita, 1943. *Courtesy of the Library of Congress.*

First published 2017

Manufactured in the United States

ISBN 9781625858894

Library of Congress Control Number: 2017948451

Notice: The information in this book is true and complete to the best of our knowledge. It is offered without guarantee on the part of the author or The History Press. The author and The History Press disclaim all liability in connection with the use of this book.

To my wife, Toni, who gave me my beautiful children, Xavier and Niobe.

And to my parents, Joe and Mary Ann,
who encouraged me to engage my brain occasionally.

CONTENTS

CONTENTS

Contents

PREFACE

This book has its genesis in the long summer days that I spent as the administrator of a rural Kansas Historical Society historic site a few years ago. In 2011, I was hired to manage Mine Creek Battlefield State Historic Site in Pleasanton, roughly an hour south of Kansas City. I kept plenty busy there with various tasks such as clearing trails for visitors, running the gift shop, giving tours, lecturing about Kansas during the Civil War, cleaning bathrooms, preserving artifacts and even acquiring a cannon for the site. When I wasn't doing all that I was updating the social media pages for Mine Creek Battlefield, which included a lot of reading into Kansas history. As I was also hired as site administrator of nearby Marais des Cygnes State Historic Site, I had to dive deep into primary sources to understand what I was teaching to the public—and so I wouldn't look a fool to some Civil War expert who walked in the door!

Sometimes, there would be rainy days with few visitors, so I busied myself studying dozens of different state and local histories of Kansas. The more I read about the state's history, the more I ended up taking wild detours from the path I originally meant to study. For example, as I studied the Seventh Kansas Cavalry's role at the battlefield I worked at, I came across the fact that none other than William "Buffalo Bill" Cody served in the Seventh as a private. Intrigued by that, I delved into Cody's life and learned of his role as a scout for a Grand Duke of Russia who came to Kansas years later on a grand tour. Delving even deeper, I learned of George A. Custer's role in that tour. Knowing Custer served in Kansas for many years, the detour

continued, and I ended up eventually in some random story about Wild Bill Hickok killing one of Custer's men in a saloon brawl in Hays, Kansas. You see where curiosity gets you? You end up in an intellectual ditch. A fascinating ditch, but way off from where you started.

I started jotting these neat little stories down in a notebook, thinking that they would be great nuggets of history for a future book. Throughout 2012 and 2013 I continued these notes, adding other random state history stories to the notebook. Many of them had nothing to do with the Civil War and encompassed a wide variety of subjects, including sports, astronomy, crime, geology, spaceflight, civil rights and even the Donner Party. I had grand ideas about writing this book "someday." Well, life happens, and someday gets pushed back. With a three-year-old son and a newborn daughter, it gets pushed back again. You change jobs a time or two, and someday continues its long march.

Finally, in August 2016 I decided that it was now or never and I needed to actually write this thing. I wrote a seventeen-page book proposal and sent it to The History Press thinking that it was a long shot, but at least I had tried. I was amazed when they got back to me just a couple weeks later and they accepted my pitch. With the encouragement of my managing editor Amanda Irle, I have spent many late nights (after putting the kids down) during the last few months studying and compiling some of the best anecdotes and forgotten stories that I could find. I dove into hundreds of Kansas history books, newspapers, documentaries and websites and surfaced with what I hope is a collection of the state's best hidden histories. I am particularly indebted to Bob Beebe at the National Archives–Kansas City for his help with patent files, to Tom Keating and my parents, Joe and Mary Ann Zink, for interesting story leads and to the Library of Congress for its invaluable photos. While some of these stories may be well known, my goal has been to find the hidden details behind the histories that the reader may have never known. I hope you enjoy reading this as much as I have writing it. I've learned so much.

Ancient Lands, Ancient Peoples and First Contact with Westerners

Glaciers of Ancient Kansas

If you could go back in time to 700,000 years ago, you'd find Kansas to be a far colder place. At the time, a massive continental ice sheet had advanced all the way down into the northeastern part of the state. This same ice sheet covered all of modern-day Canada and stretched from Washington State all the way to Maine, dipping down to Kansas, Missouri, Illinois, Indiana and Ohio in the middle. To put it in perspective, one-third of the continent of North America was under the ice. While there are many people who know that glaciers left their mark on northeast Kansas, most people are unaware that an ice dam backed up the Kaw River to create the largest lake Kansas has ever seen.

Over the last hundreds of millions of years, there have been many ice ages in which significant parts of the world were covered in ice tens of thousands of feet thick. The latest Ice Age began 2.6 million years ago, and we are still in the midst of it today. Though we don't think of now as an ice age, we technically are still in one because of the presence of massive ice sheets in places such as Greenland and Antarctica. We just happen to be in the "Holocene" right now, which is a temporary interglacial period. The ice sheet that came to Kansas 700,000 years ago was one of the most dynamic. Some places in the polar regions and Greenland are quite stable, whereas North America's repeatedly expands and contracts.

There is evidence all over northeastern Kansas of two separate glacial advances into the state. One from southern Minnesota, South Dakota and Iowa brought massive Sioux Quartzite boulders and other rocks and left them all over the region. You can even see a giant pink boulder at Seventy-Eighth and State in Kansas City, Kansas, if you want to check one out. There are also directional grooves carved into limestone rocks all over Doniphan, Leavenworth, Douglas, Nemaha, Shawnee and other counties. Agate from Lake Superior, iron ore from the Duluth area and even some copper was brought hundreds of miles by the ice and dropped off. There are some hills in counties such as Wabaunsee that have so many erratic rocks littering them that geologists dub them *felsenmeer*, a German word meaning "sea of rocks."

With the coming of this ice sheet, one of these ice lobes dammed the ancestral Kansas, or Kaw River. The damming occurred at multiple places near Lawrence, Topeka and east of Wamego, backing up the ancient river into a massive 125-mile-long lake that stretched from Topeka all the way to Salina. It also had significant arms that reached to Clay Center and another north of Manhattan through and past where Tuttle Creek Lake now sits. Clay Center, Abilene, Junction City, Manhattan and Alma were likely all completely submerged by this lake or on its shores. The ice that came south into the Kansas River valley near Wamego is estimated to have been at least 300 feet thick, and after spilling into the valley the ice in the valley reached 500 feet of thickness. Modern-day downtown Kansas City might have had ice hundreds of feet thick just 100 miles to the east.

Geologists have known about the presence of the glacial Kaw Lake for over one hundred years because of the sediments they have studied. Lake sediments are different than any other rock or soil and stick out like a sore thumb in Kansas as there are so few of them. The campus of Kansas State University in Manhattan has tens of feet of these sediments. When a core was drilled to study them, there were fifteen feet of loess soil and over fifty feet of lake sediments under the soil. Fine sand, silt and silty clay make up the lake sediments, their color changing from pale brown above twenty-seven feet of depth and gray in the deepest parts. Organic matter and pollen fill these samples and give a rich time capsule of Kansas at that time.

Kansas' biomes changed with the advance and retreat of the ice. Wood samples buried for millennia in Doniphan and Atchison Counties give evidence of a spruce forest that grew there at one time and was later buried by the ice. As the climate turned colder and the ice advanced, different northern plants and animals came with it. Conifer forests that we associate with Canada and the Rockies moved south with the ice as well. Tundra

came to dominate the landscape, later giving way to taiga, deciduous forests and eventually familiar Kansas prairie grassland.

Eventually, the ice slowly retreated, a process that takes thousands of years. Large areas of ice-scoured land was punished by brutal winds, sending fine silts and sands flying across the land. Greenland and Antarctica have had winds clocked at speeds of over ninety-five miles per hour. Much of the sand from the ancestral Kaw lake bed blew into the modern Cimarron and Arkansas river valleys, leaving ten- to forty-foot modern sand hills that are now stabilized by prairie grasses. Today, the land has many echoes of the ice that once dominated it. The Kaw River, for example, follows roughly the course of an ancient ice sheet's farthest extent. The next time you head down I-70 between Salina and Topeka, try to imagine all of it under water.

ICE AGE PEOPLES, MAMMOTHS AND CAMELS

Parts of mammoths and mastodons have been found across Kansas and much of the Great Plains ever since people came to this area. Mammoth teeth have been found in sandpits across the state, as well as the occasional eight-foot or longer tusk such as the ones found in Pratt, Cunningham and other sites over the years. Entering North America over 100,000 years ago, the mammoth ate tree limbs on conifers like the spruce and Ponderosa pine that grew in Kansas during the last Ice Age. The region was cooler and wetter, with lush meadows and tall grasses, scattered streams and many ponds and rivers across the landscape. Huge mammoths, mastodons and other megafauna roamed this area, as the seasons were stable and the temperature stayed cool nearly all year around. Other massive creatures that lived in this region for millions of years were peccaries, horses, saber-toothed cats and even ancient camels.

What is fascinating about such megafauna is that archaeological discoveries in 2003 in western Sherman County have placed people with them as far back as 12,200 years ago. Radiocarbon dating by the Kansas Geological Survey on mammoth and prehistoric camel bones confirmed the date as even older than the previous evidence of humans on the Great Plains from 11,000 to 11,500 years ago. "Fracture patterns on the bones suggest they were broken by humans who may have been processing them for marrow or to make bone tools," said archaeologist Steven Holen of the Denver Museum of Nature and Science. "The radiocarbon dating shows that these finds are a

thousand years older than the best-documented evidence of humans on the Great Plains." Camels are often associated with the Middle East, but what many don't realize is that they originated in North America forty-five million years ago, only heading to Eurasia three to five million years ago. Their bones are found all over the state and were bigger than today's camels. The Arctic camel, for example, was 30 percent larger than today's camels. South American alpacas and llamas are relatives of these ancient creatures.

Archaeologists from the University of Kansas and the Denver Museum of Nature and Science have excavated the site off and on since 1976, concluding that the site was a campsite likely occupied only for a few weeks or even days by a group of nomadic hunters. These nomads brought stone from the Texas Panhandle area, indicating how mobile they were. These Paleoindians hunted big game animals and also rounded out their diet with berries, clams, seeds and other small animals. Their spear projectile points have been found all over the state.

With the end of the Ice Age, the continent's climate changed for the warmer. Vast ice sheets retreated, sea levels rose and the modern Kansas grasslands grew to dominate in this warmer and drier period. From 8,500 to 4,500 years ago, the cool climate (and likely introduction of human hunters) spelled the end for many large mammals. Their remains show up every few years at a construction site or in river gravel or under some farmer's field. What is intriguing though is that we still don't know exactly how far back humans lived with and hunted them here.

LEWIS AND CLARK

The story of Meriwether Lewis and William Clark's exploration of the western United States from the Mississippi River to the Pacific Ocean is a well-known tale to Americans. Soon after President Thomas Jefferson completed the Louisiana Purchase in 1803 by acquiring 828,000 square miles of land from cash-strapped France, he commissioned this Corps of Discovery with Lewis as its leader and Clark as its second in command.

From May 1804 to September 1806, the expedition famously passed through eleven future states from Illinois to Oregon, reckoning with death, disease, bitter winters, the Spanish and the mighty Rocky Mountains. Often overlooked in all of this drama is their time passing through Kansas. As their route along the edge of Kansas was only 123 miles, it is easy to forget. There

were, however, interesting notes in the journals of the men that show a Kansas barely recognizable to modern eyes.

From June 26 to July 9, 1804, the expedition worked its way west up the Missouri River along Kansas' now northeastern border. They camped for three days at Kaw Point, where the Kansas River flows into the Missouri, near present-day downtown Kansas City. Across all of their journals the men noted the land as "Kanzas, Kancez, Kansis, Kanses, Kansas (correct!) and Canzan." There was also a trial for two of the men who broke into the supplies and got drunk—which earned them one hundred and fifty lashes, respectively. The party also famously spent the Fourth of July near present-day Atchison, Kansas, and fired off a cannon in celebration. The explorers named a local creek Independence Creek, which it is still called to this day.

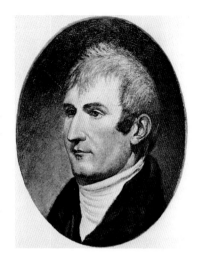

Meriwether Lewis (*pictured*) and William Clark came to Kansas twice on their famous westward journey. Clark thought the Kansas River water was "disagreeable" to taste. *Courtesy of the Library of Congress.*

What is most surprising to see in their journals, though, is their description of the local flora and fauna. Besides the usual multiple deer they shot every day, they note many buffalo, beaver, catfish, rattlesnakes and goslings along the way. Buried in their notes are descriptions of many "parrot queets." Parakeets? In Kansas? Yep, the Carolina parakeet was a green-plumed neotropical parrot with an orange face and a yellow head. The last one died in captivity in 1918 at the Cincinnati Zoo.

There are also mentions of wolves and bears in abundance along the banks of the Missouri River. It's strange to imagine the prairies of Kansas with black bears roaming around, but it was a common sight until settlers reduced their range in later years. As for the wolves, they encountered many gray wolves (*Canis lupus*). We tend to think of the gray wolf as Canadian fauna or living high in the Rocky Mountains, but their range used to cover much of the continental United States, and they were common across all of Kansas. Their bones can still be found in many places across the state.

The expedition returned to Kansas from September 10 to 15, 1806, on the way back from a successful journey to the Pacific Ocean. Sergeant John Ordway, a diarist who was a member of the party, described Kansas as

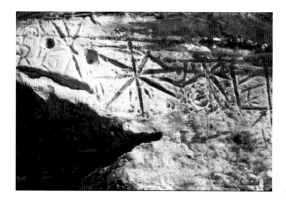

Close-up of Indian petroglyphs on a limestone cliff mentioned in the journal of the Lewis and Clark Expedition. Near Troy, Kansas, 1974. *Courtesy of the National Archives.*

"one of the most beautiful places he'd seen in his life." The timbered rivers, abundant wildlife and endless prairies to the horizon made an impression on the explorers. Native American petroglyph markings on a limestone cliff were interesting to them as well. They loved the grapes, pecans and raspberries of the area too. The only insult that Kansas suffers comes at the hand of William Clark, who said that the water of the Kansas (River) "is verry disigreeably tasted to me."

Guess we can't win 'em all.

GHOST TOWN WITH A HIDDEN MEMORIAL

In 1917, workers building a new railroad for the Anthony & Northern Railroad stumbled upon a grave marker made of sandstone lying near Ash Creek, roughly ten miles north of the town of Larned. Its face read, "A.D. 1841 W.D. SILVER DIE SHOT WITH →" (image of arrow etched into the marker). He may have been off hunting away from the Santa Fe Trail and died from an Indian attack.

The local citizens of the town of Ely (later Ash Valley) constructed a small concrete pillar roughly six feet tall and a foot wide at the base and placed the grave marker within it behind a window. No doubt for years, people would see it next to the train tracks near the bridge over the small creek. This railroad only lasted until 1940, later torn up and mostly plowed over. The only remnants of it are the occasional bridge abutment over a creek or river, random railroad spikes found in fields and the rotting grain elevators that the trains serviced.

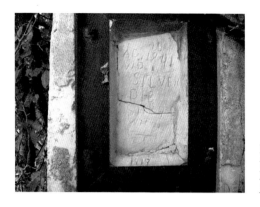

Headstone of D.W. Silver in the ghost town of Ash Valley, Pawnee County. Note that he died "shot with ▷⇒." *Photo by the author.*

The town of Ash Valley itself dried up and died in the ensuing years. All that is left is a church, some ruins of old buildings and a number of cellars and basements still out in the trees. If you can find this ghost town today and happen to be able to find where the railroad used to cross Ash Creek, you will find concrete abutments on either side of the dry creek's chasm, long since stripped of their steel. Off in the trees nearby sits this forgotten monument with the grave marker of W.D. Silver, who met an unfortunate end in some sort of run-in with the locals in 1841. It is certainly one of the oldest gravestones in the state.

THE SAINT WHO CAME TO KANSAS

The Catholic Church has a whole lot of saints, which are people that are recognized as having a very high degree of holiness and followed their God's ways. Have you ever thought about how many saints there are? No one really knows the exact number, as there was no formal canonization process for the first one thousand years. Some estimates say that there are around ten thousand saints in all. Many in those early years were canonized by popular demand and not by a formal process with church investigations into the candidates' background as a pious individual. Only ten of those saints are American, and one of them—Rose Philippine Duchesne—even made it all the way out to Kansas.

Duchesne had quite an interesting early life. Being born in 1769 in France, she had a front-row seat to some historic events in her early years. He father was an esteemed lawyer in their hometown of Grenoble, which was the scene of the famous "Day of Tiles" unrest in 1788, a prelude to the

beginning of the French Revolution. Her mother was the sister of Claude Perier, a powerful industrialist who helped finance Napoleon's rise to power. Perier's grandson Jean Casimir-Perier later became president of France. Suffice it to say, this family was well connected.

In 1781, Rose and her cousin were sent to be educated at the monastery of Sainte-Marie-d'en-Haut, a monastery for the social elite. Rose felt a strong pull toward the monastic life, which alarmed her father, and he removed her from the school to be taught at home. Her decision soon after to join the Visitation of Holy Mary religious order was opposed by her family, but she went anyway. The French Revolution's Reign of Terror came to the monastery, and in 1792, the revolutionaries shut it down and scattered the nuns. She returned to her family for a few years until Napoleon allowed the Catholic Church to operate again. After attempts to restart the dilapidated monastery in 1801 failed, she later joined the Society of the Sacred Heart and its mission of educating young women. In 1815, after the end of the Napoleonic Wars, she founded a school and convent in Paris but still wanted to do more.

As a child, she heard many stories of missionaries who went to New France, which later became part of the United States and Canada. She longed to spread the faith to the natives of Louisiana and the interior of the continent. She and four other sisters were allowed to head to New Orleans in 1818 to begin their work. The trip took ten weeks, and to them, it was the adventure of a lifetime. After arrival, they took a steamboat up the Mississippi River to St. Louis and settled nearby in St. Charles, Missouri Territory. This was remote frontier at the time, and they established their first convent in a log cabin.

The first school they built became the first free school west of the Mississippi River. Rose proclaimed that "poverty and Christian heroism are here" and worked to learn English and educate the locals. By 1828, she and her companions had gone from five members to several schools in six communities. Pope Leo XII was impressed with their work and, in 1826, formally approved their society. They continued to expand and built their first brick building in 1835. By all measures, their decades in Missouri were a success.

The sisters worked closely with the local Jesuits in Missouri, and in 1841, some were asked to join them in a new mission to the Potawatomi tribe in Eastern Kansas, in modern-day Linn County. Rose wasn't selected to go, as she was seventy-one years old (quite an advanced age for those days), but Jesuit priest Father Verhaegen insisted she go. "She may not be able to do

much work," he said, "but she will assure success to the mission by praying for us." Rose was inspired by stories of other missionaries and wished to bring the faith to and educate Native Americans.

Rose had a very difficult time in Kansas, though. Being feeble and incapable of learning the Potawatomi language, she was unable to teach the children. She instead spent entire days in prayer, to the bafflement of the tribe. To them, this strange white lady was a curiosity. The children called her Quahkahkanumad, or "Woman Who Prays Always." After a year of simple village life, her body could not handle the hardship any more. In 1842, she retreated to St. Charles. She spent the last ten years of her life there living in a small room under a stairway near the chapel. She died in 1852 at the age of eighty-three.

The cause for the canonization of Duchesne began in 1895, with the case for her sainthood bumped up by successive popes in 1909, 1940 and finally 1988. Pope John Paul II canonized her on July 3, 1988. She was seen as someone who turned her back on a life of privilege to follow a life of simplicity and faith. Not many people can say they witnessed the French Revolution and Napoleonic Wars and also lived with American Indians. Her year living in a primitive Indian village in Kansas at such an advanced age was a big factor in her canonization, as well as the decades of work she did before.

This just goes to show that taking a trip to Kansas is always worth the trouble. You might even end up a saint!

INDIAN BURIAL GROUND TOURIST ATTRACTION

In 1873, a Pennsylvanian Civil War veteran named Benjamin Franklin Marlin headed west with his wife and children to homestead in the wide-open state of Kansas near the town of Salina. Land was plentiful, being that there were only 365,000 people in the state. He was part of a huge wave of settlers that skyrocketed the state population to 1 million by decade's end. One day, while digging to build a dugout home for his family, he encountered human bones—lots of them. Marlin told others his tale of finding the bones, and it passed into family and local lore for decades. Marlin sold his 161-acre property in 1878, but he was sure to tell the new owners about the bones.

In 1936, Howard Kohr, the grandson of the people Marlin sold the property to, scoped out the property to find the site of the lost burial

ground from the stories he had heard his whole life. He was inspired by recent excavations of a prehistoric lodge on the property by local amateur archaeologists Guy and Mabel Whiteford (and their son Jay). The Whitefords were called back to help Kohr dig out what would become a major part of their lives for the next decade.

Guy was a local police officer, and he and his wife stumbled into archaeology by accident. They were looking for fossilized rocks in the creeks and throughout the countryside to build a rock garden for their home in 1925 and came across many Indian artifacts along the way. The Whitefords took this new hobby seriously and found many artifacts along the river valleys of Saline, Ottawa, Rice, McPherson and Ellsworth Counties.

They even collaborated with the Nebraska and Kansas State Historical Societies, learning proper excavation techniques from the professionals and gifting many artifacts from their finds to them. They also cultivated an important relationship with Dr. Waldo Wedel, the assistant curator of archaeology at the U.S. Museum at the Smithsonian Institution. They had worked with Wedel in 1934 when he was with the Nebraska State Historical Society on an excavation that they participated in.

After Kohr rediscovered the site on October 1, 1936, the Whitefords immediately jumped into the project. Wedel was interested in their progress at the Whiteford site, as it could tell so much about the culture and lives of the Plains Indians of that region. He urged them to keep him updated as to any developments. The Whitefords wrote to him on October 9, "We have discovered a burial pit and have been working on it for the past week, have unearthed more than 50 skeletons, eight small pots....Have not found the outside walls of the pit, so cant [sic] say as to the size of it." As it turns out, somewhere between 150 to 200 individuals were buried at this site between the years 1000 and 1350 AD.

The discovery was announced in the local *Salina Journal* the next day, and Wedel telegraphed them immediately to let them know he would be happy to have artifacts from the find for his research. The find was nothing short of a sensation. The recent excavations of the prehistoric lodge on the Kohr site were so popular that the Whitefords saw opportunity knocking. In Guy's October 9 letter, he matter-of-factly states, "We have a fence around the pit and an eighteen by twenty foot tent over it and if some of the people around here want to see it, its [sic] going to cost them." The admission rate to the dig site was a quarter—roughly half the price of a movie ticket in those days. Undeterred by the cost, the crowds came in huge numbers to see the site. This was no minor feat during the Great Depression.

Before long, the site was being marketed as "The Largest Prehistoric Indian Burial in the Middle West." Thousands of Kansans and travelers from out of state came to marvel at the pit. The bodies were left in their original positions, with many of their belongings meticulously noted and left in place. Such objects included beads, pendants, flint knives, milling stones, pots and turtle shells. The burials covered a wide range of ages, from infants to "elderly" adults over forty-five years old. To protect the bones from degrading, they were periodically shellacked with varnish, giving them their dark-brown appearance in photos. A building was placed over the pit with "Indian Burial Pit" in huge black letters on the side.

In 1937, the property was sold to the Price brothers, Lloyd, Levi, Howard and John. The Whitefords moved into a house on the property to help promote and run the operation, give tours and sell merchandise related to the site. Many different groups came to visit the site, such as school field trips, Scouts, church groups and people just out to see something different on a weekend. It truly was a mom-and-pop operation, with visitors being encouraged to honk their horn when they pulled up so as to alert the Whitefords of visitors. People from every state, the District of Columbia and all other continents (besides Antarctica) made up the roughly fifteen to twenty thousand visitors each year. The Whitefords lived and worked the site until 1946, until the current owners wanted to take it and its profits over for themselves. Cut out, the Whitefords moved west and spent their final years in Oregon and Washington.

For many years, this site was seen by many as a curiosity, and it operated without controversy. There may have been individual protestations, but no organized protest or stance by any groups happened until 1972. In that year, the Central District of the American Lutheran Church was planning a theological conference in Salina and made a proclamation that the burial ground had no archaeological value anymore and that the viewing of Indian skeletons was "contrary to the spiritual beliefs of the Indians." The conference was not held in Salina due to the continued operations of the site for "purely commercial reasons."

With growing awareness of the poor condition and interpretations of the site, there was much discussion at the Kansas State Historical Society and at public hearings over whether the site should be purchased by the state. The historical society even had plans to acquire the site and build a visitor's center for $1.4 million. With $90,000 of state funds appropriated to buy the property from the Price brothers, public debate turned to what would happen to the site once it was bought. American Indian voices

started to be noticed, as many disapproved of the site's continuation as a tourist site. By 1986, the Indians had become more organized, and leaders from six tribes worked to propose legislation banning public display of their ancestors' burials.

Between 1986 and 1989, negotiations between the tribes (especially the Pawnee), the State Historical Society, the state legislature and the Price family led to the creation of a new burial law. The Treaty of Smoky Hill was an agreement to use the state funds to provide a proper burial of the peoples on display at the burial pit. The Kansas Unmarked Burial Sites Preservation Statute provided for monetary compensation to the Prices, a final study of the remains allowed to the historical society before reburial and for the removing of the building and landscaping of the area.

This progress had all been accomplished by good faith discussions and hearings by all parties and compromises from each group. With this bill passed, no other burial sites could operate again in the future as the Whiteford site had done for fifty-three years. Coincidentally, Guy Whiteford died at the ripe age of ninety-five just one month after the signing of the bill. In 1990, the U.S. Congress passed the Native American Graves & Repatriation Act, which in the same spirit worked to return Native American remains and cultural artifacts to the places and tribes they were acquired from.

On April 13, 1990, a reburial ceremony was held by the Pawnee tribe on the site. Blankets and shawls were placed over the skeletons, as is tradition, and 125 tons of sand were placed over the bodies. A concrete cap was placed over the pit to discourage any future diggers, and a simple wooden fence surrounds the grass-covered and unmarked former tourist destination. All state historical markers, billboards and mentions in tour guidebooks are long gone. You can still see references to it in old books and maps, and some visitors travel to other local Native American sites in the state, such as Pawnee Indian Village museum in Republic County. The site remains a cultural memory for many Kansans, and if you ask anyone who grew up between the 1950s and '70s, there's a good chance one of them visited the site on a school bus.

Bleeding Kansas and Civil War

The Man Who Hanged His Would-Be Executioner

With the passage of the Kansas-Nebraska Act in 1854, the United States allowed Kansas to decide whether it was to join the Union as a free state or a slave state when it achieved statehood. Missouri was already a slave state, and many proslavery settlers flocked to Kansas to settle and decide the issue. Many antislavery settlers came as well, causing tensions between the two camps. Before long, violence erupted, with people on each side engaged in murders, threats, destruction of property and intimidation of their opponents. Illegal voting was rampant, as thousands of Missourians crossed the border to vote and influence territory elections. Tensions continued mounting, and it got even uglier when hundreds of proslavery "border ruffians" sacked antislavery stronghold Lawrence. In retaliation, John Brown murdered five proslavery settlers in the Pottawatomie Creek Massacre. This guerrilla violence known as "Bleeding Kansas" continued for years as a prelude to the coming American Civil War. Stakes were high, as the balance of power in Congress between slave and free states depended on how territories entered the Union.

John Brown's violence only escalated the conflict even more, and forays such as his raid into Missouri to liberate slaves and destroy property were returned in kind. A proslavery Georgian named Charles A. Hamelton was seasoned in raids into Kansas to threaten Free-Staters and steal their

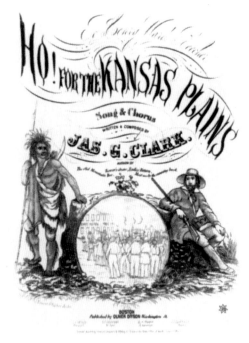

Left: "Ho! For the Kansas Plains" songbook, an antislavery song dedicated to abolitionist Henry Ward Beecher, a New Englander who armed antislavery settlers, 1865. *Courtesy of the Library of Congress.*

Below: Interior view of the Samuel Adair cabin in Osawatomie, which John Brown used for planning abolitionist raids and defense during his time in Kansas. *Courtesy of the Library of Congress.*

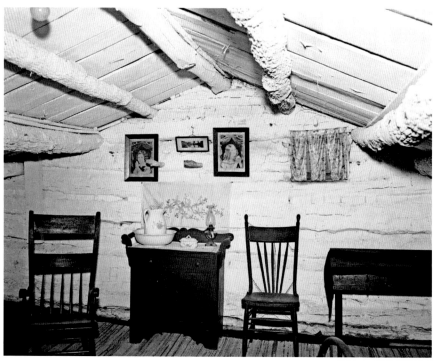

property. Linn County was a target on a number of occasions as it bordered Missouri and many Free-Staters had settled there. James Montgomery was one such leader, having founded the Self-Protective Company not long after moving to Kansas in 1854. This group provided protection to free-state settlers and ordered proslavery settlers out of the territory. U.S. troops were even ordered down to the county by territorial governor James W. Denver to keep the peace.

Having recently been run out of the state by Free-State firebrand James Montgomery, slaveholder Hamelton informed the proslavery men whom he had raised that "we are coming up there to kill snakes, and will treat all we find there as snakes." Hamelton had been raiding in Kansas on many occasions, harassing Free-Staters, destroying property and stealing goods. With thirty men who answered his call, he rode across the border to Trading Post, Kansas, on May 19, 1858. Rounding up eleven Free-State settlers at various farms, the gang drove prisoners to a remote ravine merely hundreds of feet from the Missouri border. Hamelton knew these men, as some had been his neighbors. Many of them didn't realize he intended to kill them and were taken unarmed, as they had not participated in any border

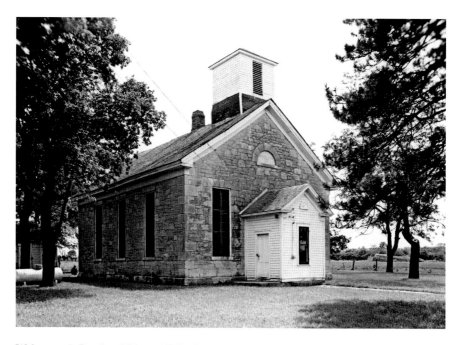

Wabaunsee's Beecher Bible and Rifle Church was built by New England settlers inspired by Henry Ward Beecher. He supplied smuggled rifles into Kansas for abolitionists. *Courtesy of the Library of Congress.*

violence. Hamelton gave his men the order to kill, and they began firing. The eleven captives fell, with five dead and six of them feigning death—surviving the ordeal. Of the survivors, five were seriously injured and one came out unscathed. Hamelton and his men then rode off back over the border, leaving the bodies as proof of their retribution. The community set off to chase down the men—to no avail—and gathered to treat the wounded and collect the dead. Word spread quickly, and Free-Staters from all over descended on the county to prevent further raids.

As word of the atrocity got out of Kansas, the incident made headlines nationwide. Shock and disgust horrified many Americans, with John Greenleaf Whittier even penning a poem about the massacre, "Le Marais du Cygne," for the September 1858 issue of *Atlantic Monthly*. W.B. Tomlinson described the ordinariness of one of the victims of the massacre in his book *Kansas in 1858*, published soon after the massacre:

> *William Stilwell of Sugar Mound, recently from the state of Indiana. He was a young man, not over 28 and had a young and beautiful wife and 2 small children. When he left home the morning of the massacre, his wife, with a presentiment of evil on her mind, urged him to take the Territorial road to Kansas City via of Osawattomie [sic]. He assured her that there was no danger in taking the most direct road—that he was known as [a] peace[ful] man and would not be molested. He was killed with a double-barreled shot-gun, loaded with pistol balls, the charge entering his left breast.*

John Brown himself came to the site of the massacre a few weeks later and built a fortified home that he and other abolitionists occupied during the rest of the summer. The log fort was reportedly two stories high and around 220 yards south of the ravine. Tensions were high, but Hamelton and his men had retreated to Missouri, never to return. He and his family eventually moved back to Georgia within the next few years. He later served as a Confederate officer in the Civil War and was never prosecuted for his crimes. Almost all of his men escaped punishment for the deed—save for one. One of the gang members, William Griffith, was captured and arrested by Union soldiers in 1863 at the height of the war. He was then brought back to Linn County for trial that fall. Massacre survivor William Hairgrove and others identified Griffith's role in the massacre, with Griffith claiming he only helped capture the men, not shoot them. Found guilty, he was slated for execution on October 30, 1863, over five years after the crime.

The jury in Mound City found him guilty of murder in the first degree, and soon after, Judge Solon O. Thacher sentenced him to hang. In front of a crowd of thousands of spectators, Griffith was led to the gallows near Little Sugar Creek. The scene was described in *Legal Executions in Nebraska, Kansas and Oklahoma Including the Indian Territory: A Comprehensive History*:

> *A little after noon Griffith was conveyed to the wood where he stepped onto the wooden platform a few inches above the ground. His wrists, knees and ankles were bound and the noose was adjusted. The black cap was pulled over his face at 1:07 p.m., and in but a moment William Hairgrove, one of the survivors of the massacre, cut the restraining rope with a hatchet; the four hundred pound weight dropped, jerking Griffith upward. The body rebounded and hung motionless while the attending physicians monitored his vital signs, and in twenty-five minutes they pronounced him dead.*

With Griffith's hanging, we have the extremely rare instance of a man executing a man that tried to execute him. The Marais des Cygnes massacre site is now an official Kansas Historical Society State Historic Site. There visitors can read interpretive signs, see the ravine it happened in and try to get a sense for the mood at the time, as Whittier captured in the final stanza of his poem:

> *On lintels of Kansas*
> *That Blood shall not dry;*
> *Henceforth the Bad Angel*
> *Shall harmless go by;*
> *Henceforth to the sunset,*
> *Unchecked on her way,*
> *Shall Liberty follow*
> *The march of the day.*

THE ESCAPE OF SLAVE ANN CLARK

The Underground Railroad, the informal network of safe houses manned by abolitionists across the country, stretched into Kansas during prewar territorial days. Many Kansans risked a $1,000 fine and six months in prison if discovered participating in helping hide or transport escaped African

slaves, but many did anyways. In 1855, the Kansas territorial legislature even placed a death sentence on anyone promoting or supporting escaped slaves. This legislature was nicknamed the "bogus" legislature by antislavery advocates because there was so much illegal voting from proslavery Missourians crossing the border that the elections were suspect. The Free-Staters formed their own constitutional convention in Topeka later that year, but it was rejected by the U.S. Congress. Their attempt to bring Kansas into the Union as a free state failed, making the Underground Railroad the only way out for most slaves. The two sides didn't meet again until 1857 at Lecompton, near Lawrence.

The reasons for supporting the Underground Railroad were many, from people belonging to antislavery churches (Quakers, Wesleyans and so on) to free blacks and former slaves looking to help out their brethren and even people who simply thought the institution was an abomination.

First territorial capital building of Kansas near Fort Riley. Here in 1855 the first territorial "bogus" legislature convened, promoting a proslavery course. *Courtesy of the Library of Congress.*

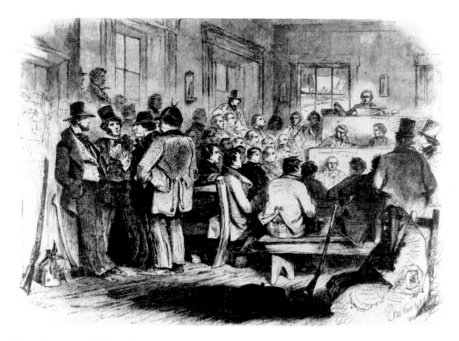

Free-Stater constitutional convention in Topeka, October 23, 1855. Congress rejected this and their request to join the Union. *Courtesy of the Library of Congress.*

Lecompton's Constitution Hall was one of the busiest buildings in Kansas Territory in the 1850s, where pro and antislavery factions fought for territorial control. *Courtesy of the Library of Congress.*

The story of runaway slave Ann Clark illustrates just how difficult the passage to freedom could be. Ann was the forty-year-old slave of a Lecompton man named George Clarke. After escaping from him, she headed west and hid at a Topeka farm for a few weeks. Her protector couldn't get her north, and she was soon discovered by proslavery sympathizers. The posse that captured her hoped to obtain a reward once they returned her to Lecompton. Before her captors could bring her back to her master, she made a mad dash into the night when the men were eating and drinking and the ladies with them in the kitchen let their guard down. She stayed all night in a ravine under heavy brush, remaining still while the party searched for her.

The next morning, Ann saw a man walking down the road to Lawrence and decided to plead with him for help. He was carrying a book, which she hoped meant he was maybe an abolitionist or at least an educated man. Luckily for her, it was her owner's neighbor, Dr. Barker. Barker told her to stay in the ravine and head south to the back of his house, where he would hide her. He kept her there for a couple days and then took her by wagon to Lawrence and Topeka. Hiding under several blankets, she remained concealed until they arrived at the home of Caroline Scales. Scales's home was an Underground Railroad stop that concealed numerous slaves in a giant hogshead cask in its cellar. "When Ann came, we put some straw, clothes and blankets into the hogshead and had her stay in it," said abolitionist and Underground Railroad "conductor" John Armstrong. "Mrs. Scales kept boarders, and during the day, while they were out, Ann used to come up in the kitchen and do a great deal of housework." Armstrong claimed that nearly three hundred slaves made it to Canada from the house in Topeka.

Clark stayed at the Scales home, helping out and waiting for Armstrong to raise $70 and prepare her transport. The route from Topeka to the Nebraska border was called the Jim Lane Trail, named after and laid out by the Jayhawker firebrand fighter/politician. Six weeks later, Armstrong took Ann Clark up the Lane Trail, through Nebraska and to Iowa with a borrowed enclosed carriage pulled by mules. After a three-week journey, Quakers in Iowa took her the rest of the way to Canada. She was one of an estimated two thousand people to escape slavery in Kansas through the Underground Railroad. Her gratitude manifested itself in the many letters she wrote to Armstrong in the years after. Hers was one of many stories but is typical in the fact that it took a great deal of concealment and infinite patience to run from determined bondage in those days.

FIRST KANSAS COLORED INFANTRY:
AMERICA'S FIRST BLACK TROOPS

Who can forget the 1989 Civil War film *Glory* and the bravery of the Fifty-Fourth Massachusetts? That regiment is far and above the most famous group of black soldiers in the entire war. What has been overlooked for many years, though, is they weren't the first black troops to fight for the Union. By the time the Fifty-Fourth was mustered into federal service in May 1863, black troops from Kansas had already been fighting Confederates out west for over seven months.

The First Regiment Kansas Volunteer Infantry (Colored) was recruited by a controversial U.S. senator from Kansas, James Henry Lane. Lane had been a known antislavery Jayhawker and firebrand since the mid-1850s and was the one that recruited the first African American troops to serve the North in the Civil War. Not only was it a controversial venture for its time but Lane also went against Secretary of War Edwin Stanton's wishes,

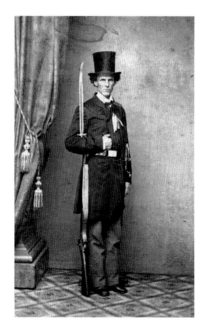

Abolitionist and fiery militant Jayhawker James Henry Lane served as a controversial U.S. senator and general from Kansas during the Civil War. *Courtesy of the Library of Congress.*

authorizing the raising of the regiment on August 4, 1862. Many black men aged eighteen to forty-five from across Kansas enthusiastically answered the call to fight, mostly runaway or former slaves from Missouri. With a flair for the dramatic, Lane called this group the "First Kansas Colored Infantry of the Liberating Army." By 1862, over six hundred men had enlisted in the hopes of building a better future for blacks in America. These uniquely motivated soldiers were paid a hefty sum of ten dollars a month as well as adequate rations. They were first organized at Fort Lincoln, in rural Bourbon County.

Like most progress in American history, it was delayed. Though many progressive Kansans supported their service in war, it would take five months for them to officially be accepted into federal service. However, before the First Kansans were even officially accepted,

part of the regiment saw its first combat on October 28, 1862, at Island Mound in Bates County, Missouri. Here 225 men of the regiment fought a Rebel force of 500 and drove them off. With 10 dead and another 12 wounded, they were the first black troops to die for the North in the war. The *Lawrence Republican* reported, "The blacks behaved nobly and have demonstrated that they can and will fight. The battle of Toothman's Mound [also Island Mound] proved that black men can fight and they were now prepared to scour this country thoroughly, and not leave a place where a traitor can find refuge."

Later joining the Department of Kansas, they were sent to Indian Territory (now Oklahoma) to assert federal control over it. In the Battle of Honey Springs on July 17, 1863, they held their ground under heavy fire and forced another Confederate retreat. The First Kansas impressed Major General James Blunt, commander of Union forces at the battle. He later wrote of them, "I never saw such fighting as was done by the Negro regiment. The question that negroes will fight is settled; they make better solders in every respect than any troops I have ever had under my command." After this success, Senator Lane raised a second black infantry unit in 1863 under future Kansas governor Samuel J. Crawford.

Disaster struck the First Kansas at the Battle of Poison Springs on April 18, 1864, in southern Arkansas. After repelling repeated Confederate attacks, the First ran low on ammunition and were overrun. Incensed that black soldiers would dare take up arms against them, Confederates brutally executed any wounded or surrendering black soldiers. Others were scalped and stripped of their belongings. Confederate editor of the *Washington Telegraph* and future Arkansas Supreme Court justice John R. Eakin lauded the massacre of the black troops, saying, "They did right....we cannot treat negroes taken in arms as prisoners of war without a destruction of the social system for which we contend." The First Kansas lost 117 dead and 65 were wounded. Criticism of black troops increased in the North after this, but their overall contribution was unassailable. Lane and Crawford had raised 2,083 African American men for the U.S. war effort and the First was re-designated the Seventy-Ninth Regiment Infantry U.S. Colored Troops on December 13, 1864. They aren't as famous as the Fifty-Fourth Massachusetts, but they fought for the same reasons and displayed the same courage nonetheless.

THE GENERAL WHO WAS CAPTURED BY A PRIVATE

Many Kansans don't realize that a major Civil War battle occurred in the state. If they did, they would find it quite interesting that not only were there quite a few important people at this battle, but also a private captured a general, which doesn't happen every day.

When Confederate general Sterling Price launched a major cavalry raid into Missouri in the fall of 1864, the goal was to take Missouri for the Confederacy and damage Lincoln's chances at reelection. The Confederacy had suffered nonstop defeat since Gettysburg the previous summer and wanted Northern opinion turned on Lincoln. Perhaps they could convince George McClellan, who was running opposite Lincoln, that the war wasn't ending any time soon and he would sue for peace.

Long story short, Price cut a bloody swath through Missouri up from Arkansas but failed to take St. Louis and was soundly defeated at the Battle of Westport in Kansas City on October 23, 1864, in which thirty thousand men fought near the present-day Country Club Plaza. As Price retreated, he decided to go through Kansas and punish the state for its Northern allegiance.

Two days later, on October 25, Price was engaged in an all-day rearguard action against pursuing Union forces under General Alfred Pleasanton. The brigades of Colonel Frederick Benteen and Colonel John Philips led

General Thomas Moonlight served Kansas in the Civil War, fighting bushwhackers, border guerrillas and Price's Missouri Raid. Glass plate negative between 1865 and 1880. *Courtesy of the Library of Congress.*

an attack on the stalled Confederates at Mine Creek, near present-day Pleasanton, Kansas. Though outnumbered 7,000 to 2,600, the Federals attacked, making this the second-largest cavalry engagement in the Civil War. The Confederates were outgunned, as many were only armed with single-shot muskets while the Federals were outfitted with modern repeaters. Over 600 Confederates were captured—including General John S. Marmaduke.

When the Union troops met the Confederates at the creek, there was much confusion, as many Confederates were wearing Union blue uniforms that they had lifted along their raid. Private James Dunlavy of the Third Iowa Cavalry describes his capture of Marmaduke as follows:

> *I saw some rebels, dressed in the Federal uniform, and mistaking them for Union soldiers, started toward them. When I got within a short distance, General Marmaduke saw me shooting at the "Butternuts," and mistook me and started towards me. I had the advantage of him, so I let him come up. I leveled my carbine upon his breast and ordered him to surrender.*

Dunlavy earned the Medal of Honor for his capture of the general, and Price was harassed further by Union troops that day. Eventually, the general was pushed over the border back into Missouri, where he continued his retreat to Texas. General Marmaduke, interestingly enough, went on to one day become the governor of Missouri. He and Dunlavy maintained a friendship through correspondence over the years as well. Besides Marmaduke, there were four other future governors at the battle: Samuel J. Crawford (third governor of Kansas), John L. Beveridge (sixteenth governor of Illinois), T.T. Crittenden (twenty-fourth governor of Missouri, the guy who put up a $5,000 reward for capture of Jesse James) and lastly Thomas Moonlight (governor of Wyoming Territory).

There were a number of other notable people at the battle as well. Another general, William L. Cabell, was captured by Calvary M. Young of the Third Iowa, who went on to win the Medal of Honor as well. Cabell was later mayor of Dallas, Texas, and began a Cabell mayoral dynasty there. His grandson Mayor Earle Cabell was in JFK's doomed motorcade almost one hundred years later.

Buffalo Bill Cody served with the Seventh Kansas Cavalry, which engaged the retreating Confederates that day, too. Other "Wild West" figures were there besides Cody. Wyatt Earp's brother, Newton, was with the Fourth Iowa Cavalry. Famed future mountain man John "Liver Eating" Johnson served

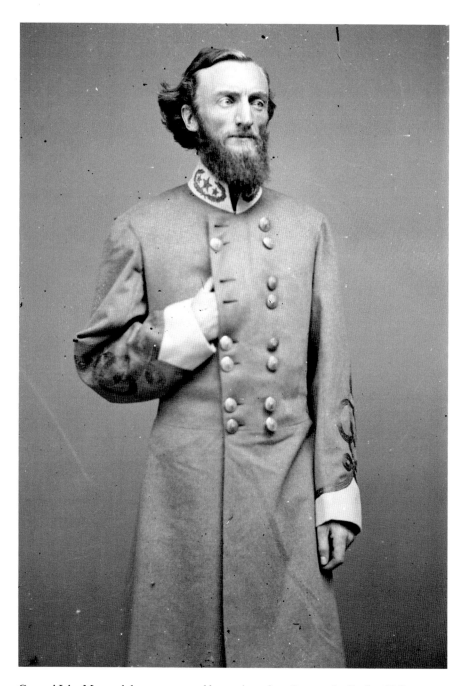

General John Marmaduke was captured by a private from Iowa at the Battle of Mine Creek, near Pleasanton. Marmaduke later became governor of Missouri. *Courtesy of the Library of Congress.*

with the Second Colorado Cavalry at Mine Creek. Robert Redford later played him in the film *Jeremiah Johnson.*

Also on the Union side, as mentioned before, was General Alfred Pleasanton. He was a major cavalry commander at Gettysburg and the man who gave Custer his big break, personally promoting him to brigadier general. He led Federal forces at the Battle of Brandy Station in the east, making him the only general to lead major cavalry battles on both sides of the Mississippi.

Frederick Benteen, the colonel who led his brigade in the attack at Mine Creek, later commanded Company H at the Battle of Little Bighorn. Historians have debated his role at that battle ever since, with some thinking he didn't do enough to support Custer's attack and others praising his defense of the surviving Seventh Cavalry that night. George W. Yates, who would perish at Little Bighorn, was in the Thirteenth Missouri Cavalry here, too.

Anyone and everyone was at Mine Creek or in support nearby. This collection of notables at the battle has been forever overshadowed by the private who captured a general, though. You can't beat that.

JIM LANE IS LUCKY THERE'S A CORNFIELD NEARBY

Quantrill's massacre of Lawrence was one of the most brutal atrocities of the American Civil War. On August 21, 1863, somewhere between 300 and 400 Confederate guerrilla riders let by William Quantrill stormed into town and killed many of the adult males of the town. Over the course of four hours, the raiders fanned out across Lawrence, burning a quarter of the buildings, executing 185 to 200 men and boys and looting everything they could get their hands on. Lawrence symbolized abolition to them, and they also came for revenge—especially against U.S. Senator Jim Lane. Lane was, himself, a ruthless warrior and antislavery Jayhawker. He had enraged many pro-South (and neutral) Missourians with his sacking of Osceola, Missouri, two years before, killing 9 people. His raising of the first black troops in U.S. History, the First Regiment Kansas Volunteer Infantry (Colored), incensed many Confederate sympathizers as well.

Quantrill's men were told by a young spy that Lane was out of town when they arrived in Lawrence. Lane was actually at home, but Quantrill went for the Eldridge Hotel first instead. This move by Quantrill gave Lane enough time to run into a cornfield and hide in a ravine in his nightshirt. Had he

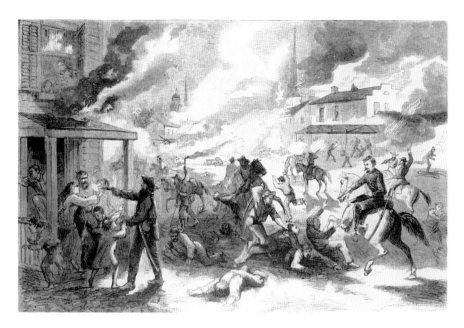

Harper's Weekly depiction of the destruction of Lawrence, Kansas, and the massacre of its inhabitants by the Rebel guerrillas, August 21, 1863. *Courtesy of the Library of Congress.*

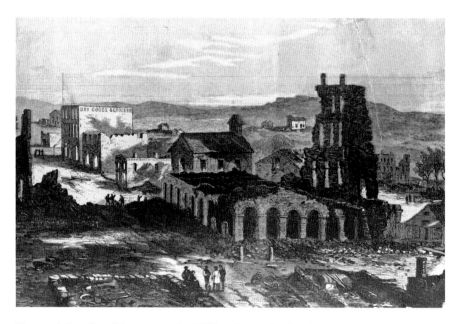

Sketch of the ruins of Lawrence after William Quantrill's Confederate guerrilla raid and massacre on August 21, 1863. From *Harper's Weekly*, September 19, 1863. *Courtesy of the Library of Congress.*

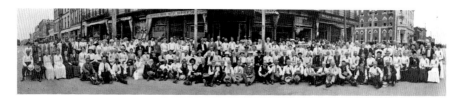

Survivors of Quantrill's raid on Lawrence meet in August 1913 to commemorate its fiftieth anniversary. Between 160 and 190 men and boys were executed by pro-Confederate guerrillas. *Courtesy of the Library of Congress.*

been captured, the guerillas planned to take him back to Missouri and burn him at the stake. The raiders later came to his home, but his wife met them at the door, telling them her husband was away and couldn't "receive visitors." The assembled men contented themselves by burning his fine brick home to the ground. Lane later gathered up some men (and a pair of pants) to pursue the retreating raiders but never caught up to Quantrill.

3

WILD WEST

CUSTER'S COURT-MARTIAL

Any mention of George Armstrong Custer (1839–1876) stirs up the American imagination. In the decades before the 1960s, he was seen as a gallant soldier romantically fighting to the end for the American people. Later reevaluations by historians placed him as a sophisticated social climber who egotistically attacked oppressed native peoples and got himself and his men needlessly killed. Either way, he was an interesting character, and his time in Kansas includes a court-martial that was quite telling as to the man he had become—and what led to his demise.

If anything, Custer was a daring and oftentimes reckless man. This is what propelled him to such dizzying heights and also what led to his downfall. Graduating dead last in his class at West Point, he piled up demerit after demerit for pranks and other disciplinary infractions. His academics suffered as well, and he graduated last in the class of 1861. With so many demerits, he was often punished with extra guard duty and other chores. With the outbreak of the Civil War, though, his recklessness was seen as daring. His battlefield cavalry exploits were brilliant, and his bold leadership led to many successful cavalry charges during battles. Custer had many horses shot out from under him, but he earned the nickname of "Boy General" at the Battle of Gettysburg when he held off J.E.B. Stuart's assault. At the incredibly young age of twenty-three he was promoted to brigadier general,

and by the end of the war, Custer was a major general. He served the Army of the Potomac with bravery and blocked General Lee's final retreat at Appomattox Court House. Custer was even in the parlor of the McLean home when Lee officially surrendered to Grant, and his wife received the table from the surrender as a gift from General Philip Sheridan. Sheridan wrote to her, "Permit me to say, Madam, that there is scarcely an individual in our service who has contributed more to bring about this desirable result than your gallant husband."

With his meteoric rise covered in newspapers across the nation, Custer became a celebrity. He was feted by high society, presidents and other leaders of the time. No doubt this fame got to his head, as he worked hard to lobby for higher position and worked his friends in high places to get his way. He even took a tour in support of President Andrew Johnson's policies in hopes of being rewarded by a colonel's commission. Not only did he work the back channels to get his way, he was also flamboyant with his appearance to enhance his public appeal. Donning a broad sombrero over his golden locks (which he added scented cinnamon oil to), he also wore a red scarf around his neck and a gold lace–coiled black velvet uniform. This was clearly a man who had an image to sell.

In July 1866, Custer was made lieutenant colonel of a new regiment to be based at Fort Riley, Kansas: the Seventh Cavalry. Indian attacks against white encroachment on their lands was a problem for westward expansion, and many forts were built across Kansas to protect the frontier during this period. During the next year, the Seventh Cavalry scouted the western part of Kansas and Colorado and supported Major General William Scott Hancock's campaign against the Cheyenne. By this time, Custer believed he was living a charmed life and that he had a special "Custer Luck" that got him through just about anything. Perhaps having eleven horses shot out from under you does that to a man.

On July 13, 1867, Custer arrived at Fort Wallace, the westernmost fort in Kansas in current-day Wallace County. This fort, just miles from the

Battle between Cheyennes and the Seventh Cavalry near Fort Wallace in western Kansas, June 26, 1867. Wood engraving from *Harper's Weekly. Courtesy of the Library of Congress.*

The bodies of Lieutenant Smith, Captain Yates, Lieutenant Calhoun and Captain Thomas Custer were exhumed at Little Bighorn and reinterred at Fort Leavenworth, 1877. *Courtesy of the Library of Congress.*

Colorado border, was wracked with cholera and short supplies of medicine, food and ammunition. The beleaguered post was under constant Indian threat, and Custer decided to take seventy-five of his men nearly 230 miles east to Fort Harker (near present-day Kanopolis in central Kansas) to get needed supplies. Leaving on July 15, Custer didn't have authorization from his superiors, and the way in which he conducted himself on this journey was suspect, too. During the trip, Custer neglected to pursue Indians who were reported to have killed two of his men. He hadn't even buried the bodies. Not only that, but he also had earlier ordered his men to chase and shoot three deserters without trial, with one, Charles Johnson, dying.

Arriving at Fort Harker on the nineteenth, he was placed under arrest by Colonel Andrew J. Smith. None other than General in Chief of the U.S. Army Ulysses S. Grant ordered a September court-martial trail for Custer at Fort Leavenworth, Kansas. Lasting from September 15 to October 11, 1867, Custer's trial covered the charges of "Absence of leave from his command and conduct prejudicial to good order and military discipline." He was also charged with wanting to "pursue private business," which was his hope to see his wife at Fort Riley. Lesser charges of using four mules and two ambulances for his personal use on the journey to Fort Harker were considered as well. Mostly, though, he was being punished for this AWOL journey of his when he should have used Fort Wallace's resources to pursue Indians.

He pleaded not guilty to all charges and even had some witnesses in support of him. Not all of it was particularly helpful. Lieutenant Thomas Custer, his own brother, testified that George told him, "I want you to get on your horse and go after those deserters and shoot them down." Nevertheless, George Armstrong Custer was found guilty of five of eleven charges and suspended from rank and command without pay for one year. No doubt his prior service was taken into account for this lenient sentence. Custer and his wife were even allowed to stay in Major General Philip Sheridan's suite of

rooms at Fort Leavenworth. In the spring of 1868, he and his wife moved to Michigan, where he enjoyed fishing, hunting and relaxation. Kansas had seen new Indian attacks across the state in August, and the call went out to bring Custer back. He was back with the Seventh Cavalry in September the day after receiving a telegram from Sheridan stating, "Generals Sherman, Sully and myself, and nearly all the officers of your regiment, have asked for you....Can you come at once?" His Indian-fighting career was back on.

Custer's actions in Kansas and his treatment of deserters is a perfect illustration of the man he still was by 1876 at his doom at the Battle of Little Bighorn. His rash behavior led to two hundred other men's deaths, including his younger brothers, Boston and Thomas, as well as his nephew Henry Reed and brother-in-law James Calhoun. Apparently, his court-martial hadn't dampened his belief in himself. There are still echoes of Custer across Kansas, from exhibits at Fort Hays, Fort Larned and Fort Riley to the dumbbell and boots of his held by the Kansas Historical Society in Topeka. The most powerful testimony to his legacy, though, is at Fort Leavenworth National Cemetery. Among the thousands of immaculate military tombstones are the graves of Thomas Custer and James Calhoun. Not far away is another Custer-linked grave—deserter Charles Johnson.

WYATT EARP COMES TO WICHITA

When one thinks about Wyatt Earp, a few images come to mind immediately for most people: his days in Dodge City with friend Doc Holliday and the later gunfight at the O.K. Corral in Tombstone, Arizona, in 1881. Such legendary stories are what made him a household name—decades after his death—in numerous books, movies and TV shows. But before he became the heroic figure portrayed by Kurt Russell in *Tombstone*, he made some interesting stumbles in Kansas before his fame took off.

Born one of seven siblings in 1848 in Illinois and raised in Iowa, Earp longed to get off the farm and see the world. With three of his brothers serving in the Civil War (with brother Newton fighting at Mine Creek in Kansas in 1864), he attempted to run away and enlist on numerous occasions. His father came and retrieved him each time, as he was only thirteen. As he grew up, he had an adventurous lifestyle, working as a teamster, a boxing referee and later a constable in Lamar, Missouri. Married in 1870, his young wife, Urilla, died of typhoid later that year. Devastated, he roamed frontier

towns, frequented saloons and brothels, was sued twice, was arrested on multiple occasions and worked as a strongman. He was even arrested once for stealing a horse but escaped from his cell.

In 1874, he moved to the Chisholm Trail cow town of Wichita, Kansas. His brother Virgil had opened a brothel that catered to the cowboys driving up from their cattle drives from Texas. Wichita was a rough and smelly place at the time, full of vice and restless men. With nearly twenty thousand longhorn cattle passing through town each week on their way to the railroads farther north in Kansas, the town was full of cowboys that were nearly all armed. The town even posted a notice to new arrivals, "Everything goes in Wichita. Leave your revolvers at police headquarters and get a check. Carrying concealed weapons is strictly forbidden." Drinking, socializing, fighting, prostitution and violence were commonplace in the west side of town, with town leaders appreciating the economic benefits of the cowboys passing through but decrying the moral degradations of being a frontier town.

With hundreds of Texans walking the boardwalks from music hall to saloon to brothel, the crowding of rooms (sometimes eight men to a

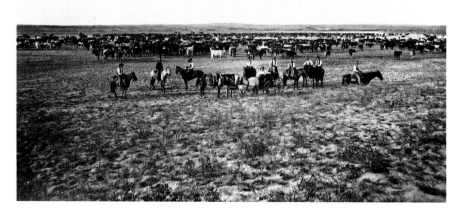

Cowboys herding cattle on the plains. Over twenty million cattle were herded from Texas to Kansas between 1866 and 1886. *Courtesy of the Library of Congress.*

room) and liquor was bound to lead to disorder. Wyatt came to town in this atmosphere and was soon working for local saloons to keep order. Later, he was hired by Wichita marshal Michael Meagher as an official city policeman, walking the city streets to keep the peace for sixty dollars a month. No doubt he broke up a few fights and kept an eye on characters his brother pointed out to him as troublemakers at his brothel.

Wyatt earned a reputation as an effective officer, known to carry a Remington that he could pistol-whip opponents with if he had to. He apprehended horse and wagon thieves and stood up to rowdy groups of armed men on occasion. He was also a good fistfighter, no doubt having picked up some skills from his days working in the boxing world. Bat Masterson later said of Earp, "There were few men in the West who could whip Earp in a rough-and-tumble fight." In 1875, the *Wichita Beacon* wrote of an incident Earp was involved in:

> *On last Wednesday* [December 8], *policeman Earp found a stranger lying near the bridge in a drunken stupor. He took him to the "cooler" and on searching him found in the neighborhood of $500 on his person. He was taken next morning, before his honor, the police judge, paid his fine for his fun like a little man and went on his way rejoicing. He may congratulate himself that his lines, while he was drunk, were cast in such a pleasant place as Wichita as there are but a few other places where that $500 bank roll would have been heard from. The integrity of our police force has never been seriously questioned.*

Earp wasn't without his faults, though. On January 9, 1876, he was at the Custom House Saloon with his feet up on a table enjoying drinks with some friends when his loaded revolver slipped from his holster, struck the floor and discharged a bullet. The bullet "passed through his coat, struck the north wall then glanced off and passed out through the ceiling." Wyatt was embarrassed enough by the accident, but even more so when the *Wichita Beacon* reported on January 12 about the incident. His biographer Stuart Lake later left the event out of his biography of Earp after a request by Earp to omit it from *Wyatt Earp, Frontier Marshal*. Lawmen were supposed to have more control over their tool than that, and he knew it.

Wyatt's time in Wichita came to an abrupt end, though, on April 2, 1876. Wyatt's boss, Michael Meagher, was being challenged in the city's marshal election by a man named William Smith. Smith made some disparaging remarks either about Meagher or Wyatt and his brother (sources differ),

and Wyatt took offense. Challenging Smith to a fistfight, Earp beat him handily. Meagher won reelection, but he could not save Wyatt's job and was forced to fine Earp thirty dollars and fire him. A Wichita commission took nominations for hiring new police officers, and Wyatt was not re-hired, as his behavior was "unacceptable."

Being done in Wichita after a good run as a lawman, Wyatt followed his brother James to Dodge City, where the cattle trade had newly shifted. Soon he was working as chief deputy marshal for the town and met and befriended Doc Holliday, whom he credits with saving his life once at the Long Branch Saloon. Wyatt's penchant for getting rough with an opponent might have gotten him kicked out of Wichita, but it was the kind of character trait that served him well later in important moments in his life, such as the gunfight at the O.K. Corral.

DONNER PARTY'S FIRST VICTIM

The Donner Party story is one of the saddest and most spectacular misadventures in American history. There were many thousands of pioneers on wagon trains who braved the Oregon Trail in the mid-1800s to head west to California, but the Donner Party's 1846 journey is remembered above all of them. The decision to take a different route resulted in them being caught in the Sierra Nevadas by an early, heavy snowfall high in the mountains near Truckee Lake. For four months, as food supplies ran low, many of them were forced to resort to cannibalism for survival. Of the eighty-seven members of the party—which started out in Independence, Missouri—only forty-eight lived to see California. What many people don't realize is that they lost their first member in Kansas.

When the group originally left Springfield, Illinois, on April 23, 1846, the *Sangamo Journal* noted the departure in an article, "HO! FOR OREGON AND CALIFORNIA":

> The company [Donner-Reed] *which left here last week, for California, embraced 15 men, 8 [5?] women, and 16 children. They had nine wagons [sic]. They were in good spirits, and we trust, will safely reach their anticipated home. A company have left Putnam county, consisting of 16 males and 7 females, for Oregon. John Robinson, one of the first settlers*

of Madison County, was one of their number. A Chicago paper states that
some forty persons will leave Rockford this spring for the same destination.

Of the many intrepid travelers who joined the group in Illinois and
Missouri, Sarah Keyes may have been the bravest. At age seventy in the
winter of 1845–46, she was informed by her doctors that her health had
deteriorated to such a point that she likely only had a few months left
to live. She wasn't terribly surprised, as she was very old for the time—
average life expectancy was thirty-seven. Born in 1776 in West Virginia
to a Revolutionary War veteran, she had seen her share of years. Keyes
knew she only had so much time left and decided to push her body for one
more grand adventure—to see her son one more time. This son of hers
had migrated to Oregon years earlier and she'd rather not die sitting in a
rocking chair back in Illinois.

One of the Donner Party's group leaders was her son-in-law James Reed,
who was married to her daughter Margaret. After Sarah insisted that she
go with her daughter and the grandchildren, James agreed to let her go.
Word was sent ahead to her son in Oregon to meet her at Fort Hall in Idaho.
Leaving in the spring of 1846, a specially designed wagon was outfitted for
her to provide a comfortable ride for her frail body. By the time they left
Independence, Missouri, she was already suffering from consumption, an
old term for wasting away of the body from tuberculosis.

Being one of the organizers of the wagon train, James Reed, an Irish
immigrant, had made a comfortable life for his family as a successful
businessman and farmer. This wealth allowed him to build this special
wagon, which was two stories high. It had spring-cushioned seats, an iron
stove and sleeping bunks. It was by some accounts the fanciest and most
massive wagon anyone had ever built for a westward journey on the Oregon
Trail. Eight oxen were required to pull this wagon, and it was nicknamed
the Palace Car by fellow travelers. Two other wagons followed it, provisioned
with food, tools and liquor. Though they were ready as they could be, they
tearfully departed with their friends and well-wishers. In her diary, their
twelve-year old daughter Virginia noted, "My father, with tears in his eyes,
tried to smile as one friend after another grasped his hand in a last farewell.
Mama was overcome with grief. At last we were all in the wagons. The
drivers cracked the whips. The oxen moved slowly forward and the long
journey had begun."

When the caravan left Independence on May 1, 1846, it comprised 63
wagons, 119 men, 59 women, 110 children, 58,484 pounds of bread, 144

guns, 700 cattle, 150 horses, 38,000 pounds of bacon, 1,065 pounds of powder and numerous other supplies. This massive caravan later split into two or three separate trains. By May 19, the Reeds and Donners had joined one of those splits. Going was slow, with average speeds of ten to fifteen miles a day being the norm. Not only were the loads incredibly heavy for the oxen, but hilly terrain and water crossings also slowed progress. The constant bumping and jostling was difficult even under the most comfortable of circumstances, and Mrs. Keyes was undoubtedly uncomfortable on her journey.

On May 26, the group reached the Big Blue River in present-day Marshall County, roughly 140 miles northwest of Independence, Missouri. Due to recent rains, the river was heavily swollen and the group was forced to make camp until the waters receded. The water remained high for days, so the men got to work creating a crude boat made of large cottonwood trees. This boat, called the *Big River Rover*, could rest the wheels of wagons in each dugout. Once the wagon was placed on the boat, lines from shore could pull the raft back and forth by hand.

While all this work was taking place, Sarah Keyes lay on her deathbed. Full of hope to see her son again, it was not meant to be, and she died with her daughter at her side on May 29, 1846. The other members of the train were saddened by her death, and the travelers pitched in to give her a proper sendoff. Some of the men fashioned a coffin for her from a cottonwood tree that they felled, and a grave was dug for her under an oak tree. A young Englishman named John Denton carved her name and age on a gray stone that he found. The inscription read "Mrs. Sarah Keyes, Died May 29, 1846, Aged 70." Later, a fellow traveler, Edwin Bryant, wrote:

> *The event...cast a shade of gloom over our whole encampment.... All recreations were suspended, out of respect for the dead, and to make preparations for the funeral....At 2 o'clock P.M., a funeral procession was formed, in which nearly every man, woman and child of the company united, and the corpse of the deceased lady was conveyed to its last resting place in this desolate but beautiful wilderness. Her coffin was lowered into the grave. A prayer was offered to the Throne of Grace by the Rev. Mr. Cornwall. An appropriate hymn was sung by the congregation with much pathos and expression. A funeral discourse was then pronounced by the officiating clergyman, and the services were concluded by another hymn and a benediction. The grave was then closed and carefully sodded with the green turf of the prairie, from whence annually will spring and bloom its brilliant and many-colored flowers.*

It's telling to contrast the care that the band of travelers put into giving Mrs. Keyes such a lovely and dignified sendoff with the hurried burials they later carried out when they frantically tried to cross the Sierra Nevadas. The rest of the party crossed by May 31 and continued on their ill-fated journey. The location of Mrs. Keyes's burial was named Alcove Spring by the travelers, and to this day, you can go there and find inscriptions by Mr. Bryant and Mr. Reed made on rocks there during those days. Grieving granddaughter Virginia wrote in her diary, "It seemed hard to bury her in the wilderness and travel on…but nowhere on the whole road could we have found a more beautiful resting place."

Old Sarah Keyes has often been considered one of the luckiest Donner Party members, having checked out peacefully before all of the horror struck. Son-in-law James Reed was later banished by the party in October after stabbing to death a young teamster named John Snyder. Snyder was frustrated and began to beat his oxen with a whip, and as Reed tried to intervene, he was whipped by Snyder. In self-defense, Reed stabbed him. Reed avoided hanging (which some called for), and the other travelers allowed Margaret and the children to continue under the care of the other travelers. Reed was to meet up with them in California.

Edwin Bryant had traveled ahead of the party and warned them not to take the Hastings Cutoff, the shortcut that they ended up taking. He thought the wagon train was unsuited for such a difficult crossing, and he was right. They ignored him and were stranded. Luckily, Margaret and all of the Reed children survived the months-long ordeal of starvation and cannibalism. Their exiled father, James, led a rescue party of men and supplies into the mountains on February 19, 1847, and rescued his family and more with subsequent rescue parties. Mrs. Keyes surely would have been proud of her family's fortitude in surviving their ordeal. Maybe they had the same pluck as a seventy-year-old grandma embarking on a two-thousand-mile wagon trip.

SKELETONS FROM A MASSACRE

In the spring of 1973, heavy rains flooded Walnut Creek, a small creek east of Great Bend, Kansas. When the floodwaters receded on April 1, a local land owner noticed human bones protruding out of the creek banks. Sheriff Marion Weese was called to the site to investigate a possible murder scene, and he brought evidence bags in which to place the skeletal parts. The news reports

at the time speculated that a previously unknown mass murder had been discovered. Kansas Historical Society archaeologists, led by state archaeologist Thomas Witty, suspected that something very different had taken place.

After finding steel arrowheads still sticking out of the bones, the archaeologists knew this was something very old. Searching the archives and knowing their state history, they came across a little-known story of teamsters attacked and massacred on the trail in 1864. The bodies of eight white men were found together in a mass grave, and nearby were two black men in a separate grave.

In June 1864, a caravan of thirty wagons carrying thirty men (many of them mere teenagers) set out from Fort Leavenworth heading southwest on the Santa Fe Trail to carry supplies and flour to Fort Union, New Mexico. The journey of over seven hundred miles was a risky one, as hundreds of Arapaho, Comanche and Kiowa Indians had been raiding travelers on the trail. A wagon train full of flour, beef, tools and other goods was a rich target for peoples marginalized by the westward-expanding Americans. The government refused to give the wagon train a military escort because the army assured officials that treaties with the Indians were in place. The teamsters were also denied weapons, which would prove fateful. Some wagon masters knew, though, that the Indians were displeased with their treatment by the government and were wary of them.

On the morning of June 18, 1864, the wagon column got to moving again after twenty-one days of travel at roughly ten miles a day. They had camped at the big bend of the Arkansas River, near present-day Great Bend, Kansas. The trail would take them past a new military installation a few miles away named Fort Dunlap that was manned by the forty-five volunteer members of the Fifteenth Kansas Cavalry. Though the soldiers' mission was to built the future Fort Zarah, the place was practically empty when the wagons approached in the late morning. Due to the Civil War still raging back east, the frontier forts were poorly manned by unprofessional volunteers, many of whom had retreated to Fort Larned (thirty-two miles away) for safety against recent Indian attacks.

As the wagons approached the camp, still a mile away, the train halted as 125 Sioux braves suddenly rode up on horseback and surrounded them. Appearing friendly at first, the Indians and wagon master James Riggs shook hands, talked for a few minutes and offered tobacco. The rest of the warriors, though, were making their way down both sides of the halted wagons when suddenly they attacked the unarmed teamsters. Arrows began to fly, and gunfire erupted up and down the caravan. The unarmed men could only

Fort Larned National Historic Site exterior walkway, 2006. Operating from 1859 to 1878, the fort is remarkably well preserved. *Photo by the author.*

flee toward the fort and abandon their wagons. When the violence subsided, ten teamsters were lying dead and scalped. The Indians cut open the bags of government flour, spilling it on the ground. They also took their fill of wagon canvas, personal belongings and other items that they wished to take before riding off. The surviving men and the soldiers at the fort were greatly outnumbered and could only watch helplessly as the events unfolded.

When the warriors left, the survivors returning to the wagons were shocked to find two teamsters still alive. One of them, a thirteen-year-old orphan named Robert McGee of Easton, Kansas, was found scalped and riddled with arrows and a bullet to the back. His pleading for someone to shoot him was ignored, and he and another boy were rushed to Fort Larned to recuperate. The other boy died, but McGee went on to make a full recovery. He recalled how he was awake during the whole ordeal, and everyone was amazed that he survived with sixty-four square inches of his scalp and hair removed. Infection killed many scalping victims, but McGee was more fortunate than others.

Robert McGee lived a long and interesting life after this, making his living as a sideshow curiosity. In 1890, he was promoting himself as the only man who had ever survived a scalping. He gave talks to spellbound audiences about his exploits along the Santa Fe Trail, and some of his promotional fliers still survive today. His scalp's giant bald section was surely a sight to behold for his audience as he told his story of horror and survival.

McGee's departed fellow teamsters lay in their forgotten graves for 109 years until the floodwaters exposed their bones. This just goes to show that just under the surface lie many stories that may still be resurrected and told in full. Fascinating stories and lost ways of life are literally right under our feet if we are fortunate enough to come across them.

A RUSSIAN GRAND DUKE VISITS

Grand Duke Alexei Alexandrovich Romanov of Russia (1850–1908) cut an imposing figure. Born into the Romanov Dynasty of Russia, he was one of four sons of Czar Alexander II. As his brother Alexander III (later czar) was next in line of succession, the younger Alexei was chosen for a naval career. Standing at six feet, one inch tall and handsome in his naval uniform and thick beard, he was somewhat of a playboy bachelor his entire life. He dedicated himself, though, to modernizing the Russian navy and agreed to go on a goodwill tour of many nations to represent the Russian Empire. This grand tour would include a jaunt through Kansas.

The Russian squadron of six steam-powered ships that made up the goodwill party included the duke's personal staff, as well as two hundred officers and over three thousand sailors, leaving Russia on August 20, 1871. Visiting Denmark and England first, they arrived in New York Harbor on November 21. He headed to Washington, D.C., the next day to meet with President Grant and was photographed by Mathew Brady. After that, he traveled by train back to New York, up to Canada, visited Chicago right after the Great Fire and then on to St. Louis. He next met up in Nebraska with General Philip Sheridan, Lieutenant Colonel (Brevet Major General) George Armstrong Custer and "Buffalo" Bill Cody himself. On January 13, 1872, they all took the grand duke on his first buffalo hunt, which they followed with champagne and a party. The hunt made world news, as it was such a unique convergence of famous persons together.

After traveling to Colorado, where he went on another buffalo hunt, Alexei could not get enough of this new sport. He succeeded in shooting at least twenty-five of them near Colorado Springs. With the duke's famous traveling party of Custer, Cody and Sheridan, the U.S. government really laid out the red carpet for him to fulfill his desire to hunt. In the reckless Kansas fashion of the time, the party continued to shoot buffalo from the train as they headed east across Kansas. The herds were so numerous that shooting them from a train was a common pastime.

The party made its next stop in Topeka, where the members were greeted by a massive crowd that had gathered to see the grand duke, as well as the aforementioned famous escorts of his. In Topeka, the hunting party went to J. Lee Knight's photo gallery to pose for a series of famous photos together. They were then taken to the Kansas Statehouse, where a cornet band, a chorus group and the entire legislature convened to sing him a song set to the tune of "Old John Brown":

Mid the grandeur of the prairies, how can youthful Kansas vie
With her Russia-loving sisters, in a fitting welcome cry?
With her heart give full expression, and the answer echo high
The Czar and Grant are friends!
Ho! For Russia and the Union
Ho! For Russia and the Union
The Czar and Grant are friends!

Before leaving Topeka, the grand duke was treated to a grand dinner at the Fifth Avenue Hotel. The party left Topeka in good spirits, having shot its way across the state and plundered the caviar and champagne supplies the entire way, not to mention dancing and flirting with the ladies in every city. Custer stayed on with the grand duke all the way to Mardi Gras in New Orleans and then to Florida. Until Custer's death, they continued to write letters to each other and considered themselves great friends. Libbie Custer thought the duke was more interested in "pretty girls and music" than the country he was passing through, though.

The Grand Duke left Pensacola, Florida, with hundreds of pounds of buffalo meat on ice that he took with him to his next stops in Rio de Janeiro,

George A. Custer (*reclining*) and Russia's Grand Duke Alexei hunted buffalo from a train in Kansas and visited the Kansas Legislature in Topeka, 1872. *Courtesy of the Library of Congress.*

Singapore, Hong Kong and Japan. Heading back to Russia in December 1872 via Siberia, the grand duke would never forget his days in the Wild West, and he told tales of this grand trip the rest of his life, especially about the train hunt in Kansas. His nephew, the future Czar Nicholas II (the final czar of Russia), loved to hear him talk of Custer and his friendship with him. When Alexei died in 1908, Nicholas was devastated by the loss of his "favorite uncle."

Some historians think that the widespread accounts of Alexei's buffalo hunts increased the rate at which these animals were slaughtered in the following years. Newspapers all over the nation glorified his manly feat with national hero George Custer, helping popularize the reckless practice. Over 3.7 million buffalo were killed in the two years after his visit (1872–74), and the great southern herd of Kansas that he had shot at was almost totally destroyed within three years.

4
SCIENCE

APOLLO 13 COMES TO KANSAS

Sometimes, great things come from humble beginnings. The Kansas Cosmosphere and Space Center in Hutchinson is one such place. The massive museum holds tens of thousands of spaceflight artifacts and is one of the top aerospace museums in the world. Second only to the National Air and Space Museum in Washington, D.C., it holds the largest collection of U.S. space artifacts in the nation. It even holds space artifacts from Russia as well, with the largest collection outside of Moscow. Visitors can go there today and see the actual Apollo 13 Command Module *Odyssey* and the *Liberty Bell 7*, as well as German V-2 rockets, flight suits, moon rocks and other objects. Still, it's pretty strange all of this is in Kansas. It sits hundreds of miles from mission control in Houston or NASA's launch pads at Cape Canaveral. So what's the deal? It all began with a used planetarium projector, some folding chairs and the poultry building at the Kansas State Fair.

The Kansas State Fair was officially awarded to Hutchinson in 1913 after rotating between different cities in Kansas such as Topeka and Wichita over the previous few decades. As it grew, like many state fairs of the twentieth century, it became a professional operation with a dedicated fairgrounds and permanent structures. In 1962, one of these permanent structures, the poultry building, was chosen by future Cosmosphere founder Patricia "Patty" Brooks Carey for a planetarium. With rented

folding chairs for spectators and a used planetarium projector that she bought from her hometown of Oklahoma City, the pop-up planetarium was a hit. There was no other planetarium in Kansas then, so this was quite novel to most visitors. Patty's passion for astronomy drove her to raise $7,200 from wealthy friends and neighbors to purchase a star ball for the planetarium—and did it all in one weekend. She had a way of persuading people and the energy to get things done.

Patty was the daughter of a banker and lawyer from Oklahoma who encouraged her to expand her mind, and her parents took the children on around-the-world tours. She fell in love with planetariums after seeing one in Germany. Carey once said,

> *As a child I saw a wonderful machine in Germany. It could project the sun, moon and stars on a dome and show their movements in a simulated night sky. It could take one years into the future or the past. It was called a planetarium. I was hooked on this wonderful and fascinating creation. That was the beginning of my interest in astronomy. A seed had been planted, waiting for a little nourishment to grow. The idea for a planetarium for Hutch was conceived and implemented in just three days in October of 1962.*

The planetarium gained in popularity over the next four years, and Carey knew it needed a proper, permanent home. At the poultry building, ticket sellers had to stand freezing out in the cold on winter days, and the interior had to be warmed by space heaters. She campaigned and raised $55,000, and the planetarium was offered a wing in the new science building at Hutchinson Community College. In 1966, the operation gained more legitimacy with the opening of the new wing and the hiring of a director. Carey wasn't done yet, though. She wished to expand ever more and had a vision of adding a museum dedicated to space exploration. These were exciting times in the late 1960s and through the 1970s, with NASA landing men on the moon, launching SkyLab and beginning development of the space shuttle.

The pivotal year for the future of this endeavor was 1976, when the planetarium hired a new executive director named Max Ary. Ary had relationships with many people at the Smithsonian, NASA and even a few astronauts. With Ary on board, the planetarium announced the $1.5 million Kansas Cosmosphere and Discovery Center. Back in the 1970s, a lot of space artifacts were sitting forgotten in warehouses and considered old and

useless. There wasn't as much of a sense of the value of everyday items, as later generations learned with baseball cards. Carey and Ary crisscrossed the United States collecting a plethora of objects that no other museum was even trying to get. Simply making calls to a few places would land them old spacesuits, rocket parts, astronaut tools—and even a lunar module mockup. The groundbreaking for the new space center to hold such treasures was probably the most unique in Kansas—and maybe even world history. A satellite signal was sent from space to set off a dynamite charge to blow out the first load of dirt.

Opening in 1980, the 35,000-square-foot museum includes classrooms, a planetarium, three levels of exhibits, school group programming and even one of the world's first IMAX dome theaters. Over fifteen thousand artifacts are owned by the museum, with only 7 percent even on display at any given time. In 1997, a major expansion included an SR-71 Blackbird jet for the lobby, a partial replica of a space shuttle and 105,000 total square feet of space. Visitors are treated to World War II German V-1 and V-2 rockets, a Soviet Vostok spacecraft, an Apollo 11 moon rock and even the flight-ready backup for the USSR's Sputnik-1, the first man-made satellite.

The Cosmosphere grew to be such a major player in space expertise that in 1998 it was named an affiliate of the Smithsonian Institution. The SpaceWorks division at the Cosmosphere, a division that is contracted to restore flown spacecraft and other artifacts, is contacted by museums worldwide for exhibit production and professional restoration and replication services. The team also worked on the Apollo 13 Command Module *Odyssey* and the *Liberty Bell 7*—both on display in the gallery. Many of the props and artifacts used in Ron Howard's *Apollo 13*, as well as *Magnificent Desolation: Walking on the Moon 3D* and the miniseries *From the Earth to the Moon*, were built by the SpaceWorks team.

Many high-profile former astronauts have come to the Cosmosphere to speak and to see the objects that they themselves worked with. Charlie Duke, an astronaut who flew on Apollo 16 in 1972 and was one of only twelve men to walk on the moon, came to Hutchinson to speak at the Cosmosphere. "As I walk through and see the various mockups and the spacecraft that were flown, it's a trip through memory lane for me," Duke said. "I spent six years on Apollo and worked on five of the nine missions that went to the moon, so it brings back many, many memories." Apollo 13 astronauts Fred Haise and James Lovell came to the Cosmosphere on the fortieth anniversary of the Apollo 13 flight to speak and see their old craft. "The last time I saw it was when I crawled out of it in the South Pacific," said Haise. Coming to

the Cosmosphere is like a walk down memory lane for many space veterans. Gene Cernan, the last man on the moon—and friend of the Cosmosphere—visited Hutchinson many times and was a great promoter of the museum. Most appropriate of all, one of the main fundraisers for the space center in 1980 was Apollo 17 commander Ron Evans, a Kansas native and University of Kansas alumnus.

Many of us grow up in Kansas taking the Cosmosphere completely for granted. By the time of Patty Carey's death in 2003, it was entrenched as one of the wonders of the state, with hundreds of thousands of visitors a year. We go there with family members, on field trips, to see IMAX films and so on. Of course we grow up and eventually realize that maybe Kansas is a funny place to have a world-class space museum. I guess all it takes is a feisty lady with a love for space, a used star ball projector and a state fair poultry building to get one going.

GEORGE WASHINGTON CARVER, HOMESTEADER

One of the great misconceptions about famed scientist George Washington Carver is that he invented peanut butter. He did spend decades studying the peanut, though, finding over three hundred new uses for it, such as shaving cream, milk and coffee. He is most widely known as working at the Tuskegee Institute in Alabama for over fifty years, living modestly and refusing to cash in on his scientific breakthroughs. What people also don't realize is that he spent his formative years in Kansas, with his humble beginnings no doubt influencing his character.

Born into slavery in Diamond Grove, Missouri, on or around July 12, 1864, he and his mother were purchased by a farm family in Missouri named Carver. Confederate raiders kidnapped George, his mother and a sister of his soon after. Only he was found and returned to the Carvers, whom he continued to live with even after the abolition of slavery the next year. He moved to Fort Scott, Kansas, at age thirteen and supported himself by working the laundry at a local hotel—all while going to school. He moved around a few more times in his teens, including to Olathe, Paola and Spring Hill. Ex-slaves Ben and Lucy Seymour of Olathe befriended George, and he helped Lucy with her laundry business while he continued his schooling and also working in a barbershop. Moving to Minneapolis, Kansas, with them in the summer of 1880, he finished high school there.

Being a very bright and curious student, George was accepted by letter into Highland Presbyterian College, a small school in northeast Kansas. Upon arrival, though, school officials discovered that he was African American and thus rejected him. Said Carver, "I was admitted, went, but when the president saw I was colored he would not receive me. I had spent nearly all my money, and had to open a laundry here." After befriending a white family by the last name Beeler, Carver stayed in Highland for nearly a year working for them. One of the Beeler sons, Frank, moved out to Ness County in the western part of the state to open a store. Eventually, the entire Beeler family worked to recruit other Highlanders to head west to a town that they were platting called Beelerville (present-day Beeler). They opened a hotel and store, and the town slowly sprang into being.

Having been stranded in Highland for the past year due to a racist school rejection, Carver decided to take the 300-plus-mile journey west by wagon with J.F. Beeler and join the great migration. At this time, in the summer of 1886, 160 acres of land were free for settlers as a way to populate the American interior. All you had to do was make a claim at a local land office, and you would receive full title on the land after five years of residence on the claim. After initially working for a white settler name George Steely, Carver bought a relinquished claim south of Beeler in August of that year. After heading to Wakeeney and paying the fourteen-dollar filing fee on his homestead application, he began work on the claim.

Keep in mind that the Great Plains at the time were a roadless, treeless expanse of grass. Pretty much the only timber in the state was along rivers and creeks, the rest rarely survived—burning up in prairie wildfires that swept across the plains yearly. By the spring of 1887, on this treeless setting, he had built a sod house, as that was the only building material around. Many businesses, schools and churches were similarly constructed of sod in the early days of the state. Life was not easy, but Carver did the best he could and made his little house as comfortable as possible. He brought in a bed, table and chairs, a stove and a cupboard into his small one-room structure that was no more than fourteen square feet. He was twenty-two years old and had all the time in the world to focus on succeeding at homesteading. He also wasn't the first African American to head to western Kansas. The town of Nicodemus, roughly eighty miles north of his homestead, was founded by and for African Americans.

George could not find any water when he tried to dig a well, so he hauled his in from a neighbor's farm. This neighbor also let Carver borrow farm equipment to help him get started, as he only had a spade, a corn planter and

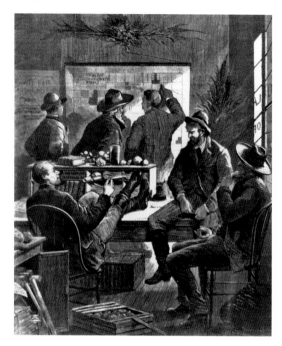

Left: Kansas land office, from the July 11, 1874 issue of *Harper's Weekly*. The Homestead Act sent waves of settlers to these offices to claim free land. *Courtesy of the Library of Congress.*

Below: Once common across Kansas, sod structures were replaced by wooden structures shipped by rail. This sod schoolhouse was the last one near Oberlin, 1907. *Courtesy of the Library of Congress.*

Undated photo of African American farmers in Nicodemus, a unique western Kansas community settled by free blacks that left the South after the Civil War. *Courtesy of the Library of Congress.*

a hoe. Across seventeen acres, young Carver manually plowed the land to grow vegetables and corn in addition to shrubs, fruit trees and eight hundred other trees. For meat, he kept chickens, and eventually, he had enough to support himself. Rex Borthwick, a farmer whose great-grandfather knew Carver, said that he even set up a greenhouse in the sod house, growing all kinds of plants. He made money by working as a ranch hand for his neighbors as well.

Being well liked by the community, Carver would come to town on Saturdays and play the accordion for local dances. He would play baseball and cards with locals as well and was a member of the Ness County literary society. The *Ness County News* featured George Washington Carver in a March 1888 issue and noted that he had a remarkable knowledge of geology, general science and botany in particular. He kept busy by sketching the plants that he saw around the area and kept a huge collection of over five hundred of them next to his employer's home. He also collected geologic samples from the area. The editor of the local paper noted, "He

is a pleasant and intelligent man to talk with, and were it not for his dusty skin—no fault of his—he might occupy a different sphere to which his ability would otherwise entitle him."

Eventually, Carver wanted more out of life than simply homesteading and decided to hit the road again in pursuit of his education. Carver decided to mortgage his land on June 25, 1888, and obtained a $300 loan at a bank in Ness City to pay for this education. Once he left, the rest is history. He studied at Simpson College in Indianola, Iowa, and later studied botany at Iowa State Agricultural College (later Iowa State University) in Ames. Being the first black student there in 1891, he broke barriers and stereotypes as to what a black man could accomplish in the field of science. Later, Booker T. Washington offered him a position at the Tuskegee Institution in Alabama, where Carver worked from 1896 until his death in 1943.

Many people marvel at Carver's character the more they learn about him. He did incredible things, figuring out how to make plastic out of soybeans and turning sweet potatoes into cereal, as well as the famous three hundred byproducts of the peanut. He not only did all of those things but also refused to cash in on his work. He received many awards but turned away any royalties from the sale of his products and lived in a modest home at Tuskegee. It shows that a man who met three presidents and even gave Gandhi advice about agriculture never forgot his roots.

In a lonely field way out in Ness County today there is a small marker in his honor that reads, "Dedicated to the memory of George Washington Carver 1864–1943 Citizen—Scientist—Benefactor who rose from slavery to fame and gave to our country an everlasting heritage. Ness County is proud to honor him and claim him as a pioneer. This stone marks the northeast corner of the homestead on which he filed in 1886. Erected by friends and the Ness County Historical Society 1953."

THE WORLD'S SMALLEST IMPACT CRATER

In the 1880s, settlers near Brenham, in southwest Kansas, noticed that every once in a while their plows and other farm implements would strike something hard and make a clanking sound as if hitting a rock. Being an area that has deep, fertile soil with few significant rock outcroppings, such collisions were curious. Upon closer inspection, these obstructions were discovered to be rocks that resembled chrome-like metal with bits of beautiful olivine

(green) stone in it. What they had found were remnants of a long-ago meteor impact—evidenced by one of the smallest impact craters in the world.

Most likely originating in the asteroid belt between Mars and Jupiter, the Brenham meteoroid made its way to this small corner of the earth at least one thousand years ago. Estimated to be roughly five hundred pounds before reaching earth, it spent billions of years quietly waiting for its journey. Traveling from west to east, the roughly ten tons of stony metal meteorite slammed into the Kansas prairie at a sub-hypervelocity speed. This means that unlike larger meteorites, which come at such speeds as to create shock waves and high-energy surface excavations, Brenham was slowed significantly by the atmosphere. Mud and rock were thrown into the air for sure, with meteorite fragments found at least seven miles away. This impact, though, was less a spectacular explosion and more akin to throwing a rock into the mud. It would have still been an earth-rattling event nonetheless. The fact that there have been so many meteorites found here (and not vaporized) is testament to this smaller-scale impact.

For hundreds of years, it is likely that Native Americans came across fragments of it when in the area. As this meteorite and its fragments have been identified, pieces of it have been found in many random places. One such place is in a Hopewell Indian burial mound in Little Miami Valley, Ohio. The stones, called pallasites, looked like nothing else that could be found on earth and were likely prized. Some fragments are entirely iron-nickel metal and once polished can look like a mirror. On top of that, they are unlike other meteorites found anywhere else in the world. Their internal structures and shapes are unique to this specific impact and are famous the world over. Pallasites stand out from other meteorites because of that chrome-metal interior and often have yellow, green, red and orange crystals inside. That being said, they are a very rare type of meteorite and quiet striking to see.

Ranging in size from grains of sand size to nearly three-quarters of a ton, Brenham meteorites were noted by the 1880s settlers as meteorites. The Kimberlys, a homesteading family at the time, worked to get scientific experts out to the land to look for themselves. In 1890, Dr. F.W. Cragin and Chancellor F.H. Snow of the University of Kansas were the first people to examine the meteorites collected by Mrs. Kimberly. Other scientists visited the field and collected specimens in subsequent years, such as Dr. George F. Kunz and Dr. Robert Hay. All of the experts had failed to notice a small depression there that many mistook for a buffalo wallow. Buffalo wallows are natural depressions in the land that collect water and are used so often

by buffalo to drink and bathe in that they inadvertently expand them into noticeable circular "dents" in the prairie.

Near the northeastern border of the meteorite field sat what was later realized by scientists in 1925 to be the impact crater itself, which was a thirty-five- by fifty-five-foot ellipse—incredibly small for an impact crater. It was used as a watering place for the Kimberlys' stock and even cultivated for nearly twenty years. It still had a discernible rounded rim, though, and was deeper than any wallows in the area. H.H. Ninninger of McPherson College in central Kansas requested permission to excavate the crater. The Kimberlys had excavated a bit themselves, finding oxidized meteorites two and a half to three feet down. Once Ninninger was granted permission, he joined with the Colorado Museum of Natural History to provide the funds for the work.

Using a road scraper, Ninninger's team dug a thirty-six- by fourteen-foot cut at six and a half feet deep. Countless oxidized meteorites were found in this dig, ranging from the size of a grain of rice to fifteen pounds. The soil around each fragment was rust-colored up to two centimeters from the object, and many were found clustered together. After digging deeper to at least eleven and a half feet, other specimens were found that were twenty-two to eighty-five pounds. Sometimes sixty individual fragments were found in a cubic foot. These fragments were sent to labs all over the United States and the world for cleaning, polishing and study. Today, they can be found at the Smithsonian, Harvard and overseas. Every major scientific museum in the world has a sample, as they are rare and highly regarded.

It's estimated that around 15,000 pounds of the Brenham meteorite have been found so far. More fragments are still being found today, with the biggest being a 1,430-pound mass found by geologist Philip Mani and meteorite hunter Steve Arnold that sits in a private collection in Texas. They found it by driving a metal-detector equipped ATV over Kiowa County fields. According to Philip, the moment of discovery went as follows:

An hour and a half into the dig and little did we know it would be another hour and a half before we were ready to lift and recover our meteorite. Steve carefully dug around, probing for the meteorite. At first it appears we may have found two meteorites. Steve worked away the soil and the two melded into a single, large meteorite. A pallasite. We were excited at first, but we quickly became anxious too. Steve's work slowly revealed the meteorite appeared to be about 10 inches thick and about three feet long. I continued to film while Steve continued to dig. I started becoming very anxious. I think

the reason we were more anxious than excited was because we realized we could be very close to recovering a meteorite which might rival the weight of the Greensburg meteorite.

Other specimens are housed nearby, including a 990-pound mass called the Space Wanderer that resides at the Big Well down the road in Greensburg. It was found and dug out by hand at the Ellis Peck farm near Greensburg. Some 8,500 other pounds of the Brenham meteorites were housed for many years at the now-closed Kansas Meteorite Museum and Nature Center in Haviland, Kansas. The biggest pieces have likely been found, so most finds these days are grapefruit sized or smaller.

Other meteorites have been found throughout Kansas, but the Brenham crater is the only confirmed impact site. There are a few candidates for possible other subterranean impacts, though, and geologists are still working on them. One such site is the Edgerton structure in northwestern Miami County. If confirmed, it would be a Precambrian feature buried by Paleozoic sediments. There are also two other topographic ellipses in the state, the Garden City ellipse (ten by fourteen kilometers) in Finney County and the Goddard ellipse (eleven by thirteen kilometers) in Sedgwick County. Some have suggested Cheyenne Bottoms in Barton County (twenty-two by thirty-two kilometers) could also be a surface expression of a deeper Precambrian impact structure. We'll never actually be able to see them, but it's fun to think of a huge impact giving my home state a good wallop from time to time. In the meantime, we'll have to make do with our humble little crater that's no bigger than a small house.

THE STERNBERG FOSSIL-HUNTING DYNASTY

Far in the geologic past, Kansas was covered at different times by a succession of seas. Limestone, sandstone and shale make up the vast majority of rocks across the state. Pick up some rocks around the Kansas City area and you are likely to find Pennsylvanian-era sea fossils such as crinoids or brachiopods from roughly 300 million years ago. If you head a little farther west to the Flint Hills, you'll travel forward another 50 million years in time to the Permian and you'll find some great corals. Keep driving west on I-70 toward the Colorado border and start kicking up the chalky rock there and you're likely to find Cretaceous shark teeth from 80 to 100 million years

Left: Close-up of fossil shell embedded in glacially formed loess bluff in Doniphan County, 1974. *Courtesy of the National Archives.*

Below: Famed nineteenth-century photographer Alexander Gardner photographed Native American petroglyphs at Hieroglyph Rock on the Smoky Hill River, east of Fort Harker in Ellsworth County. *Courtesy of the Library of Congress.*

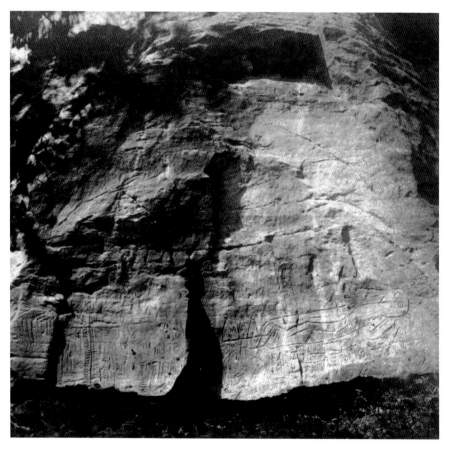

ago. Ammonite shells three meters wide have been found out there, as well as many other fossils. Kansas has many world-famous fossils to its credit in museums and collections around the world—and owes its beginnings to a junior medical officer in the U.S. Army.

George Miller Sternberg (1838–1915) was a young assistant surgeon in the U.S. Army. The bright young New Yorker started his military career with the dubious distinction of being captured at the First Battle of Bull Run. Escaping capture, he later participated in the Peninsular Campaign and many other engagements, followed by hospital duty in the North. Rising the ranks in the military, he was soon married to a woman named Louisa Russell from Cooperstown, New York, and shipped off to the frontier in late 1865. Serving at Fort Harker near Ellsworth and later at Fort Riley, life was hard, as he took part in several campaigns against Cheyenne hostile to U.S. encroachment on their lands. Louisa died during a cholera outbreak in 1867. At this time, Fort Harker was the end of the developed railroad, and vast herds of buffalo still roamed the prairie all around them. The young state's population was only 300,000 at this time as well, with most of it on the more developed eastern half of the state. Many people came through this area to document it before it was settled, including famed Civil War and Lincoln photographer Alexander Gardner. It really was, to them, the edge of civilization, novel and alien.

While serving in Kansas, Sternberg took a keen interest in the fossils he was noticing in the rock outcroppings he frequently came across. Beautifully preserved leaf imprints in the Dakota Sandstone Formation caught his eye, and he shipped them back east. He also explored the Smoky Hill Chalk and Pierre Shale formations in western Kansas, finding fantastic Cretaceous remains such as mosasaur bones, shark teeth, clam shells and fish skeletons among others. He also discovered *Xiphactinus*, a spectacular bony predatory fish up to twenty feet long with frightening, pointed fangs. His specimens were widely admired and studied at the Smithsonian in Washington, D.C.

He got his younger brother, Charles H. Sternberg, interested in paleontology as well. Charles made quite a career out of it. As for George, he went on to even more amazing things still. He left Kansas in 1870 and went on to become what's considered the first American bacteriologist. He studied and discovered the causes of malaria and lobar pneumonia, as well as pinpointing how bacilli overcome the immune system in tuberculosis and typhoid fever. He served as the eighteenth U.S. Army Surgeon General from 1893 to 1902 and established the Army Medical School, the U.S. Army Nurse Corps and the Walter Reed Army Institute of Research.

While big brother George was off battling infectious diseases, Charles H. Sternberg (1850–1943) took his interest in paleontology and fossil hunting to even greater lengths. Coming to Fort Harker with the rest of the Sternbergs to live on George's nearby ranch in 1868, he was soon out in the field doing

With his portable darkroom, Alexander Gardner (*seated*) looks at a rare plant specimen found on a hill above Fort Riley, Kansas, 1867. *Courtesy of the Library of Congress.*

his own hunting. Studying for a brief time at Kansas State University under noted geologist Benjamin Franklin Mudge (the discoverer of well-known dinosaurs *Allosaurus* and *Diplodocus*), Charles left to get back into the field. He and his sons George, Charles and Levi traveled much of the American West, including Kansas, Texas, Wyoming, Washington, Oregon and Montana, discovering dozens of unique specimens.

He was hired to collect Kansas fossils for Edward Drinker Cope during the "Bone Wars," a period of an intense, bitter and ruthless rivalry between Cope and fellow paleontologist Othniel Charles Marsh. Sternberg later worked for Marsh as well, getting to see both sides of this fascinating feud. The work wasn't easy, as it was difficult to get fresh food and water to the dig

sites in these early days. The danger of Indian attacks was a real threat as well in those years. Their most famous find might be the *Trachodon* mummy, a brilliantly preserved specimen of *Edmontosaurus annectens* with extensive skin impressions around the skeleton. In Kansas, such amazing finds included rhinoceros, turtles, elephants and three-toed horses from the "Sternberg quarry" in Phillips County. They spent much time in western Canada as well, exposing the Cretaceous dinosaur fossil beds in Alberta. He was very proud of the work he had brought to the world and once poetically wrote, "My own body will crumble to dust, my soul return to the God who gave it, but the works of his hands, those animals of other days, will give joy and pleasure to generations yet unborn." He accomplished all of this without ever completing a degree as well.

The Sternberg family fossil dynasty continued with sons George (1883–1969) and Charles (1885–1981) and Levi (1894–1976) all pursuing careers in vertebrate paleontology. George found his first fossil in Logan County when he was nine near Beaver Creek while on expedition with dad, mom and younger brother—it was a near full plesiosaur fossil from the Cretaceous. He later discovered a triceratops in Wyoming and a giant

The author sitting upon a fossil-rich Cretaceous chalk formation at Monument Rocks in Gove County, 2006. *Courtesy of Joe Zink.*

buffalo fossil with six-foot horns near Hoxie, Kansas. He always credited his father's knowledge of paleontology having greater influence on him than formal schooling. After traveling for many years collecting all over the world, he returned to Kansas and became Fort Hays State University's curator of museums in 1933. Holding the position until 1955, he famously discovered the "fish within a fish" Xiphactinus fossil in the Niobrara Chalk in Western Kansas. The fifteen-foot-long specimen has a six-foot-long specimen of another fish inside it that it ate shortly before death. The Sternberg Museum in Hays is named for the family and includes thousands of finds by Charles and the others.

The other two sons stayed in Canada, with Charles working with the National Museum in Ottawa and Levi as a member of the Royal Ontario Museum in Toronto. Charles became a prolific dinosaur hunter in Canada, describing nearly every possible species found in the nation. His highest level of education was high school, but he went on to publish forty-seven papers on fossil vertebrates and even helped establish Dinosaur Provincial Park in Alberta.

Later Sternbergs followed in their fathers' scientific traditions, with George's son Charles William Sternberg (1908–1994) growing up working on fossils with his father, much as his father had done with his own father. He made a few great discoveries himself, including a thirty-foot Tylosaur that you can still see to this day at the Sternberg Museum of Natural History. His heart wasn't in paleontology though, so he studied and earned his master's degree in geology, later working as a geologist in Israel, the United States and Turkey. George's brother Charles (yes, this is confusing, as every other guy is named George or Charles) had his own sons Stanley and Glenn, who chose microbiology and pathology paths. The apples didn't fall far from the tree. And to think this all began when an army surgeon was shipped out to the prairie and started looking at the rocks under his feet. That curiosity that awoke inside him echoed across generations.

HOLLYWOOD IN A SALT MINE

Roughly 250 million years ago during the Permian era, what is now Kansas was at the bottom of an ancient sea. This Permian Sea, which spanned from Kansas down to Texas, was cut off from the rest of the ocean, creating a barred basin. Millions upon millions of years of salt deposits were laid down

by this continually evaporating and refilling sea and were eventually buried by overlaying rock. Sitting between 400 and 2,500 feet underground, these deposits cover over 100,000 square miles in Kansas, Oklahoma, the Texas Panhandle and New Mexico, with 27,000 square miles in western Kansas alone. Being overlaid with shale, redbeds and silty shale, these water-soluble salt beds were never dissolved and remain remarkably intact. Furthermore, lying in the center of North America, the region is geologically stable, with the salt dipping no more than 30 feet per mile.

Fast forward a few hundred million years to 1887, when an Indiana man named Ben Blanchard came to Hutchinson in 1887 looking for oil. Hoping to increase land values by tapping oil, he was surprised to discover salt—a lot of it. No major salt finds had been discovered west of the Mississippi River, and a few decades later, Carey Salt (now the Hutchinson Salt Company) began mining it in 1923. President Warren G. Harding was even on hand for the dedication on June 23. At the mine, rock salt has been produced for decades using the room and pillar mining system, in which salt is removed in a checkerboard pattern, leaving forty-foot-square salt pillars to hold up the ceiling. From picking at the salt with pickaxes to modern blasting techniques, the process has become much more efficient over time. Four tons of salt heads up the mine elevator every three minutes. Because of some impurities in the salt, it's mostly used as rock salt for roads and such. The mine is vast, with nearly one thousand acres carved out (roughly 150 miles if all the excavated voids were lined up). Over 500,000 tons of salt are mined every year, used for feeding livestock and for de-icing roads all over the Midwest—including Chicago.

One of the most fascinating things about this ancient salt is that there are often places where water is trapped in tiny bubbles in it. This fluid dates from the Permian, and in 1998, a geologist and two biologists discovered a hibernating bacterium in a salt crystal that they claim is 250 million years old. Scientists are still investigating the veracity of this claim, countering that it could have been a later bacterial intrusion.

Either way, you can see the crystal it was found at Strataca, the Underground Salt Museum in the mine. For a fee, visitors can take the elevator down 650 feet and explore the mine on a guided tour. Also in the mine, thousands of government records and Hollywood film master prints are in storage. The original prints of *The Wizard of Oz, Gone with the Wind, Ben Hur, The Exorcist* and others reside in the humidity-controlled storage of Underground Vaults and Storage, a secure storage company. Visitors can see some of their other Hollywood holdings as well, including Christopher

Above: President Harding talks to farmers in Hutchinson weeks before his death, 1923. He also dedicated the Carey Salt Mine on his visit there. *Courtesy of the Library of Congress*.

Left: Movie costumes from *Superman* and *The Matrix* are but a fraction of the artifacts that Hollywood stores in the salt mine under Hutchinson. *Photo by the author*.

Reeve's Superman costume, James Dean's shirt from *Giant* and Agent Smith's suit from *The Matrix*. There's even equipment down there left by the Atomic Energy Commission that they used in the early 1960s to test to see if the mine could be used for storing nuclear waste. It was deemed unfit.

There are only fifteen active salt mines in the United States, but Hutchinson's is the only one that visitors can tour. With the opportunity to go underground and see the Hollywood memorabilia, take a tram tour, learn about the geology of the salt and even chop your own samples, no wonder the city is immensely proud of it. The mining industry is such a part of Hutchinson that the high school mascot is a Salt Hawk. Think of this place the next time you drive on an icy road and you see a truck spreading salt.

5

WILD EVENTS

SIXTEEN TRUCKLOADS OF DIRT ON A FAMILY'S YARD

*The soil is the one indestructible, immutable asset that the nation possesses. It is
the one resource that cannot be exhausted.*
—Federal Bureau of Soils, 1878

The Dust Bowl is one of the most infamous and cautionary tales in American
agricultural history. When we think of it, we immediately imagine skies
blackened by massive dust clouds originating from ruined topsoil blown
off failing farms. Hundreds of thousands of people were affected, leading
to mass migrations to California and elsewhere. Western Kansas was hit
hard—over fifty counties were affected by severe wind erosion. What many
people don't realize is that it was a disaster waiting to happen...and the
Turks of all people were the ones who got the ball rolling.

Western Kansas farmers were used to droughts and had lived with them
for decades before the Dust Bowl of the 1930s. Since settling the western
half of the state since the 1870s, dry periods had regularly alternated with
times of prodigious rainfall. This region is known as the High Plains, with
an elevation of roughly 2,500 feet to 4,000 feet at the Colorado border. With
less than twenty inches of rain a year on average, the region is classified as
semiarid. Long droughts were not uncommon, and for millennia, a shortgrass
prairie was all that it could support. European explorers to Kansas called

the Great Plains the "Great American Desert," believing that it wouldn't support agriculture. The high winds, lack of timber and relative absence of surface water made it seem like a hopeless wasteland. Throw in the random droughts, and you have a challenging area to farm in.

Americans being Americans, though, they eventually thought they'd give this region a try. Economic and population pressures on the East Coast drove millions of people westward to look for a better life and their own land to work. Slow encroachment westward on the prairie by settlers and railroads convinced many farmers that it was doable. There were some wet years when crops were successful, though. The soil under the newly broken prairie was rich and dark and full of nutrients.

In 1862, the federal government passed one of the most consequential pieces of legislation in U.S. history: the Homestead Act. Settlers were offered 160 acres of land by the government at little or zero cost if they moved out to it and improved the land. Over 1.6 million homesteaders eventually moved west and settled 270 million acres of land across multiple western states, including Kansas. With the Civil War ending in 1865 and the Transcontinental Railroad's completion in 1869, masses of new immigrants and settlers came to Kansas. Farms, roads, towns, railroads, businesses, ranches and every other hallmark of modern civilization sprang up on the formerly desolate prairie. The strong grasses that carpeted the soil and held in the moisture were being broken up across the entire state. The native prairie was driven to the absolute margins.

Initially, many farmers attempted cattle ranching; but the prairie winters could be harsh, and many scores of cattle were frozen to death in blizzards. Overgrazing and interspersed droughts over the years made it more difficult to keep them well-fed. The grasses were often too dry and withered to sustain a healthy operation, so many landowners switched to the plow.

Over the years, as farming came to dominate the state, technology advanced in a multitude of ways. Mechanized farming and the empire of the tractor was at hand. More land than ever before was broken up, with grasslands retreating even farther. Straight rows in expertly disced fields stretched to the horizon in every county. World War I (1914–18) saw a massive expansion in the acreage of planted wheat as well. When the Turks, who fought for the Central powers, closed off the Dardanelles waterway— thus cutting off Russian wheat from the west—America had to step up and supply wheat for the Allies. The demand for wheat for America and its allies abroad increased the area of wheat cultivation by twenty-seven million acres. The government guaranteed wheat prices at two dollars a bushel (double the

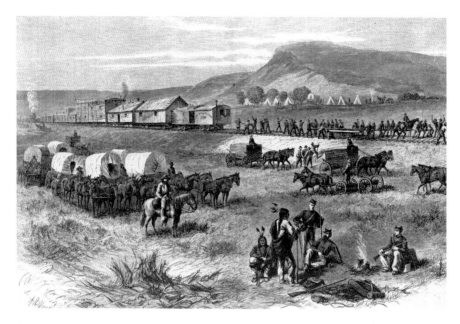

Railroad construction in Kansas, wood engraving by Alfred R. Waud, 1875. Scenes like this were common across the Great Plains in the 1870s. *Courtesy of the Library of Congress.*

price from just seven years before), further encouraging its spread. Nearly half of those acres were from newly plowed grasslands. The postwar chaos continued in Russia as the Russian Civil War and eventual triumph of Russian Communism cut off that region's wheat for years to come. Public support for the First World War was massive, with over 4.7 million men and women serving in the war effort. Fort Riley hosted and trained tens of thousands of enlistees itself.

After the war, the larger tractors and new combines—machines that could both harvest and thresh the grain—pushed the land to even more effective production. Falling wheat prices in the 1920s resulted in more being planted to compensate for it. The 1920s were relatively wet years, with many people falsely assuming that the climate would stay that way and that it had "turned" for the better. Another 5.2 million acres were plowed under as well. With 50,000 acres of grasses being cultivated a day, the price of wheat fell even further due to a glut on the market. By 1930, it was down to forty cents a bushel. With three times the amount of wheat under cultivation compared to a decade before, the land was ready to blow away.

The year 1931 saw the beginning of a new drought that summer, which foreshadowed what was to befall Kansas and the rest of the Great Plains

164th Depot Brigade soldiers at Fort Riley, in the shape of the Armed Forces service flag, 1918. Fort Riley was a major training area during World War I. *Courtesy of the Library of Congress.*

for the next decade. When the wheat failed to grow, the newly exposed soils were baked bone-dry by the relentless prairie sun. Coupled with harsh prairie winds, millions upon millions of tons of the dried soil lifted into the air. What was once prairie grasslands had turned into sand dunes. Farmers hadn't understood the underlying ecology of the plains at the time and were unaware that deep plowing had ruined the formerly anchored soil.

The resulting dust clouds were immense, and there was often nowhere to hide from them. Some called them "black blizzards," and these clouds could travel hundreds of miles across Kansas down to the Oklahoma Panhandle, Texas, Colorado and New Mexico. Visibility was often reduced to about three feet, with people running for cover when they saw them roll in. Over 100 million acres of land across those five states were affected by severe erosion and drought. In 1932, the first of these blizzards began to strike. One originating near Amarillo and heading north to Oklahoma saw a cloud of dust ten thousand feet high that looked like a "range of mountains on the move." Kansas farmer Lawrence Svobida described an approaching dust storm as follows:

> At other times a cloud is seen to be approaching from a distance of many miles. Already it has the banked appearance of a cumulus cloud, but it is black instead of white and it hangs low, seeming to hug the earth. Instead of being slow to change its form, it appears to be rolling on itself from the crest downward. As it sweeps onward, the landscape is progressively blotted out. Birds fly in terror before the storm, and only those that are strong of wing may escape. The smaller birds fly until they are exhausted, then fall to the ground, to share the fate of the thousands of jack rabbits which perish from suffocation.

One of the worst of the black blizzards hit Kansas on April 14, 1935. That day, known as "Black Sunday," began with new and immense dust clouds blocking out the sun all across western Kansas. With weeks of 100-degree days, there was more dry dirt ready to be whipped up. The dust, built up slowly over many hours by converging weather fronts, caused relentless fifty-mile-per-hour winds and whipped itself into a rolling black mass. As it churned along the ground, it added more topsoil to it and proceeded to Oklahoma and then to Texas. Many witnesses recall almost zero visibility amid pitch-black conditions at the height of day. Folk singer Woody Guthrie rode out the storm in Pampa, Texas, and said, "You couldn't see your hand before your face." One man was blinded, and one woman was so panicked she contemplated killing her baby so it wouldn't suffer. The best one could do is to get indoors and place wet towels under the cracks of doors and across windows and other joints to keep the fine particles out. It was a day that every person who lived through it remembered the rest of their lives, much like JFK's assassination or 9/11 for people today. Some 4.7 tons of dust were dumped per acre in parts of Kansas, with cars even denting in

under the weight of it. A Kansas City news editor for the Associated Press named Edward Stanley was in Boise City, Oklahoma, for this storm and coined the term "Dust Bowl" from it. He was originally referring to the round geographic area across the five most-affected states as a bowl, but the term later came to define the entire era.

Farmers and townsfolk alike all across western Kansas had to frequently dig out after such storms, with drifts of dust sometimes reaching up over their homes and burying their tractors and other vehicles. One family had to remove sixteen truckloads of dirt from their yard alone, and sidewalks were cleared with snow shovels in the middle of the summer. It's no wonder that tens of thousands of people fled west. Not only was the Great Depression in full swing, but the region also reminded many of nothing more than a dirty desert. Thousands of abandoned farms sat empty for years, dust silently piling up on them. Those that did stay had virtually no crops to work. Car engines were clogged with dust, and grit got into every crack of a house. Livestock sometimes ate too much dust-covered grass, and their stomachs became stuffed with fatal "mud balls." Add in "dust pneumonia" from inhaling too much dust into your lungs, and you have an incredibly miserable region in so many ways. Wearing a gas mask outdoors was often your only way of going outside, as the dust particles were roughly one-fifth the size of the period at the end of this sentence.

Dust Bowl era dust storm rolling into Elkhart, in far western Morton County, May 21, 1937. *Courtesy of the Library of Congress.*

Massive dust drifts pile up on a farm near Liberal, southwestern Kansas, 1936. The Dust Bowl's "black blizzards" hit this region hard. *Courtesy of the Library of Congress.*

In 1935, the U.S. Congress passed the Soil Conservation Act, which promoted soil preservation education for farmers. Conservation of the soil was made a top priority by the government, and the Soil Conservation Service (SCS) was created by FDR to supply technical assistance to local soil conservation districts across affected areas. SCS chairman Hugh Bennett promoted terracing, contour plowing, stubble-mulch farming and planting strip crops. "Shelter belts" of trees were also planted as wind breaks from Canada to Texas, with hundreds of thousands of cottonwoods and other trees lining western Kansas. By 1939, the reformed farming methods, coupled with returning rains, brought an end to the Dust Bowl. It took a massive ecological disaster to teach the farmers of Kansas and other states how to properly plant in the harsh prairie, but they have learned from it. Since then, Kansas has once again become a thriving breadbasket for America.

KNUTE ROCKNE'S PLANE CRASH

On March 31, 1931, a thirteen-year-old boy near Bazaar, Kansas, named James Easter Heathman was at his family farm when he heard TWA Flight 599 flying low over the property. This was not a rare occurrence, as air travel had grown greatly in the last decade and flights between Kansas City and Wichita were becoming more and more common. Thinking it was cars racing down the road, he didn't pay it much mind until a telephone operator called their home to inform them that witnesses reported a plane crashed nearby. Jumping into the family's Model T, James and his father and brothers rushed to the site of the crash, which was three miles southwest of Bazaar. When they arrived, they instantly realized that there were no survivors. Landing upside down, the tail of the plane was sticking straight out of the ground, and the engines were smashed into the earth. Mail bags were scattered across the prairie fields, and most of the eight victims were ejected from the plane. As the work began to identify the bodies by their billfolds and luggage, crash responders were startled to see that one of the victims was one of the most famous men in America: Notre Dame head football coach Knute Rockne.

Knute Rockne was a beloved heroic figure to many people across the nation due to his success on the gridiron through espousing the virtues of honorable success and hard work. He was seen as an "All American" man who pulled himself up by his bootstraps, despite being a Norwegian by birth. Being savvy enough to realize that college sports was a media-driven enterprise, he worked hard to promote the Fighting Irish in the nation's newspapers and radio stations. His 105 victories, 3 national championships, 5 undefeated seasons and popularization of the forward pass made him a household name. Quips such as "One man practicing sportsmanship is far better than a hundred teaching it" made him a role model for many athletes and coaches for generations to come. In March 1931, he was en route to California to assist in the production of the film *The Spirit of Notre Dame*, which was released later that year.

Rockne was no stranger to Kansas, as he had many connections with the University of Kansas over the years. In 1914, when the Jayhawks were in the market for a new head football coach, Notre Dame athletics director Jesse Harper told Kansas athletic director W.O. Hamilton to hire Notre Dame assistant Knute Rockne. KU ignored the recommendation and went with H.M. Wheaton, who coached KU to a 5-2-1 record in his only season. Knute later struck up a friendship with legendary Kansas basketball coach

Knute Rockne, legendary head coach of Notre Dame University football, in an undated photo. His death in a plane crash in Kansas shocked the nation. *Courtesy of the Library of Congress.*

Forrest "Phog" Allen, having traveled to KU on a number of occasions to bring the Irish track team to the Kansas Relays in earlier years. He was even an official one year. Allen and Rockne also planned a Jayhawks-Irish football game, which Rockne wrote to him about the day before his death, March 30, 1931:

> *Dear Phog:*
>
> *I am still working on the football game for 1932—I find our authorities will be delighted to entertain you in South Bend in '32, but the obstacle just now is a return engagement in Lawrence. I have had telegrams from several influential men, including Conrad Mann, which are helpful as he stands quite high here. However, the faculty is doing a lot of strenuous objecting to our traveling, etc.*
>
> *Am leaving for Los Angeles tonight and am going to stop to see the boys in Kansas City on the way back.*
>
> *Warmest regards.*
>
> *Yours cordially,*
>
> *K.K. Rockne, Director of Athletics*

After seeing his mother in Chicago, Rockne traveled to Kansas City to see his sons, Billy Rockne (eleven) and Knute Rockne Jr. (fourteen), who were students at Pembroke Country Day School. Tragically, he missed seeing them by twenty minutes, as they were returning by train to Kansas City from Miami with their mother and their train was delayed. Needing to catch his flight, he reluctantly went to the airport and missed seeing his boys. He sent a final Western Union telegram to his wife that said, "LEAVING RIGHT NOW WILL BE AT BILTMORE LOVE AND KISSES—KNUTE." Knute and the seven others boarded TWA Flight 599 to take the next leg of the journey to Wichita. The plane was a Fokker F.10 Trimotor, a three-engined plane built with laminated wood, as many planes were at the time. Roughly an hour into the flight, moisture had seeped into one of the wing's interiors and weakened the water-based resin glue that bonded the ribs and spars to the plywood outer skin.

After flying in rain for over an hour, one of the spars finally failed, causing the left wing to flutter and completely separate from the plane. The exact sequence of events is unknown, as some analysis points to turbulence or icing on the aircraft that could have overstressed the wing as well. The final call the copilot made was to Wichita, saying, "The weather here is getting tough. We're going to turn around and go back

to Kansas City." Shortly after that, the critically wounded plane plunged to its doom.

When the Heathmans arrived at the site, the sight of the five dead men lying outside the plane left an impression on young James for the rest of his life. "My uncle Clarence seen it come out of the clouds," Heathman remembered. "He said the wing was broke off. The plane was turning end-over-end. You can picture in your mind what that ride was like. There wasn't any fire. There was the smell of gasoline and hot oil. I can still smell that today." The family stayed at the crash site until ambulances and the coroner arrived to take the bodies, which the Heathmans helped to load in the vehicles. The whole incident was very traumatic for the father and the boys, with James skipping lunch and dinner that day. When the rest of the family returned to the site later in the day, James's father was so shaken up that he refused to go. Rockne's daughter, who years later met James on the sixtieth anniversary of the crash, was told by him that he found a rubber wrap attached to the leg of one of the victims. She replied, "Yes, that was definitely him; he wore a wrap around one leg. Dad had phlebitis." A rosary was also found in one of his pockets.

The bodies were taken to the town of Cottonwood Falls, thirty miles from the site, for identification. Incidentally, Jess Harper, a friend of Knute's and also the coach whom Rockne had replaced at Notre Dame—AND the same guy who told KU to hire Knute in 1914—lived only one hundred miles from the crash site and was called down to identify his body. News of the crash was kept from Knute's sons by Pembroke school authorities until family friends could talk to them first. Mrs. Rockne, having received Knute's telegram from earlier, got another one from Western Airlines, "WE REGRET IT BECOMES OUR PAINFUL DUTY TO NOTIFY YOU OF THE DEATH OF MR. KNUTE ROCKNE WHO WAS A PASSENGER ON OUR WESTBOUND PLANE." Once his demise was confirmed, word spread fast and it made front-page news across every newspaper in America. The *New York Times* front page was almost completely dominated by news of the crash. The phone operators at the *Chicago Tribune* were flooded by calls, and operators began answering the phone with "Yes, it's true about Rockne." A massive outpouring of public surprise and grief followed, with President Herbert Hoover declaring his death to be "a national loss."

Coaches across the nation from Stanford to Ohio State and West Point lionized Knute Rockne and mourned his passing. "Unquestionably the greatest of football teachers," said coach Mal Stevens of Yale. "His delightful sense of humor, his quick sympathy for a fallen adversary, his

indomitable spirit are more than a legend and will carry on as an inspiration to all who love the game of football." Even Norway's King Haakon VII posthumously knighted Rockne and sent a representative to the funeral. Over 100,000 people lined his South Bend, Indiana funeral procession, and it was broadcast live across the United States, Europe and even parts of Asia and South America.

At the same time as the nation reacted to his death with grief, it quickly turned to outcry over how the disaster could have occurred, spurring a detailed investigation. The death of such a high-profile American prompted such thoroughness in the investigation that it triggered an aviation safety revolution that had far-reaching consequences that last until this day. With the realization that the wooden frame was to blame, airliners began grounding all wood-composed planes to undergo more rigorous inspections and maintenance. TWA and Fokker received such bad publicity that it nearly sank the companies, resulting in blows to their reputations that took years to recover from. Manufacturers moved to all-metal aircraft from then on, and one of the most dangerous forms of travel quickly turned into one of the safest. The Boeing 247 and the Douglas DC-3 were designed in response to the crash, and their track records for safety resulted in a sevenfold increase in airline travel within a few years of the Rockne crash.

Besides aircraft redesigns being a positive from this tragedy, the U.S. Department of Commerce began publishing results of aircraft investigations. Before this, they were kept secret and there was no public clamoring to release crash results. Other comparable crashes to Rockne's had occurred before this but were lightly commented upon in the media. The death of the forty-three-year-old coach in his prime who had just led his program to back-to-back undefeated seasons was the sensational spark that lit the fuse. Intense public interest in this also led to the creation of the Civil Aeronautics Board, an independent investigation organization that was tasked with studying every plane crash in the United States. It was a forerunner of today's National Transportation Safety Board, and the public now demanded independent reviews and publishing of all crash findings. Safety improvements made flying more attractive to the public at large as well, with public confidence in flying growing in the 1940s.

In subsequent years, Rockne's legend only grew. Future President Ronald Reagan portrayed George Gipp, aka "The Gipper," in the 1940 biographical film *Knute Rockne, All American*. He had numerous items named after him, such as a Studebaker car, a World War II Liberty ship, streets, a Notre Dame campus building, a musical and even a town in Texas. One of the most

interesting memorials, though, sits at the crash site in Kansas to this day. James Easter Heathman, the thirteen-year-old boy who responded to the crash, spent the rest of his ninety years tending to a memorial that he built in honor of the coach. The tall granite marker that he built memorializes the eight who died on the plane. He spent years taking thousands of curious Rockne fans to the wire fence–surrounded memorial on his private property out of his dedication to the memory of Knute. Never taking a dime for his efforts, he felt it was his way of honoring the coach. He was so accommodating to Notre Dame coaches, alumni and fans who came to the site for memorials every five years that he was even honored by the athletic department upon his death in 2008. "Easter was a wonderful man whose lifelong dedication to honoring the memory of Knute Rockne will forever be appreciated by Notre Dame," school spokesman Dennis Brown said.

Notre Dame alumni and Knute Rockne fans to this day make the pilgrimage to Bazaar, Kansas, to visit the crash site and memorial to Knute. Much like Buddy Holly, Big Bopper and Ritchie Valens fans journey to Clear Lake, Iowa, the site holds an emotional connection between the admirers and the memory of the deceased. If you ever happen to be driving on the Kansas Turnpike, you might also notice the Matfield Green rest stop near Bazaar. It has a large exhibit encased in glass memorializing Rockne and the other crash victims. Knute died decades ago, but his memory and connection to Kansas echo to this day.

TARRING AND FEATHERING—OVER AGRICULTURE

Agricultural politics has always been a hot topic in Kansas, as nearly 90 percent of the state's land is dedicated to farming. Kansas ranks no. 1 in wheat production, with over one-fifth of the nation's wheat grown here. Debates about corporate farming, farm subsidies, environmental regulations, taxes and tariffs and other issues have enflamed the passions of partisans of every stripe over many decades. It usually doesn't involve two guys getting tarred and feathered, though.

In the early years of the twentieth century, populism, socialism, progressivism and other political movements grew in reaction to America's Gilded Age of the late nineteenth century. Rapid economic growth coupled with the extreme concentrations of wealth of the Industrial Revolution stood in stark contrast to the abject poverty of millions of immigrants and poor

working people of all stripes. The Progressive Era, as the early twentieth century was dubbed, saw an explosion of social activism and political reform to address problems of inequality, education, sanitation and other such public concerns.

This era of activism touched all segments of society, rallying people to growing movements such as prohibition and women's suffrage. Small farmers and merchants in North Dakota began to advocate for their rights as well, having felt exploited by out-of-state banks and other interests that they felt had too much power over their product. Corporate political interests in Chicago, Illinois, and Minneapolis, Minnesota, had a stranglehold on grain pricing and transport. Many farmers felt that North Dakota was treated like a "tributary province of Minneapolis–St. Paul," as Minnesota millers milled their grain and Minnesota bankers made their loans. All major decisions were made in the cities, thus resulting in the rise of the Nonpartisan League.

The Nonpartisan League was a new political party founded in 1915 by Arthur C. Townley, a farmer ruined by fluctuations in the grain market. He traveled all over North Dakota in a borrowed Model-T Ford and signed up thousands of other disaffected farmers to this new cause. His message of state control against the big interests that were exploiting them resonated with many farmers who had become fed up with high percentage loans, exorbitant transportation fees and poor insurance coverage. A simple six-dollar fee was required to join, and a wave of support and cash followed.

His ire particularly fell upon the railroads, East Coast banks and Minneapolis grain merchants. The party erupted in popularity, sweeping its candidate Lynn Frazier into office as governor in 1916. In 1919, the legislature enacted the League's entire program, implementing state-owned insurance agencies, grain elevators, banks and mills. Frazier made many powerful enemies, though, with business groups and newspapers declaring him a socialist. The League's inexperience in politics led to corruption and infighting, leading to Frazier being recalled in 1921. This had never happened in U.S. history before and wouldn't happen again until Gray Davis was recalled as governor of California in 2003.

The Nonpartisan League revolution in North Dakota had not gone unnoticed in other agricultural states. Within two years, the league had expanded into Minnesota and other states. On December 28, 1917, the league established its first headquarters in Kansas in Topeka. Kansas governor Arthur Capper provided references to the league in order for members to obtain rented offices, resulting in some agricultural experts believing that he was "almost Nonpartisan." League organizers soon spread

the word throughout Kansas of their goals for the state and how they aimed for the "destruction of the middleman." The mantra that "a farmer raised a bushel and got paid for a peck while a consumer pays for a bushel and receives a peck" resonated with many farmers across Kansas as well.

This political movement didn't occur in a vacuum and was complicated by the United States' entry into World War I. Hostile merchants and newspapers charged League members with socialism and disloyalty during the war as Townley and other leaguers blamed the war on "big-bellied, red-necked plutocrats" and demanded "conscription of wealth" instead of men. Due to the massive war effort and the severe charges of treason for opposing the war (socialist Eugene Debs was sentenced to ten years in prison for simply publicly opposing the draft), the Nonpartisan League was damaged in the minds of many. Drought and a drop in commodity prices at the end of the war triggered an agricultural depression as well, causing state-owned industries in North Dakota to struggle.

With the NPL struggling, the banking industry refused to help the North Dakota League raise money through state-issued bonds. Their popular appeal plummeted and their state bank was soon declared insolvent. With the special election move to recall Governor Frazier, the NPL organizers in other states had an even more difficult time convincing farmers to join their cause. Rising prosperity among farmers in the early 1920s continued the downward spiral for the movement as well. This didn't dissuade organizers from promoting the league, though they often met opposition. None of their opposition was more dramatic than what happened in Great Bend, Kansas, on March 12, 1921. The Associated Press reported the following account of the incidents that day:

> *An anti-Non-Partisan League demonstration here today and tonight culminated in the escorting from town of J. Ralph Burton, former United States Senator from Kansas, and several associates, and the tarring at Ellinwood, near here, of J.O. Stevic and A.H. Parson, organizer and Kansas state secretary, respectively, of the League. After being tarred Stevic and Parson were compelled to lie on the ground and roll. Their clothing was replaced and they were ordered to leave Barton County. About 200 men participated in the tarring. Former Senator Burton, who has been active in the Non-Partisan League movement in the state, with members of his party, was scheduled to address a meeting at Ellinwood this afternoon. When they arrived here they were taken in charge and escorted to St. John in Stafford County.*

In a statement by Stevic, himself, he substantiated the press release (except by placing the tarring in Great Bend, not Ellinwood):

> *We underwent terrible treatment. Parsons and I had left Ellinwood and had got to Chase when the mob overtook us. They took us to Great Bend and we were turned over to another mob. We were then taken to a lonely place. Two men were stationed to each of our arms, holding them up while we were fearfully beaten up by others. Then a circle of automobiles ringed about us and tar pots appeared. We were stripped to the waist and tar applied. Half blind we staggered away, hearing another mob was after us. We sought shelter in a straw-stack, but at 3 o'clock in the morning we went back to Great Bend to learn the hour. We walked twenty miles on the railroad and came to a farm house. The farmer said he doubted we were human beings, but he took us in and two Leaguers were secured, who brought us to Salina.*

The Kansas press largely denounced the mob action (and the men of Great Bend in particular) as barbaric, with the *Emporia Gazette* calling the action "an un-American outrage worthy of the Germans in Belgium." The *Gazette* was no fan of the NPL, calling it a "menace to good government in the state" and arguing that "socialism must be fought not with tar and feathers, but with logical arguments." Not all papers denounced it, though, with the *Great Bend Tribune* advising that "the town and county should take things easy, and be ready to defend the stand it has taken against one of the most unloyal organizations in the United States."

Reports that the mob was made up of ex-servicemen American Legion members was corroborated by many eyewitness accounts of fistfights between legion members and Nonpartisans in Ellinwood and Lyons in the preceding days. The Legion's Kansas Department released a statement ordering all local posts to discontinue interfering in NPL activities and announced that an investigation into the mob action would be forthcoming. The NPL's isolationist stance angered many servicemen at the time, as patriotism was running high after the victory in World War I. The widespread American isolationism before World War II had not grown yet, and the great American "Red Scare" against communism in the years after the war was running hot.

Governor Allen of Kansas ordered an investigation into the Great Bend affair but was criticized by many after it fizzled and went nowhere. The incidents roused passions on both sides in speeches and elections in the coming years, with frequent reference to it as either a "disgrace" or a "grand defense of our state" depending on the speaker. It had little effect

on the NPL's fortunes, though, as the party declined naturally due to falling membership and increased farmer prosperity. At its height, with only around five thousand members in the state, it was never considered a successful state for the party. North Dakota, South Dakota, Minnesota, Montana and Idaho were the league's strongest states, with Colorado and Nebraska following closely behind. The likely culprit for the league's lack of success was its founding after entry into World War I and its platform being emotionally attacked as "pro-Germanism" in that moment. Had it been promoted before the war, proponents may have been well-received.

The NPL briefly bounced back in popularity during the Great Depression and Dust Bowl of the 1930s, when farmers were once again distressed. Kansas farmers were double-walloped with both calamities in particular. North Dakota elected an NPL governor twice in 1932 and 1936, but FDR's New Deal policies, such as the Agricultural Adjustment Act (AAA), addressed many of their grievances and paid farmers subsidies to keep them afloat and to decrease production. Still to this day, though the North Dakota Democratic Party is officially named the North Dakota Democratic-Nonpartisan League Party after the merger of the Democrats and the NPL in 1956. Their legacy in Kansas is mostly relegated to a story about a tarring and feathering. Perhaps it wouldn't be had they organized in the state earlier. It just goes to show that once again, timing is everything.

THE DAM THAT DISPLACED FOUR TOWNS

If you happen to look at a topographical map or satellite image of Kansas, you might notice Tuttle Creek Lake in the northeast part of the state, near Manhattan. The state's second largest lake, Tuttle Creek is roughly 16 miles long and is 1.3 miles wide at its widest. This slender reservoir is a popular place for boating, fishing and recreation. It had a controversial birth, though—four small towns were flooded to make way for the lake.

Between 1900 and the 1930s, there were a number of floods in northeast Kansas. The Blue River Valley was no exception and was prone to frequent floods. This valley had been recognized for many years as one of the causes of flooding along the larger Kansas River, which the Blue River drains into. The Kansas River, in turn, would flood Topeka, Lawrence and most of all, Kansas City. These kinds of domino effects happened in many places across river valleys draining into larger rivers, and farmers and businesses lobbied to have them dammed up.

The economic impact from flooding events could be devastating downriver. Farmland, factories and residential areas in the cities could be affected, so the U.S. Congress worked to ensure that they were protected from needless devastation. The nation was still trying to work its way out of the Great Depression in 1938 when Congress authorized the Tuttle Creek Dam to act as a means of flood control. The last thing anyone wanted was the Kansas River to flood the Missouri River, which in turn could flood the Mississippi River and devastate communities for thousands of miles.

Local residents of many communities upriver of where the dam was to be built were very concerned about being forced out to make way for the reservoir, so they founded the Blue Valley Association in 1938. This group wrote letters, spoke up in statehouse meetings, lobbied representatives, made phone calls and fought for years to prevent the project from ever coming to fruition. A group of women of the valley even went to President Truman's hotel in Kansas City one night demanding to meet with him. He granted them five minutes to voice their grievances. The men of the town drafted a plan to promote soil conservation techniques to prevent flooding, hoping to convince elected representatives.

Soon after this, though, the worst possible thing that could befall the area happened. In the summer of 1951, massive rains pummeled Kansas, Nebraska and Missouri, flooding the Kansas and Missouri Rivers. In some places, sixteen inches fell in four days between July 9 and 13. Manhattan, Lawrence, Topeka and Kansas City all suffered significant flood damage, and 17 people were killed and over 518,000 displaced. The Kansas City Stockyards were devastated, never to recover, and the flooding at the downtown airport was so significant it led to the creation of Kansas City International Airport far from the river in Platte County, Missouri. Norman Rockwell even made a painting called *Spirit of Kansas City* that showed the city's determination to rebuild.

Residents of the valley fought hard to stop the creation of the dam, even adopting the slogan "Let's quit this dam foolishness." They even helped Democrat Howard Schultz Miller win a seat to Congress in 1952. Another meeting with a president—this time Kansas native Dwight D. Eisenhower—gave the women of the valley further hope that the project could be halted. Not long after, though, in 1953, another series of floods hit Kansas. Eisenhower's hometown of Abilene was devastated. This was the final nail in the coffin. The president officially authorized the dam and others to be built to prevent such floods as these.

Interior holding pens of the Kansas City, Kansas stockyards, May 1936. The Kansas River flood of 1951 devastated the stockyards, which never fully recovered. *Courtesy of the Library of Congress.*

The vast Kansas City stockyards, straddling Kansas and Missouri, 1907. Operating from 1871 to 1991, millions of cattle, sheep and pigs were sold to the highest bidder. *Courtesy of the Library of Congress.*

The people of Garrison, Randolph, Stockdale and Cleburne all had to move to make way for the new reservoir. The U.S. Army Corps of Engineers began the dam's construction in 1959, and the residents moved out. Homes, businesses and other structures were dismantled. Many people stayed in the area and moved to other towns. There were even huge fights over relocating cemeteries. The dead of Garrison, for example, were moved to nearby Carnahan, and the cemetery was renamed the Garrison-Carnahan Cemetery. Through all of this passion and loss, only Randolph was rebuilt, and it was moved up the hill from its old site. By July 1962, all of the former towns were submerged.

Today, if you go to Tuttle Creek, there are still parts of buildings and foundations visible under the water. Part of old Randolph is even exposed in a silted-in area on the north side of the lake. So if you go to Tuttle Creek to enjoy the outdoors or the yearly Country Stampede Music Festival, remember that it was once the site of a years-long fight. There are many people in the area who grew up in those towns and fondly recall their former communities. Whenever they go to the lake, they think of their memories of their childhoods and their homes there under the waves. The dam has done its part, though. Engineers credit it and others like it for helping save Kansas City and other cities from devastation during the massive floods of 1993.

THE MAN WHO SHOT JOHN WILKES BOOTH

When John Wilkes Booth assassinated President Abraham Lincoln on April 14, 1865, the largest manhunt in American history commenced. Over ten thousand federal troops and innumerable civilians assisted in the search for the assassin. Soldiers from the Sixteenth New York Cavalry caught up with him on April 26 at the tobacco farm of Richard H. Garrett in northern Virginia. After setting fire to the barn to flush him out, Sergeant Boston Corbett snuck up behind the barn and shot Booth in the back of the head through a crack in the barn. Booth was carried out of the burning barn, dying two hours later on Garrett's porch. When the nation learned of who killed Booth, Corbett was seen by many in media and the public as a hero, though he directly disobeyed Secretary of War Edwin M. Stanton's orders to capture Booth alive. Little did they know what a character Corbett was.

Born in London, Corbett immigrated to New York in 1839 and was apprenticed as a hatter during his youth. Hatters of that era were exposed to dangerous amounts of mercury nitrate fumes when treating hat felt, which may have led to his later psychosis and hallucinations. His erratic behavior could definitely be tied to his profession. A deeply religious man, he was known to randomly proselytize to people on the street and to scold co-workers who swore in his presence, followed by singing or praying for them. In 1858, he was so mortified by a pair of prostitutes propositioning him that he castrated himself with a pair of scissors so as to avoid temptation. He sought medical treatment later—only after having a meal and going to a prayer meeting.

After the Civil War, he led a rambling, incoherent life, preaching around the country and being fired from numerous jobs after stopping work to pray for co-workers. He would sometimes cash in on his fame as "Lincoln's Avenger" but was never invited back to groups he spoke to due to his erratic behavior. Increasingly paranoid that the government was out to get him for killing Booth, he began carrying a gun everywhere. He was even kicked out of an army reunion for pulling his gun on men who questioned his account of Booth's death. He would also brandish it at people who "looked at him funny."

It was in this frame of mind that he came to Kansas, settling near Concordia in 1878. He built himself a dugout home (a home dug out of the ground) and worked as a traveling preacher. His fame as Lincoln's Avenger often outran his reality as a mentally disturbed man, and in January 1887, Corbett was offered the job of assistant doorkeeper at the Kansas House of Representatives in Topeka. Those trusting Kansans thought they hired themselves quite the national celebrity to protect the esteemed leaders of the state. Clearly these people didn't realize what they were getting themselves into. Not too long after, on February 15, he pulled out his revolver and chased officers of the House from the building, convinced they were discriminating against him. After his arrest, a Topeka judge deemed him "mentally unfit," and he was placed in the Topeka Asylum for the Insane. The next year, though, on May 26, he made a daring escape on horseback. No one is sure what happened to him after this, as he told an old war friend in Neodosho, Kansas, that he was heading to Mexico. There's evidence that he might have died in the Great Hinckley Fire of September 1, 1894, in eastern Minnesota.

TORNADOES IN KANSAS

Kansas sits in the middle of "Tornado Alley," the stretch of Great Plains from central Texas up to South Dakota that is the most tornado-prone place on the planet. With over 1,200 tornadoes a year, the United States gets more tornadoes than any other nation. The combination of cool, dry air from Canada and warm, moist air from the Gulf of Mexico meets here and spawns these monsters with sometimes very little warning.

Between the years of 1950 and 2015, 4,052 tornadoes were reported in Kansas, killing 298 people and injuring over 3,300. They've occurred in every part of the state, though most occur in fields and don't damage anything. There are some, though, that are famously destructive and no place is immune. The F5 half-mile-wide behemoth that hit Topeka on June 8, 1966, killed 16 people and injured 450 more, destroyed or damaged every building on the campus of Washburn University, caused over $100 million in damage and even damaged the dome of the Kansas State Capitol building and other downtown structures. Legendary television journalist Bill Kurtis was filling in as anchor for WIBW-TV at the time and famously told the public, "For God's sake, take cover."

The deadliest tornado in state history was a three-quarters-of-a-mile-wide F5 that hit the small town of Udall on May 25, 1955. Of the roughly 500 people in this tiny community, 75 were killed as the tornado destroyed 192 buildings, which included the high school, grain elevator, downtown businesses and 170 homes. There was no warning, and a further 270 people were injured. Over 70 percent of the town's population was either killed or injured, and another 5 people outside of town were killed. With half of the families losing 1 or more members, the devastation is hard to imagine.

The largest tornado to ever hit a community in Kansas happened on May 4, 2007, and struck the town of Greensburg in southwest Kansas. This twister was measured at just under two miles wide, killed eleven and injured sixty-three. Greensburg was 95 percent flattened, and the damage exceeded $250 million. In all, 961 homes and businesses were destroyed. On a hopeful note, though, Greensburg vowed to rebuild itself to "green" standards, with the city hall, school and hospital all being rebuilt with the highest Leadership in Energy and Environmental Design (LEED) certification. Leonardo DiCaprio even made a documentary television series called *Greensburg* that documented the sustainable rebuilding of the town.

It's not all bad news for Kansas, though. Climatologists and meteorologists have noticed that Tornado Alley has been shifting to the south and east

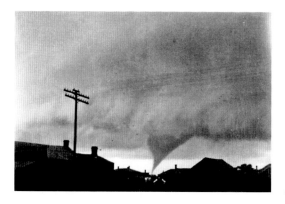

Tornado in Lebanon, Kansas, in 1902. Photographs of tornadoes in that era were incredibly rare, making each one a marvel to behold at the time. *Courtesy of the Library of Congress.*

since the early 1980s—possibly linked to climate change. The central area of yearly tornadoes has shifted from Oklahoma to Alabama, dubbing the region from Alabama up to Indiana as "Dixie Alley." Tennessee has seen a 67 percent increase in tornadoes while Oklahoma has seen a 35 percent decrease. Kansas currently ranks in at no. 7 in most tornadoes in the United States, behind Oklahoma, Texas and Florida. We're no. 1 in average number of largest twisters, though, with more F3 to F5 scale touchdowns than any other state. Hooray?

6

CRIME

KANSAS WOMEN GIVE CARRIE NATION A FEW WHACKS

Carrie Nation (1846–1911) is one of the most colorful people to ever call Kansas home. She started her anti-alcohol activities from Medicine Lodge, where she organized a local chapter of the Woman's Christian Temperance Union. There she promoted alcohol prohibition, women's rights and women's suffrage. She was deeply religious, as was her minister husband. Her stance on alcohol carried zero nuance, as she once stated, "There are but two sides to this question—the children of God and the children of the devil."

Beginning in 1894, Nation and her followers would arrive at bars and saloons, declare them "murder shops" and proceed to smash bottles, barrels, mirrors, the bar and everything else up with hatchets and other implements. Over the years, she smashed up numerous bars in Kansas, Missouri, New York, West Virginia and New Jersey and was arrested thirty different times.

She often intimidated owners with her weapon-wielding supporters, dubbed the "Home Defenders," but she didn't always get away with it. In Enterprise, Kansas, in 1901, she received a beating by the wife of a saloon owner, who whacked Nation in the head with a broom. After recuperating for two days, she headed to Holt to bust some saloons and was egged by onlookers at the train platform. Next, she went to Topeka, where another

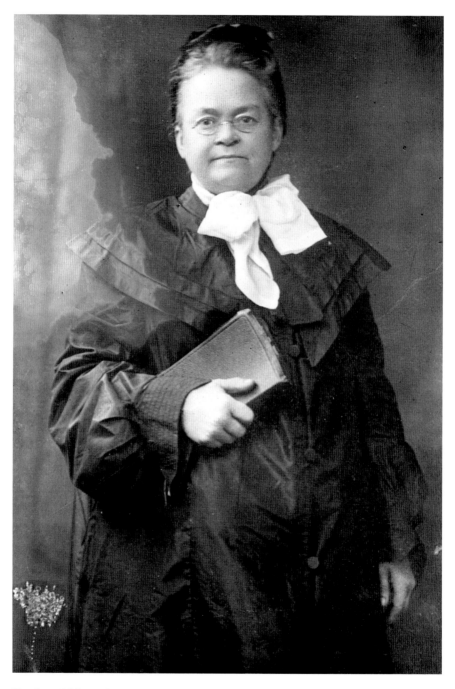

Hatchet-wielding saloon smasher Carrie Nation aimed to see alcohol banned and was arrested thirty times for attacking bars in Wichita, Kiowa, Enterprise, Topeka and elsewhere. *Courtesy of the Library of Congress.*

saloon owner's wife was defending a bar and gave Carrie four good thumps with a broomstick. The first knocked off her bonnet, and as she bent over to retrieve it, the rest "smote her upon that portion of the anatomy which chanced to be uppermost."

There's truth to a newspaper article in 1904 that claimed, "If Mrs. Nation were a man, the grass would have been several feet deep over her grave a year or two ago." When injured, she almost always got it from a fellow woman. The men at that time would almost never strike a woman, let alone a motherly-looking one. Victorian Era women were treated as if they were a gentler, more moral sex and their role was to civilize the men. This kind of thinking is evidenced by Governor Stanley of Kansas, who told her, "You are a woman, but a woman must know a woman's place. They can't come in here and raise this kind of disturbance."

Whether people loved her or hated her, Carrie Nation's actions drew crowds of onlookers, and she was a media sensation. No wonder so many bars—even some to this day—had signs on their walls proclaiming "All Nations welcome but Carrie." She died in 1911.

THE DALTON GANG INSPIRES THE EAGLES

When the notorious Dalton Gang came to Coffeyville, Kansas, on October 5, 1892, the outlaws thought they would try something no one had done before: rob two banks at the same time. Coffeyville's C.M. Condon & Company's Bank and the First National Bank were to be twin sitting ducks for the thieves. Having successfully stolen horses and robbed trains across such dispersed places as Indian Territory, New Mexico, California and Kansas, the gang wanted the ultimate infamy. Bob, Grat and Emmett Dalton were familiar with Coffeyville, in southeast Kansas, as their parents had farmed there for a time.

Knowing the layout of the downtown and where the banks stood in relation to their escape routes, they thought they had an advantage when it came time to get away. Unfortunately for them, a number of citizens recognized them when they rode into town and were well aware of their exploits. The fake beards they wore apparently fooled nobody.

Once inside the banks, a brave employee successfully delayed the gang by telling them that the safe was on a forty-five-minute time lock and that they had to wait for it to open. In the meantime, word had spread across town

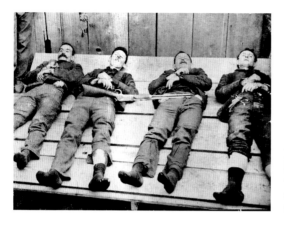

Members of the Dalton Gang lying dead after their shootout with the assembled townspeople of Coffeyville, 1892. *Courtesy of the National Archives.*

that the Daltons were there. In the days before the FDIC, a bank being robbed directly affected the people whose money was deposited there. Determined to resist the gang, residents gathered their guns and headed downtown to confront them. As the gang members exited the banks, they were surprised by a massive shootout. Grat and Bob Dalton were shot dead, as were Bill Power and Dick Broadwell. Three townspeople were hit, including town marshal Charles Connelly, who died that day. Dalton brother Emmett was shot twenty-three times but survived and spent fourteen years in Lansing prison.

The shootout was a national sensation, and curious people flocked to Coffeyville from all over Kansas to see the bodies. Some scraps were even cut off of their clothes and are now housed at the Kansas Historical Society Museum. The Dalton Gang's infamous bloody end became one of the Wild West's most legendary stories. American rock band the Eagles was even inspired to write their double-platinum 1973 hit outlaw concept album *Desperado* after reading about the Daltons. If you look at the back cover of the album, the band members are laid out dead like the Dalton Gang was. Inspired by the outlaw nature of the gang, the Eagles titled the opening track "Doolin-Dalton":

> *Go down little Dalton, it must be God's will*
> *Two brothers lyin' dead in Coffeyville.*
> *Two voices call to you from where they stood,*
> *"Lay down your law books now, they're no damn good."*

BONNIE AND CLYDE TAKE A TOLL ON KANSAS

There are few criminals who capture the public imagination and gain them a fan club in the eyes of the wider public. Some of them, such as Jesse James, are cheered on as a sort of Robin Hood character. They are praised by some for their daring in ripping off what's seen as an unjust system. Butch Cassidy and Australia's Ned Kelly have also been fascinating to biographers, filmmakers and their fans for decades. Bonnie and Clyde also have a special place in that echelon of criminals who have been turned into folk heroes of sorts. Jay-Z and Beyoncé parlayed their aura into a song, and who could forget Warren Beatty and Faye Dunaway's award-winning classic film from 1967? The duo's crime spree, though, really only lasted from 1932 through 1934 and has been shrouded in so much myth and lore that it's easy to forget the real details—and it's impossible to tell their full story without focusing on their time in Kansas.

When Texans Bonnie Parker and Clyde Barrow formed the Barrow Gang in 1932, they already had criminal records. Bonnie had already served time in a failed bank robbery attempt when she was twenty-two, and Clyde went to prison at seventeen for stealing turkeys. Bonnie was technically still married to a man she wed when she was sixteen, but he was in prison for murder and was out of the picture. Clyde's brother and sister-in-law were members of the gang in addition to other criminals that they had met over the years. They had been involved in a number of random crimes, such as robbing filling stations and grocery stores, but headed to Kansas to begin what made them famous—bank robberies.

The gang's first bank robbery was in Lawrence, Kansas, of all places. It happened in March 1932. After abandoning the idea to rob a bank in Okabena, Minnesota, Barrow gang members went south to Lawrence. Clyde Barrow and his friends Ray Hamilton and Ralph Fults checked into the Eldridge Hotel in downtown Lawrence and spent the whole day scoping out the First National Bank, just down the road at 746 Massachusetts Street. For the next two days, they observed how the bank president would arrive at the bank at roughly 8:35 a.m. and let himself into the building. Other employees would trickle in within the next thirty minutes. "Let's do it tomorrow," Barrow suggested after the same bank opening procedure had played out two days in a row. Fults and Hamilton agreed, and the plan was set.

The next day, according to Fults's autobiography, Barrow and Fults were waiting for the bank president at the front door of the bank. Barrow revealed to the president that there was a sawed-off shotgun under his coat and

instructed him to take him to the vault. Two other bank employees were seen walking up the sidewalk, so Fults intercepted them and took them into the vault too. Hamilton drove the getaway car, and the trio absconded with tens of thousands of dollars. They drove without stopping all the way to East St. Louis, Illinois. This robbery, though unreported to police, seems plausible, as many banks before the FDIC would prefer to hush up this sort of event so as to prevent a "run" on its holdings and cause the bank to fail. The bank is now Teller's restaurant, and today, you have to walk through the old vault to get to the bathrooms.

But why Kansas? Why did this state become a favorite target of the gang? Fults opined that it was the best of all lower forty-eight states to rob because as a relatively flat and mountain-less terrain, Kansas had a network of straight roads everywhere that intersected with another road every couple miles. This network of roads is still the fourth in the nation with over 287,000 miles of them, just behind Texas, California and Illinois. This makes escape routes almost impossible for law enforcement to seal off.

The next year, their crime spree continued across Indiana, Minnesota, Missouri, Arkansas, Texas and others, and they found themselves in Kansas once again. Laying low for a while in southwest Kansas whenever the law closed in on them, they found it to be a sparsely populated getaway to ride out the heat. There are reports that they stayed in Hugoton for a time under the pseudonyms Blackie and Jewel Underwood. They also spent a large part of June and July at two tourist cabins rented in Great Bend, where Bonnie could recover from leg burns she received in a car crash in Texas.

Clyde stayed with Bonnie most of the time in Great Bend while other members of the gang committed robberies to support the group. Clyde traveled to Oklahoma and robbed the National Guard Armory in Enid and procured a number of weapons for them. They also attempted to drive to the home of Pretty Boy Floyd in hopes of joining him in a robbing spree, but they could only meet his cousin. This cousin passed Bonnie and Clyde's request along to Floyd, but when he heard it, he declined, saying, "I don't want to get mixed up with those Texas screwballs." Back in Great Bend, Clyde sawed off the end of his automatic rifle so that he could fit it in his lap when he drove. A construction worker in Great Bend was hired to weld three twenty-shot clips to the gun, which Clyde would call his "scattergun" in later exploits. The "banana clip" that he created could fire sixty shots before reloading.

On September 4, the gang was fleeing a shootout with police near Alva, Enid and Ardmore, Oklahoma, and some of them were wounded. When

they were heading through Meade, Kansas, Clyde's Ford slid off a dirt road and into a muddy ditch near Meade City park. The park was full of people from Meade and the nearby town of Fowler having a nice evening of croquet and picnics. Clyde's face was too famous to go get help from the croquet players, so another gang member enlisted the help of a few men to try to help tow them out of the mud, to no avail. The players noticed the blood on Bonnie, and they were then held at gun point while the gang took the Chevrolet that they brought to help the gang out of the ditch.

One member of the gang, twenty-six-year-old Henry Massingill, attempted to steal a V8 Ford from another part of the park while a second member played lookout. He drew his .45 caliber revolver into the window of Mrs. T.E. Prather's car and demanded that she stay silent and get out of the car. To his astonishment, she began screaming and honking the horn for help. Massingill grabbed her by the throat but could not get her out of the car. Three male croquet players came to assist her, leaving their partner, Mrs. Anson Horning, at a safe distance. They scuffled with Massingill, one suffering a crack in the head and another a cut to the hand from gun swipes. Once they realized the thief was armed, they backed down. Just then, Mrs. Horning came out of nowhere and brought her mallet down on Massingill's head with all of her strength. She hit him again after he refused to drop his pistol and yelled at him, "If you don't let go of that gun I'll brain you!" The thief and his lookout were soon apprehended by the police. Bonnie and Clyde fled.

Massingill tried to give his name as D.E. "Doc" Potter, a hitchhiker, but his fingerprints soon betrayed his real identity as a Barrow gang member. A media sensation ensued, and Mrs. Horning was lauded as a hero. The *Meade Globe News* said this of her: "The diminutive Mrs. Anson Horning accomplished with her croquet mallet what dozens of officers with machine guns failed to do." Along with this great publicity came great information, as Massingill made a plea bargain to serve only twenty years in Lansing Penitentiary if he informed on the Barrow gang's operations and movement patterns. With those travel routines, the feds now knew how to ambush them.

Reports of the gang's activities in southwest Kansas set off a flurry of activity, as locals all over the region kept their eyes out for the outlaws. The citizens of a small town called Belvidere got word that a bank had been robbed in a nearby town, possibly Pratt, and decided to do what they could to catch the robbers. Some residents threw a large number of tacks on the road to blow out Bonnie and Clyde's tires. The efforts failed though, as the

duo took a different route. Not all of the tacks were picked back up, and many flat tires were reported in the coming days.

However, the most infamous Bonnie and Clyde connection to Kansas is their "death" car. At 3:30 p.m. on April 29, 1934, the duo rolled up to 2107 Southeast Gabler Street in Topeka and stole Ruth Warren's 1934 Ford V-8 sedan (a favorite of Barrow's). Seven-year-old Ken Cowan of Topeka witnessed the theft. He said he and his friends were playing in a grassy field across the street when they noticed a woman on the running board of a passing car looking for keys inside vehicles and then driving off in the Ford with Barrow. Mrs. Warren came out and yelled to the boys, "Did you see anybody take our car?" They replied that they had.

On May 23, 1934, on a rural road in Bienville Parish, Louisiana, Bonnie and Clyde were famously ambushed and killed by a posse of four Texas officers, and the car was filled with 160 bullet holes. One of the posse members refused to give up the car, and Mrs. Warren had to get a lawyer to legally force him to return it. Seven-year-old Ken Cowan remembered seeing the car weeks later back in Topeka. He said they were astonished to look at it, as "on the left side, there was damage from the bullet holes, 160 bullet holes! And that was the end of it. They wanted to make sure they got 'em." The car made Mrs. Warren a lot of money for years as a touring curiosity and is now on display in a Nevada casino.

Bonnie, Clyde and their gang had committed other crimes in Kansas and other murders (at least thirteen) and robberies in other states. They were constantly on the move, and Kansas was just one more place to steal, sleep or eat on their quest to stay one step ahead of the law. Their misdeeds have been romanticized due to their youth and the fact that they were deeply in love, though their victims would beg to differ as to how romantic their lives were. Roadside markers and plaques across many states memorialize these infamous star-crossed sociopaths, many of them in Kansas. One gets the sense that they enjoyed being infamous, as Bonnie wrote in the opening lines in her poem "The Trail's End":

You've read the story of Jesse James
of how he lived and died.
If you're still in need;
of something to read,
here's the story of Bonnie and Clyde…

INDUSTRY AND BUSINESS

THE FIRST PONY EXPRESS RIDER

The Pony Express has captured the imaginations of Americans for generations. The riders on horseback rushing across the virgin lands with their mail pouches conjure up a romantic vision of a dedicated worker battling the elements alone to complete an important job. The funny thing is that the service only lasted eighteen months, from April 3, 1860, to October 1861. With the goal of transporting mail from St. Joseph, Missouri, to Sacramento, California, the route was over two thousand miles long. Not only did riders have to cross mountains and Indian lands, but they also had to contend with every type of weather and terrain imaginable.

This whole enterprise began when partners of the Central Overland California & Pike's Peak Express Company formed to create a mail delivery service that could outcompete the overland stage routes. In hopes of winning a million-dollar U.S. government contract, they devised a system in which a series of riders handed a mail pouch off to one another at intervals along the way. Riders each rode sixty to eighty miles before being replaced, and it was touted that letters could get from the East Coast to the West Coast in ten days.

The first leg of the journey west began at the Missouri River, where a rider crossed from St. Joseph, Missouri, to Seneca, Kansas, to meet the next rider. Then that rider rode another eighty miles, and so on. Of the nearly

Hollenberg Pony Express Station at Hanover, Kansas. It served as a stop for riders transporting mail between St. Joseph, Missouri, and Sacramento, California. *Courtesy of the Library of Congress.*

two hundred young riders selected for the Pony Express, the honor of being the first went to young Johnny Fry, a skilled local rider who had recently won a major race. Just twenty years old and weighing in at under 120 pounds, he was loaded with fifty pieces of mail, including a congratulatory letter from President Buchanan to Governor Downey of California. A brass band and a crowd cheered him on as he headed the eighty miles loaded with his charge.

Fry served the Pony Express well, averaging twelve and a half miles an hour, and he never failed in his delivery duties. Local lore claims that some young girls in Troy, Kansas, invented the doughnut as an eat-as-you-go cake for Fry as he rode by. True or not, that story shows just how the men needed to stay continuously on the move.

Ultimately, the Pony Express failed because of the completion of the transcontinental telegraph in the fall of 1861. Additionally, it was very costly to supply nearly five hundred horses, two hundred stations and their employees and eighty riders. After the Pony Express folded, Fry joined the Union army as a rider and scout after being recruited by General James G. Blunt.

On October 6, 1863, traveling from Fort Gibson, Indian Territory (Oklahoma) to Fort Scott, Kansas, he and other Union soldiers were attacked by William Quantrill's raiders at Baxter Springs, Kansas. The Federal uniform–wearing raiders surprised the Union column and killed most of them, including many who attempted to surrender. Fry killed 5 of them in hand-to-hand battle but eventually was killed himself. He was one of 103 Union soldiers massacred by the guerrillas that day. He rests today in the Baxter Springs Cemetery.

UTOPIANS MAKING SILK

If you drive along Old Highway 50, roughly three miles to the southwest of Williamsburg, Kansas, you might come across an old limestone school, two stone barns and similarly constructed stone fences just off the road. They stand in stark contrast to the modern farms and wood- and steel-based construction of most buildings in the area. What you're looking at is the remnants of a failed utopian experiment by a wealthy French nobleman in the nineteenth century.

Ernest Valeton de Boissière (1811–1894) was a wealthy Frenchman born into a noble family in Audenge, a seaside community in the southwestern Bordeaux region of France. Those who knew him saw him as a friendly, portly man who made his fortune on timber and fisheries. Raised into a family that championed egalitarianism, his politics drove him into a collision course with the powers that be at the time in France. Inspired by the socialist philosophy of Charles Fourier, who promoted the utopian ideals of universal caring and sharing, he espoused his politics and beliefs publicly and in print. With the dictatorship established by Napoleon III in 1851, tens of thousands of his opponents were arrested and thousands more exiled. Napoleon's government sent him a not-so-subtle suggestion that he might "go abroad for his health." Taking the hint, de Boissière chose to flee, arriving in America in 1852. His first attempt at using his wealth to promote his ideals was an orphanage and school for black children in New Orleans. Encountering much criticism and more racial opposition than he expected, he spent the next few years traveling the country and looking for a new place to experiment with his ideas.

In these travels, he remembered particularly enjoying Kansas. The climate reminded him of the silk-producing regions of France with which

he was familiar. Such climate was ideal for mulberry trees, whose leaves are a favorite of silkworms, and he soon settled on building a utopian community supported by silk farming. Purchasing 3,500 acres of Franklin County land from the Kansas Educational Association of the Methodist Episcopal Church in 1869, he believed that the state's resources and cheap land gave him the best opportunity to build his ideal community.

Advertising in France for willing settlers, de Boissière received interest from a few dozen prospective colonists who were tired of the political situation in France and wanted a new start. Socialists and other such thinkers were especially wanted, and destitute people were not admitted. After paying an initial deposit of $100, forty French immigrants and their children came to Kansas to settle his new community. Many of them were experts in the production and manufacturing of silk. They were expected to bring their own provisions and provide for their own needs, as well as pay their room rent two months in advance. What they were promised was food, lodging and a share of the profits. The high price of living and low wages in France made this an attractive offer. They soon got to work building his dream. In the community of Silkville, all settlers would share in the responsibilities and the rewards of their labor. They soon planted thousands of white mulberry trees across seventy acres and imported thousands of silkworms from Japan and France to begin production.

Though it was called Silkville, this new settlement was never really a town. De Boissière oriented Silkville around a large three-story château that was built to house the workers of the commune. This impressive building and unquestioned center of the community included sixty rooms, comprising forty family rooms and multiple shared dining rooms. A 2,500-book library (the largest in the state at the time) was provided to bring entertainment, culture and learning for the workers and their families. Large parlors and an expansive dining room was built for group meetings as well. Other structures were built around the main château, including a stone silk barn for cocoon storage, a winery, an icehouse and factory-like loom buildings for weaving the silk. The fifteen miles of stone fence ringed the property, and a schoolhouse was built for the education of the children. The Burlington and Santa Fe Railroad even had a flag stop there.

It didn't take long for Silkville to begin churning out silk of the highest quality. De Boissière was right in that the climate of Kansas was perfect, and the community thrived. By 1872, the factory could produce 225 yards of silk ribbon daily across three looms. While the primary focus was silk, other ventures rounded out the community as well. Many of the acres were fenced

for cattle (hence the stone fencing), there was an orchard of two thousand peach trees and over one thousand grape vines began cultivation for wine production. The eight thousand mulberry trees dominated their efforts, but they also experimented with canning meat, making matches, constructing brooms, tanning leather and producing milk, butter and different cheeses. A creamery, cheese factory and blacksmith shop soon went up as well. Five hundred acres of prairie grass were set aside as hay land for the cattle, and the rest was pasture with a dozen ponds. This was no small-scale operation and had significant resources keeping it afloat.

The members of the community were expected to treat one another with dignity and be mindful of others' needs. Sharing and helpfulness were promoted by de Boissière, and he spread his utopian ideals to those living there. He disapproved of religion and marriage, leading to rumors of "free love" parties at the commune. Most people in the surrounding farms and towns were Methodists and Baptists, so it's understandable that they would look at Silkville as a queer sort of place with questionable morals. Silkville employed roughly fifty workers most of the years it was in operation and may have even grown to one hundred at its height, though there are no definitive records to prove it. Workers from France and Sweden made up the bulk of the population, with others from around the world settling there.

Silkville, though a utopian commune, was not cut off from the world. The school on the site was part of the Franklin County School system, and local people were allowed to visit the property. Very few people visited in the early years, but many neighbors were curious about the place. A newspaper article from Ottawa in the 1930s described a party held there: "Early in the summer of 1874, notices were printed in the Ottawa and Burlington papers that on a certain Sunday, excursion trains would run to Silkville, and everybody was invited to come and see how silk was made. A large crowd came to visit, eat, and dance. They all had a good time and were impressed." Other writers praised their wine, cheese and other products that they sold throughout the area.

It wasn't the only place producing silk in Kansas, though. Several counties across the state promoted the planting of mulberry trees and a statewide silk commission was established to promote growth of this industry. In 1887, the state legislature appropriated $13,000 to establish a silk station, with the first being at Larned in 1887. Nearly one-fifth of all American silk was produced in Kansas by 1888.

At its height, Silkville was becoming well known for its high-quality silk. At the Philadelphia Centennial Exposition in 1876, its silk won first prize

and was judged superior to Japanese, Italian and French silks, earning the title "The Silk Producing Capital of America." De Boissière was very proud of the silks his commune produced and personally exhibited them at the state fair in Topeka and other fairs. Though initially successful, Silkville began running into problems. Cheaper silk prices from Japan and China cut into profits, and the 1874 economic depression contributed to member turnover. Also, many workers began leaving to make their own way. The reasons for leaving were myriad. Some left because they realized that for their $100 deposit they could have simply bought cheap land in Kansas. Others wished to get married and own their own land, cattle and possessions. Other workers chose to lease land nearby and build their own homes with a lease to the commune for $10 to $36 a year for twenty-one years. The leased properties were southwest across a field from the main house. Though de Boissière was a benevolent leader, people eventually wanted to own their own slice of America and control their own destinies. Speaking only French upon arrival, some slowly assimilated into wider society once they learned English and didn't depend on the commune as much. Higher wages elsewhere were a major draw as the silk industry profits shrank.

With the slow decline of the American silk industry in the 1880s, de Boissière realized that his utopian experiment had ultimately failed. He attempted to shift Silkville's production to butter, cheese and livestock, but it was too little, too late. Keeping a stable population was nearly impossible with the girls marrying local farmers and the men leaving to take advantage of the free land provided by the Homestead Act. Throwing in the towel, de Boissière returned to France in 1884, though the commune admirably struggled on without him. The colonists who stayed behind abandoned silk for good in 1886 but continued raising livestock until 1892.

Ever the utopian idealist, that year, de Boissière returned to Kansas at the age of eighty-two to devote the property to the best possible good for mankind. Once word got out that he wanted to donate the land, many charitable organizations approached him with interest. He deeded the estate over to the Independent Order of Odd Fellows, and it was turned into an orphanage for children of deceased Odd Fellow members. According to the *Annals of Kansas* (1892), "May 11, Ernest Valeton de Boissiere, Frenchman who founded Silkville, deeded all his real and personal property, amounting to nearly $150,000, a trust for founding an I.O.O.F. orphans' home. The gift included a 3,100-acre farm with nine stone buildings, an apple orchard, a mulberry grove and a walnut grove." He died two years later in 1894 back

in his native France. By 1897, the Kansas legislature had given up on silk, discontinuing its promotion of the industry.

The property was used as an orphanage for only a short time, but the main château was gutted by a massive fire on April 29, 1916. A farmhouse built with some materials from that château stands at the site, as well as the barns, schoolhouse and fences mentioned earlier. Today, the property is a working ranch with the appropriate title of Silkville Ranch. Mulberry trees still dot the property as well, descendants of the originals that once made such fine silk for the commune. In 1972, these buildings were added to the National Register of Historic Places. They stand in mute tribute to an idealistic Frenchman who gave his dream a proper and impressive try.

THE BATTLE OF KANSAS

During the Second World War, Kansas was one of the main centers of aircraft production in the United States. Massive plane factories in Wichita and Kansas City operated by Boeing, Beech, Culver and Cessna built 25,865 planes for the war effort. In a war based upon air superiority, this was crucial for dominating the skies over Germany, Italy and Japan, leading to the total collapse of the Axis powers. Tens of thousands of workers, male and female, built these planes on often tight production schedules. Over thirty thousand workers worked at Boeing's massive plant in Wichita, alone. Many important craft were built here, including the gliders that Ike needed for D-day.

One particular struggle that took place was the "Battle of Kansas," a push to get the B-29 Superfortress in the air and flyable. As the planes were such a technological leap forward, they had loads of problems. This new design included pressurized crew stations, powerful new engines that continually overheated, sixteen-foot propellers, a new wing design and a new breakthrough in remote-controlled armaments. It took three years from inception to mass production, which was an astounding feat. By the end of 1943, though, only fifteen were airworthy and Chief of the Air Force General Hap Arnold was enraged because he needed more planes for an assault on Japan. Arriving in early 1944, he expected his planes by April 15. With his intervention, six hundred civilian experts from the Wichita plant, plus mechanics and engineers from all over the nation, were sent to Wichita to figure out the issues. Often working in icy-cold outdoor conditions and

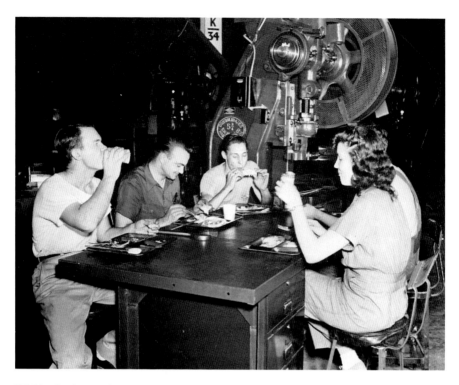

Wichita Boeing workers eating their lunch near a massive punch press, sometime between 1942 and 1945. They built warplanes such as the B-29 Superfortress. *Courtesy of the Library of Congress.*

as long as a man "could stand on his feet," they worked around the clock. With very little paperwork, they modified 150 B-29s between March 10 and April 15, 1944, meeting their deadline. The Japanese islands were bombed by these very planes two months later.

By war's end in August 1945, Wichita was pumping out 4.2 Superfortresses a day. Boeing's Wichita plant built 1,644 of the total 3,888 B-29s in the war, which was an astounding number for such an advanced aircraft. The Axis simply could not keep up with this. The Japanese called the planes "the unsolvable problem" and could not prevent B-29s firebombing Tokyo and dropping the atom bombs on Hiroshima and Nagasaki. General Arnold returned to the Wichita plant on August 29, 1945, and spoke to the workers:

> *It is a great satisfaction to me to be able to be here today and see the completion of your B-29 program even as American occupation forces are making their initial landings in Japan—landings made possible at this*

*relatively early date and with relatively reduced cost of American lives by the army air forces flying the B-29s made by you in this Boeing factory....
For myself and on behalf of the army air forces, I say to you-well done, and thanks from the bottom of my heart.*

Sprint Corporation and a Boy's Amputated Arm

Sprint is one of the five largest telecommunications companies in the United States. With over fifty-nine million customers (as of spring 2017), it provides wireless services nationwide and is a major Internet service provider. Most Kansans are proud to say that Sprint's headquarters is in Overland Park, where over ten thousand employees work in the Kansas City Metro Area's biggest corporate campus. With Sprint spending many consistent years representing Kansas City as a Fortune 500 Company, this information is old news to locals. What few people do know, though, is that the company has its roots in small-town Abilene, Kansas—and a boy's unfortunate accident.

Born in Brown's Mill, Pennsylvania, in 1872, Cleyson Leroy Brown was the oldest of his family's five children. His parents, Jacob and Mary, moved the family to Abilene in 1880 to look for new opportunities in the rapidly growing state. Between 1870 and 1880, the state's population ballooned from 364,000 to 996,000 people—a 173 percent increase. There was money to be made out West, and Jacob Brown would not be left out.

Jacob established himself as a businessman and opened a gristmill on the Smoky Hill River south of town. Local farmers brought their grain for grinding and wood for sawing by Jacob and his family. From a young age, young Cleyson would help out around the mill, much as children did back in the days before child labor and safety laws. One day, while working the corn grinder with his father, the nine-year-old's right elbow was crushed in the machinery. The damage was so severe that his arm had to be amputated. The *Abilene Weekly Chronicle* even mentioned it in its December 30, 1881 issue: "A little son of Jacob Brown met with a very serious accident on last Saturday. His arm was caught and terribly crushed in the cogs of a power corn sheller. It was thought at first that amputation be necessary, but an effort will be to save it, although he will undoubtedly be a cripple for life."

This unfortunate accident changed the trajectory of young Brown's life from then on. Being mechanically inclined, Cleyson had always loved tinkering with machines and learning how they operated. Manual labor was

out of the question for Cleyson from then on, so he dedicated himself to learning and took a keen interest in the new electronic age. He once said that "instead of using my hands to make a living I was going to have to use my head." He never complained about his accident and often said he would have probably been a farmer had it never occurred.

After high school, he tried his hand as a grammar school teacher and later studied at a business college. After managing a creamery in Wichita, he and his father founded Abilene Electric Light Works in 1898. Cleyson had a knack for electronic work and business savvy, and soon the old gristmill was supplying electric power to Abilene. His company was so successful that he decided to found a telephone company the following year, soon crisscrossing the town with electric and phone line wires. His new telephone operation was dubbed the Brown Telephone Company. The next decade was good for his new operation, and it spread to cities throughout the state.

By 1911, he had consolidated his company with three other telephone companies in Kansas, making it the second largest in Kansas. This era was a Wild West of sorts in the telephone industry, with many popping up all over the nation. The Bell Telephone Company enjoyed monopolies on telephone service in many parts of America, and it was often too expensive for many customers. This elite eastern company rubbed many people the wrong way, making a startup like Brown's attractive to prospective customers.

He was also incredibly generous to his hometown, building loyalty through the creation of the Brown Memorial Foundation with more than $1 million going to local parks, charities and projects. He diversified his personal investments to sand companies, hotels, radio stations, oil companies and even grocery chain Piggly Wiggly. This diversified wealth helped him keep his empire afloat. He won over many to his business with his ethos of giving back. "All my wealth is nothing more than for service," he wrote, "and outside of enough to care for my family reasonably it all goes into this Foundation." He wanted people to enjoy the fruits of his labor and wanted to be alive to see it instead of accumulating wealth to "buy six feet of ground."

Brown founded United Telephone and Electric in 1925 (UT&E) to purchase stock in other telephone companies, eventually giving him control of dozens of other companies across multiple states. United Telephone grew even in the early years of the Great Depression, controlling new holdings in Illinois, Ohio, Pennsylvania and Indiana. Hard times, new governmental regulations and declining subscribers forced him to relinquish his control over UT&E in 1934. Cleyson Brown died in 1935.

The company began rebounding, though, in 1937, and through expansion and reorganization into United Utilities in 1939, the company was back on its feet. By the mid-1950s, United Utilities had spread to five states and was the third-largest phone company in America. Growth followed in the ensuing decades, and in 1986, United Telecommunications (its name by then) consolidated with Sprint, which had better brand recognition as a low-cost long-distance carrier. The marriage of great local service (United Telecom) and long distance (Sprint) made this merged enterprise a key player in the coming mobile phone era.

We'll never know if Cleyson Brown would have become a "good farmer" had he never had that unfortunate accident as a child. But we do know that he dedicated himself to books and tinkering with machines at an early age, helping him master the early twentieth-century technologies that made him a wealthy man. There's a lot that went into him building what we now know as Sprint Telecommunications, but that one moment stands out as a turning point not just in his life but in the history of American business.

FIRST PATENTED HELICOPTER

Aviation fever hit America and the world in the heyday of the first years after Orville and Wilbur Wright announced the success of their flying machine in 1903. Many people initially met their claims with skepticism, but before long, people the world over were taking this new technology seriously. Tinkerers, engineers and mechanics from the United States to France and Australia got to work in shops trying to make their own flying machines. This spirit of invention soon hit Goodland, Kansas—and led to the first helicopter patent in the world.

Goodland is a small community in northwest Kansas roughly twenty miles from the Colorado border. It is here that thirty-eight-year-old railroad mechanic William J. Purvis first got the idea to attempt to build a helicopter after seeing a kid playing with a small whirlygig at a sweet shop. A whirlygig is basically a stick with a propeller on the end that lifts off when you spin the stick between your hands. Purvis gave the child a penny for the toy and left inspired. Purvis wasn't the first person to get the idea for a helicopter, though. Famed Italian painter and inventor Leonardo da Vinci made a design in 1488 for what he called the aerial screw, which was a screw-shaped device made of linen and wire. It was never built or tested, but the design

inspired helicopter-like toys in later years such as Alphonse Penaud's 1870 model helicopter that used twisted rubber bands for power. Those toys, in turn, helped to inspire Orville and Wilbur to tinker with their gliders. A French engineer named Paul Cornu designed and built a helicopter in 1907, but men on the ground were required to stand and hold it in position and it was not a great success.

Purvis soon joined forces with a fellow mechanic at the Rock Island railroad machine shop, twenty-year-old Charles Wilson, and together they got to work at building what they hoped would be a working helicopter. At Purvis's farm outside of town, the duo began drawing up plans for how to get it flying. Their goal was to get a machine that could carry packages, mail or freight at a low altitude. They didn't have the advantage of computer models to know if this would work, so they simply worked on trial and error. The machine looked like a triangle-shaped cart with a wheel on each corner and a rudder in the rear. A nearly twenty-foot-high cast-iron pole in the center supported two twenty-foot-wide rotors that rested ten and twenty feet above the ground, respectively.

Once they got it built and had tested their new creation, Purvis and Wilson announced to the town that they were going to hold a demonstration of their new machine on Thanksgiving Day of that year, 1909. The *Goodland Republic* reported that a sizeable crowd gathered to watch the demonstration of their "gyrocopter" at the Purvis place just west of the Rock Island railroad yards. After explaining to the crowd how it worked, they turned on the six-horsepower gasoline engine, and the machine lifted into the air. The helicopter was tethered to the ground and, at the moment, could only go up and down. Mobility was hampered, as the engine was sitting on the ground and fastened to the rotors with a belt. Though it wasn't doing much more that lifting up and down, the crowd was amazed, and many saw the potential in such a device. Curious onlookers soon crowded around the inventors, inspecting this new wonder and asking hundreds of questions. The pair soon became the toast of the town, with residents coming to picnic at their farm on weekends and watch their progress while the men worked.

Convinced that the aircraft was potentially useful for transporting people and goods, as well as making aerial observations, Purvis and Wilson created the Goodland Aviation Company. The Kansas State Board granted the new company a charter on December 23, and stock selling began on December 31, 1909. At $10 a share that could be bought "at Lawyer Calvert's office," so many townspeople and other locals began investing in the company that they soon raised $30,000 of capital. The charter declared the company's

purpose to be "the manufacture of flying machines, the sale thereof, and the purchase of real estate for the construction of shops for making airships." An average person's yearly earnings was $300 in 1909, so this quick raising of capital speaks to how excited so many people were for this endeavor. Purvis predicted that the stock might even go up to $100 a share.

With this money, the partners started with what they needed right off the bat—$400 to construct a hangar and workshop. Near the modern-day intersection of Highway 24 and Cattletrail Avenue, Purvis and Wilson's machine shop soon went up, and they installed a stationary steam engine to provide power to prototypes. Hopes were high when the newspaper declared, "The device has the lifting and carrying power that no other flying machine has. It can rise, remain stationary, descend, be propelled and guided."

The United States patent office approved their plans for granting a patent soon after. Filed on March 18, 1910, the patent application read:

> *William Purvis and Charles Wilson have invented new and useful improvements on Flying Machines of which the following is a specification; This invention relates to flying machines of the helicopter type, the object a novel construction and arrangement of propellers and balancing and tilting planes whereby the machine may be driven upwardly or forwardly at will, supported in a stationary position in the air and controlled in its descent so that safe landings may be made. A further object of the invention is to provide a novel construction and arrangement and mode of mounting and bracing the propeller shafts whereby ease of operation, strength and durability are secured. The invention consists of the features of construction, combination and arrangement of devices hereinafter more fully described and claimed, reference being had to the accompanying drawings.*

Over the next few months, the two men worked hard at figuring out how to get this machine to fly properly. After a number of tests, they realized that their engines were overweight and underpowered. Two seven-horsepower Curtiss aircraft motors weighing in at fifty pounds each were employed to lift it. At 1,500 revolutions per minute, the engines were believed to be sufficient at first but soon proved too weak for the task. Design flaws also affected the aircraft. Harold Norton, a Brewster mechanic and pilot who was later commissioned to build a replica of it, said that the men mistakenly believed that the blades had to be heavy and wide to get airborne. As it turns out, thinner, lighter blades were later realized to be what was necessary to get any helicopter airborne. "It couldn't do anything but tear itself up. It would

have set up a vibration they couldn't live with," Norton said. "No way could you get it to travel forward, backward or sideways because the blades didn't change pitch. It would have turned turtle, turned upside because it had more lift on one side than the other," he said.

By July 1910, the company was running into significant problems. Their tests showed that they needed at least fifty-horsepower engines to get the craft off the ground. Many aviators at the time were using a Gnome engine in their planes, but the company couldn't afford those at this time. They had made headway with torque issue they had and set two sets of blades to rotate counter to each other. That was a minor victory, though, as they still didn't have the power to get this thing to work. Purvis wanted to add a gyroscope propeller that, when turning at high speed, could propel the device forward when tilted. He rejected others' suggestions that a swiftly revolving propeller was what was needed. Either way, neither idea was pursued successfully.

Money was running out as well, and investors would often drop by to offer unsolicited and impractical advice—to no avail. The duo was scheduled to have another flying demonstration at Goodland's Fourth of July celebration that year, with the newspaper even announcing it on the front page. The event never materialized, however, as Purvis traveled to St. Louis in search of a powerful, lightweight engine that could fit their needs. He came home with nothing, though, as they didn't have enough money. Investors' doubts grew, and they refused to put any more money into this venture.

The *Goodland Republic* reported on March 17, 1911, that William Purvis had moved to the Ozarks in Missouri in December 1910 and sold his home. A final Goodland Aviation Company meeting was held at that time as well, liquidating assets such as the steam engine, a boiler, the two seven-horsepower engines, the building, tools and the aircraft itself. Wilson was not even mentioned in the article at all. The dream was dead less than two years after it had been birthed. By April, the company was dissolved for good. "The Goodland Aviation Company has collapsed very much like a balloon when punctured. They have gained some experience and lost some cash. Nobody complains and nobody blames," reported the local newspaper.

Purvis and his family later moved to Wisconsin in 1920, and he died in 1944. Wilson left Goodland in July 1910 to work in the rail yards of Kansas City, where he died at seventy-six in 1965. Purvis's son said that his father would rarely ever talk about his helicopter venture, as it hurt too much. "He hurt too bad, feeling like he lost people's money. He wasn't bitter about not

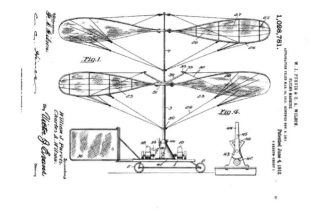

The first helicopter
patent in the United
States was granted to
Goodland's William J.
Purvis and Charles A.
Wilson in 1912. *Courtesy
of the National Archives.*

making it work," the son said. "He couldn't figure out how to control it, and
Sikorsky [the man who developed the modern helicopter] could, and that
made the difference."

Ironically, the United States Patent Office got back to the inventors in
1912, granting them Patent Number 1,028,781. By then both men were long
gone from Goodland, and the company had been dead for a year. Charles
Wilson and William Purvis may have failed to figure out the helicopter, but
many others tried and failed for years until Igor Sikorsky invented the first
practical flying helicopter in 1939. The plucky duo out of Goodland still
holds the first patent for a helicopter, though. You can't say they didn't give
it an amazing try.

The Sherman County Bicentennial Commission sponsored a rebuilding
of the aircraft in 1986, using one of the engines from the original craft.
Working from patent designs, photos and surviving parts, Harold Norton
went to work rebuilding it. In nearby Brewster, Norton spent a year on this
project. Being an experienced aviator and mechanic himself, he became
familiar with the flaws in the design and why it didn't work. He had to force
himself not to improve any flaws and to build it faithfully to the original
specifications. The replica can be found today at the High Plains Museum in
Goodland, where visitors can press a button that starts the motor and turns
the blades.

Norton believes that Purvis and Wilson were very bright, though, and
had they had more money and time they could have solved their machine's
issues. He said they were headed in the right direction, as they knew they
needed more power. The tricky thing was that if a helicopter such as theirs

were aloft for an extended period of time, the whole thing would eventually spin with the rotor. Sikorsky solved this by adding a tail rotor.

The helicopter became town lore, and stories about it passed down from generation to generation. A rumor that it flew and crashed into Goodland's water tower even became popular for many years. "It never flew and it never hit the water tank. It was a hilarious ending to the story, but it never happened," said the inventor's son, William Purvis Jr. of Prue, Oklahoma.

BIG BRUTUS

The mining industry had a major impact in Kansas, with high levels of production of lead, silver, coal and cadmium. Southwest Kansas was the world leader in zinc production for over fifty years, which was crucial to the U.S. war industries in both world wars. Miners came from all over the nation to work in often brutal conditions for low pay and labor strife—an unfortunate reality in the region. Coal mining lasted quite some time, as it was productive from the 1870s to the 1980s. As many of the coal seams were thin and close to the surface, it was deemed most economical to strip mine the deposits. In strip mining, the overlying rock and soil are removed instead of using shafts to reach the deposit.

As the decades progressed, larger and larger power shovels were designed to tear into the earth. The more that these big machines strip mined, the fewer workers were needed and the labor strife evaporated. If you head to West Mineral, a small town in Cherokee County, you will very likely see one of these big machines called "Big Brutus" towering above the prairie. Brutus is a massive electric shovel that stands sixteen stories tall and weighs in at over eleven million pounds. Many Kansans are familiar with Brutus because it is such a great tourist destination, with an adjacent mining museum and tours of the "coal monster" a popular outing. Brutus tore up the Kansas earth from 1963 to 1973 and is the second-largest electric shovel of all time and the largest remaining one today. Brutus is so huge that its ninety-cubic-yard shovel could scoop up 150 tons of coal with each thrust. For scale, the shovel is so wide you could parallel park a Ford F-150 in it.

What many people don't know, though, is what it took to get this behemoth to the site. The Bucyrus-Erie Company, a mining equipment manufacturer

Left: Striking zinc miner in Columbus, Kansas, 1936. Mining strikes plagued the state for decades, sometimes leading to brawls with non-union strikebreakers. *Courtesy of the Library of Congress.*

Below: Big Brutus, the largest electric shovel still in existence, stands 160 feet above the Kansas prairie in West Mineral, in coal-producing southeastern Kansas. *Courtesy of the Library of Congress.*

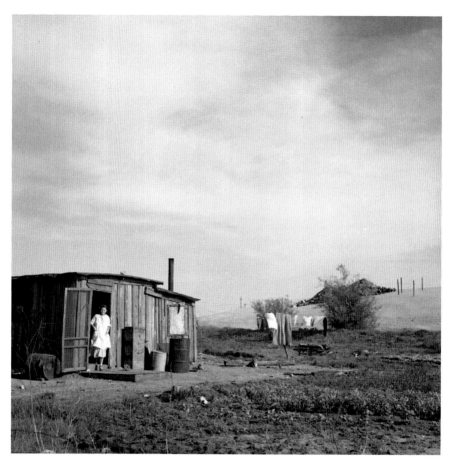

A miner's ramshackle home, Cherokee County in southeast Kansas, 1936. Times were hard for miners, who often barely earned a subsistence wage. Labor unrest was common. *Courtesy of the Library of Congress.*

out of Milwaukee, got the contract from P&M Coal Company to build Brutus for a whopping $6.5 million, not a small amount in the early 1960s. Bucyrus-Erie had been manufacturing shovels of many types for decades. If you look at pictures of Teddy Roosevelt at the Panama Canal, the shovel he sits on is a Bucyrus-Erie. Getting the materials to Panama was done by boat, but you couldn't just float this thing to Kansas. It had to be brought by train car—150 of them. Once it arrived, workers spent an entire year just putting it together. By June 1963, it was ready to dig. Once it did, it worked well until 1973, when the mine became unprofitable due to coal prices and the depletion of the area's coal. The behemoth was left rusting for years

Strip mining with a thirty-two-cubic-yard steam shovel, Cherokee County, 1936. Some 300 million tons of coal have been produced by Kansas since the 1870s. *Courtesy of the Library of Congress.*

where it last worked, later restored by a nonprofit that wanted to save the old giant. Brutus stands there to this day, delighting visitors of every generation. There's a good chance it's not going anywhere, too.

U.S. Presidents and One VP

Abraham Lincoln Drops by, Practices an Important Speech

Lincoln is arguably America's greatest president of all time, right up there next to or above George Washington in the eyes of historians. His election in 1860 tore the nation in half, but his steady leadership throughout the Civil War famously kept the Union together. Saying such things about Lincoln is obvious to most people. What's not obvious is that he really began his all-important campaign for president on a quick trip to Kansas in 1859.

Lincoln got his start in politics by serving one two-year term in the U.S. House of Representatives from 1847 to 1849. After taking a break from politics between 1849 and 1854, Abraham Lincoln reentered the ring with an interest in stopping the spread of slavery once the Kansas-Nebraska Act was signed. He hated the act and the way it allowed territories to decide whether they wanted to be free or permit slavery. That act led directly to waves of violence, illegal voting by Missouri border ruffians and lawlessness from both sides of the debate in Kansas. He said that the act "*declared* indifference, but as I must think, a covert *real* zeal for the spread of slavery. I cannot but hate it. I hate it because of the monstrous injustice of slavery itself. I hate it because it deprives our republican example of its just influence in the world."

Above: Political satire lithograph by John L. Magee for 1856 presidential campaign depicting liberty being assaulted in Kansas by proslavery ruffians. *Courtesy of the Library of Congress.*

Left: Unidentified border ruffians with swords, between 1854 and 1860. Proslavery border men crossed the border to illegally vote Kansas into the union as a slave state. *Courtesy of the Library of Congress.*

By 1859, he had gained considerable national fame with his "House Divided" speech and his debates with Senator Stephen Douglas. An old legal colleague of his from Illinois named Mark Delahey had sent Lincoln several invitations to come speak in Kansas. Delahey had moved to Kansas and was editor of the *Leavenworth Times*, which was once destroyed by a pro-slavery mob. He thought Lincoln would be well served coming to Kansas Territory and trying out his speeches.

Lincoln finally agreed to come to Kansas in November 1859 and planned to use the trip as a testing ground for a new speech condemning slavery in Kansas. Much like a comedian plays small comedy clubs to test out their material before they hit the road, Lincoln thought Kansas would be somewhat out of earshot of the East Coast media. Whether the speeches went over well or not, he knew he wouldn't get drawn into public debate with other notables in the press.

Crossing the Missouri River from St. Joseph, Missouri, by ferry on November 30, Lincoln arrived in Elwood, Kansas, for his first speech. Speaking at the Great Western Hotel, he blasted slavery and the concept of territories voting on whether to allow it or not. The next day, December 1, he set off in the cold to his next stops, speaking in Troy for two hours and later in Doniphan, where he stayed the night. The crowds were receptive to his message, and he honed it as he went, paying particular attention to the fact that the Founding Fathers considered slavery wicked. On December 2, he traveled to Atchison and spoke for over two hours to a large crowd in a Methodist church auditorium. The next day, in Leavenworth, he said, "We are not trying to destroy it [slavery]. The peace of society, and the structure of our government both require that we should let it alone in those states where it already existed. It was not, however, to be allowed to spread further."

Staying with Mr. Delahey on the fourth, Lincoln spoke one final time on the fifth in Leavenworth. It was in these last days that Lincoln and Kansas heard the news of John Brown's execution. Lincoln didn't mince words when he spoke of his disapproval of Brown's methods:

> *Old John Brown has just been executed for treason against a state. We cannot object, even though he agreed with us in thinking slavery wrong. That cannot excuse violence, bloodshed, and treason. It could avail him nothing that he might think himself right. So, if constitutionally we elect a President, and therefore you undertake to destroy the Union, it will be our duty to deal with you as old John Brown has been dealt with.*

Lincoln left Kansas on Tuesday, December 6, and never had the opportunity to return. The crowds were receptive, but what made the trip so successful for him was that he had practiced and honed the bulk of his later "Cooper Union" speech, which won him the Republican nomination for president just five months later. It seemed that Kansas proved a good testing ground for him after all. Months later, a man asked Lincoln if he would advise people to go west, and Lincoln replied, "If I went West, I think I would go to Kansas—to Leavenworth or Atchison. Both of them are, and will continue to be, fine growing places."

WILSON HAS A STROKE

Woodrow Wilson was treated like a savior in Europe at the end of the First World War. With America's involvement, the collapse of Germany and the Central powers was hastened. His postwar concept of the League of Nations was a massive hit with European powers looking to avoid another calamitous war, but getting the conservative U.S. Senate to ratify it was another matter. He needed two-thirds of the Senate to support it, which was a very tall task. When the senators blocked it, he decided to go straight to the American people and plead his case for the necessity of the league. On September 3, 1919, the sixty-year-old president went against the wishes of his doctor, Dr. Cary T. Grayson, and embarked on a national speaking tour by rail. "I do not want to do anything foolhardy," Wilson said, "but the League of Nations is now in its crisis. If it fails, I hate to think what will happen to the world....I cannot put my personal safety, my health, in the balance against my duty. I must go."

With advisors, the press, his wife, a doctor and many others in the entourage, Wilson's special excursion train headed west with stops all over the country. Speech after speech was given from the back of the train to huge, enthusiastic crowds. The trip took its toll on him, though, with headaches and asthma attacks affecting him in Montana and Colorado, including a collapse in Pueblo. Finally, when the train made it to Kansas on the night of September 25, his wife, Edith, was in her room on the train right next to Wilson's private compartment. "I feel terribly sick," the president said after knocking feebly on her door. Summoning Dr. Grayson, Edith and the doctor moved Wilson to a different room after he complained of feeling claustrophobic and his inability to sleep through his worsening headache.

Wilson finally fell asleep six hours later, but when he awoke, he insisted that he shave in order to speak in Wichita that day. Grayson urged Wilson's private secretary Joseph Tumulty that the president was seriously ill and they should return to Washington immediately.

After Wilson finished shaving and dressing for the day, Tumulty, Grayson and Edith urged him to cancel the trip. Wilson adamantly refused. If he gave up this trip, the Republican senators against his League of Nations would pounce and say he quit on his great quest. What Wilson didn't realize, though, is that nobody could understand what he was saying. His words slurred as the left side of his body went numb. Saliva drooled out the left side of his face and onto his suit. Grayson and Tumulty begged him to cancel, and Wilson continued to refuse, saying, "If we cancel this trip, Senator Lodge and his friends will say I am a quitter, that the trip was a failure." Wilson tried to move closer to the men to assure them that he was fine, but realized that the left side of his body could not move. He further insisted that he would take a break that day and continue the next. Edith finally put her foot down and told him it was time to go home. The president finally gave in after she intervened. His face was pale and drooling uncontrollably now, in the throes of a stroke.

It was in that moment that President Wilson realized that Wichita was his last stand. He would not be able to fight for his precious league any more and quietly relented. He then wept into his one good hand at the lost opportunity. What Wilson didn't know is that Wichita was not just the end of the road for his league but also for his future health. Just days later, on October 2, he suffered a massive stroke at the White House and was completely paralyzed on his left side. For the next seventeen months, Edith and Dr. Grayson conspired to hide his bedridden condition from the entire nation. As he lay in his bed near death, the president could only give her the most basic verbal instructions, and he could barely sign his name. He eventually recovered to a degree but was never fully the same. The Senate rejected the Treaty of Versailles and the League of Nations provision. Had Wilson been able to carry on in Wichita and subsequent stops, perhaps his push for the league would have been different. Wilson was right in believing that a strong league with an involved United States could better keep the peace. The weak League of Nations that ensued failed to stand up to Hitler, and history has vindicated Wilson on that count.

JFK RELEGATED TO A HIGH SCHOOL CAFETERIA

Kansas is pretty much an afterthought in presidential campaigns and has been that way for a long time. The Republican candidate for president has won Kansas every year since Nixon in 1968. Even LBJ's triumph in 1964 was a blip after six straight elections won by the GOP dating back to 1940 when FDR pummeled Wendell Willkie nationwide but still lost Kansas. On the night of October 22, 1960, though, presidential candidate John F. Kennedy briefly visited Johnson County for about an hour. The location might be the strangest part of the whole deal, as he spoke in the Shawnee Mission East High School cafeteria in Prairie Village.

With just seventeen days to go until his historic nail-biter victory over Vice President Richard Nixon, Kennedy was campaigning hard. The day before, he and Nixon had held their final televised presidential debate, which was a novelty at the time, and then he hit the road. The next day, Saturday, October 22, he made a string of quick speeches in St. Louis, Joplin, Missouri, and Wichita, Kansas. His plane was hopping from stop to stop all day, as he had three speeches left to give that day in the Kansas City metro area. Over ten thousand people came to Truman Corners Shopping Center to hear him speak that afternoon. Marveling at the crowd, he hailed Kansas City's native son Harry Truman and was proud to speak at a place that was built on land formerly owned by the Truman family. After a quick speech, he headed up Highway 71 to downtown Kansas City. Thousands more lined the entire route, waving at him from intersections and overpasses.

Arriving at the city's famous Muehlebach Hotel, thousands more people swelled and waved to him as he entered briefly to freshen up right before 8:00 p.m. The Republican Party was even there as well to hand out pro-Nixon information and "set the record straight." U.S. Senator Prescott Bush (R-CT) was even there to promote the GOP. You might know him as the father of future president George H.W. Bush and grandfather of future president George W. Bush. After this brief visit, though, the real big rally of the night was about to take place down the street at Municipal Auditorium, Kansas City's downtown arena at the time. Nearly nine thousand people crammed into the building and were treated to former President Harry Truman and others extolling Kennedy as a candidate and urging citizens to vote the Democratic ticket. Kennedy entered to thunderous applause and spoke at 9:00 p.m. with a theme of renewing "American prestige." Wild enthusiasm and thick crowds met him as he left, with police needing to push back the surging masses of people who wanted a glimpse of the young candidate.

Kennedy's final event of the day was to be a quick speech at a fundraising dinner for second Kansas congressional district representative Newell George. George was in a tough reelection fight and even had to fight for JFK's aides not to cancel the final event of the night. It was pushing 10:00 p.m. and some of these aides wanted the candidate to get back on schedule and get ready for tomorrow's event in Green Bay. George won out, and the motorcade headed the ten miles southwest to Shawnee Mission East High School.

Presidential campaign stops can happen almost anywhere. We've all seen candidates yuk it up with random farmers at some café in Iowa or at a coffee shop in New Hampshire. This late-night trip to the Prairie Village High School, however, was one of those strange stops that almost didn't happen. Not only was Kennedy far behind in Kansas in the polls, but he also didn't necessarily need the candidates that he was there to support to win. The Democratic Party was mathematically going to keep control of Congress no matter how the November elections went, but Kennedy wanted to push his word as far as he could and to prop up Democrats where he could. Besides going there to support Newell George, he also was on a mission to help elect Frank Theis for U.S. Senator from Kansas and for Kansas governor George Docking to win a third term.

That evening, Shawnee Mission East High School was celebrating homecoming, so the large auditorium wasn't available for the candidate's speech. Thus, he was relegated to the cafeteria, where supporters shilled out ten dollars a plate for a turkey dinner. Entering the cafeteria without even being announced, the crowd soon jumped to their feet and applauded him when they realized he was in the room. Kennedy made a quick ten-minute speech describing his day of travel, the previous evening's debate, international relations and his opponent: "Mr. Nixon submitted a list, or his intimate advisers did, to some magazine this week, which gave his sure states. He gave us Massachusetts, I think, and Rhode Island. He named a good deal of the United States and among the states that he claimed was Kansas. My impression has been that this election was not until November 8 and Kansas did not make up its judgment until then. My hope is that Kansas will vote Democratic as it did in 1936." The crowd, which was lined up wall-to-wall, gave him a rousing ovation.

Many Johnson County residents were there that night, though, and share fond memories of the candidate shaking their hands or signing things for them. Eight-year-old Bruce Carter was taken there by his father and wondered why he was being told to dress in his Sunday best on a Saturday night. They met Kennedy that night, Carter recalls:

I remember that my father and my Uncle Joe got to shake Kennedy's hand, and they were thrilled. He shook my uncle's hand first and then my dad's. I was standing between them and a little behind them, but I was close enough to get a really good look. I remember being impressed by how personable Kennedy seemed to be. He was dressed like a wealthy man but he did not come across that way. I later learned this was called "charisma." It was the first time that I realized that there was some other men's after-shave that wasn't Old Spice. I don't know what it was, but it wasn't Old Spice. I'm sure it was something pretty expensive.

Over one thousand people stood outside the cafeteria as well, trying to get a glimpse of the candidate through the windows. After the quick remarks, the candidate shook hands, signed autographs and worked his way back to the motorcade—surely exhausted from the day's campaigning. He left for his car to applause from people up and down the street outside the high school and headed back to Richards-Gebaur Air Base. His next stop was in Green Bay, Wisconsin, where he would give more speeches. At least there he got to hang out with Vince Lombardi, with the admiration flowing both ways.

Such is the life of a presidential candidate, with continuous jumping from plane to plane, speaking at shopping centers and glad-handing strangers all day. Perhaps JFK thought that extra push in Kansas would help, but it was pretty much ineffective. Nixon carried Kansas with over 60 percent of the vote. Not only that, Nixon also doubled JFK's vote tallies in Johnson County, and all three candidates Kennedy supported lost. Docking lost reelection for governor, George lost reelection for Congress and Theis lost his Senate bid. JFK couldn't even outshine a Johnson County homecoming dance. He got his victory nationwide, though, so let's call it a wash.

AMBROSE HECKLES NIXON

Nearly every American with an interest in history know the name Stephen E. Ambrose. He is one of the bestselling historians of all time, with dozens of notable works to his name such as *Undaunted Courage*, his dramatic retelling of the Lewis and Clark expedition, and *Citizen Soldiers*, a chronicle of the average American soldier who fought in western Europe after D-day in World War II. He was instrumental in the creation of the National World War II museum in New Orleans, and the Tom Hanks miniseries *Band of*

Brothers was modeled after one of his books. What many people don't realize, though, is that he was once a professor at Kansas State University—and was pressured to resign after publicly heckling President Richard Nixon.

The late 1960s and early 1970s were chaotic and divisive times, famous for Vietnam War protests, civil rights demonstrations and general nationwide campus unrest. When Richard Nixon made his great political comeback to win the presidency in 1968, his pledge to bring "law and order" spoke to many of the "silent majority" who supported the president and were fed up with protests and demonstrations. The war continued in 1969, and demonstrations in Washington, D.C., San Francisco and other urban centers often attracted as many as 500,000 supporters.

Kansas was not immune to such counterculture thinking, with Lawrence being a hotspot of antiwar demonstrations and teach-ins, led by members of the University of Kansas community. Many newspapers editorialized that these demonstrations against the war gave "aid and comfort to the enemy" and were often attended by only 150 to 300 people. The following spring of 1970, though, saw another surge of nationwide unrest. Nixon's incursion into Cambodia expanded the increasingly unpopular war and the student union building at KU was torched on April 20, collapsing the roof and causing over $1 million in damage. This was one of many incidents that week, including a fraternity house set on fire and a furniture store firebombed. The April 24, 1970 edition of the *Iola Register* in Iola, Kansas, ran an editorial full of indignation that called for punishment of those found guilty of such crimes:

> *"Black, brown, and yellow students are members of minority groups which have been troublesome in the past and have been involved in numerous protests. Those individuals who can be positively identified as trouble makers are put in jail with the first group* [those the author identified as not being able to prove where they were the night of the fire]. *The others, it seems clear, should be expelled. Expulsion is proper, it is explained to the public, because it has been demonstrated that these groups tend to be unhappy with things as they are.*

The May 4, 1970 killing of four student protesters at Kent State University by the Ohio National Guard further enflamed the antiwar students in universities nationwide. In the days just before the killings, President Nixon referred to campus protesters as "bums," and people on all sides expected the protests to continue into the fall. When Nixon

was invited to Kansas State to give that year's speech at the annual Alf Landon Lecture Series, he decided that it would be a safe photo-op, as Kansas State was one of the quietest and most middle American and trouble-free campuses in the nation. The lecture series, named after former Kansas governor and 1936 GOP presidential nominee Alf Landon, was a yearly who's who of American political life, with previous speakers such as George Romney, Nelson Rockefeller, Ronald Reagan and General W.C. Westmoreland. Nixon and his aides saw this speech as the perfect opportunity to get a favorable photo-op of the president with campus supporters who weren't against him.

On September 16, 1970, President Nixon arrived in Manhattan, Kansas, and spoke at Kansas State's Ahearn Fieldhouse. The capacity crowd of 15,500 guests, students, faculty and city leaders packed the arena to hear the president, and those who couldn't get in listened on loudspeakers outside. One of the faculty members who made it into the arena to hear the president speak was a new history professor—Stephen E. Ambrose. Having just came to Kansas State for his first year of his professorship, he was surprised to find a few outcast civil rights and antiwar activists in a town that still had a 1950s mindset.

When Nixon reached the stage, he was introduced by Alf Landon himself and was given a warm and respectful greeting from the crowd. Nixon praised Landon as an elder statesmen of the Republican Party and of America and then talked at length about America's great "moral and spiritual crisis." He likened the bombings and burnings on campus to Palestinian terrorism and said that destructive activists were a cancerous disease spreading across America and that they threatened to undo higher education.

Though campus bombers targeted unoccupied buildings as political statements, such as ROTC buildings or labs that made chemicals for ordnance uses for the military, Nixon railed at them as having "contempt for human life." About this moment in the speech, a few hecklers started shouting out at Nixon from the back of the auditorium. There were catcalls about his bombing and invasion of Cambodia for the last few months, and his hypocrisy in denouncing the violence on campus was pointed out. Ambrose threw out a few catcalls of his own after thinking, "Here's a fine one…to be lecturing us on bombing." Ambrose was incredulous that Nixon chose to focus on campus violence when newspaper headlines that very morning reported record bombings in Southeast Asia. His wife joined in the heckling as well. The hecklers were far outnumbered by the crowd, but they surely annoyed and scandalized the university.

The administration at Kansas State, embarrassed and angry at the way the president was treated at the signature lecture series, intended to suspend the twenty to forty hecklers once they were identified. They later dropped that idea due to either the possibility of making martyrs of them or because of insufficient evidence. Ambrose was noticed, though, as he was a notable and distinguished historian in his own right by that time. He had spent his recent years interviewing former President Eisenhower and had written a biography of him. Following the incident, Ambrose and his wife became social outcasts in Manhattan because of it. The university, clearly displeased with him, pressured him to resign and gratefully accepted his agreement to leave and take a position at Louisiana State University the following year after finishing out his year at Kansas State.

Wealthy Nixon backers such as insurance executive W. Clement Stone, Pepsico and Reader's Digest paid to have Nixon's speech rebroadcast on national television, where it was well received by a majority of viewers. This was Nixon's "campus moment" to show he had support at universities. This, plus a national poll that showed 90 percent of the public thought campus protests were mostly or completely unjustified gave Nixon the confidence he needed to continue the path in Vietnam and to reelection in 1972.

In later years, Ambrose and Nixon basically traded places in the public's eye. Nixon, once seen as a "law and order" conservative, was famously undone by his criminal activities in the Watergate scandal, never to fully recover his reputation. Ambrose, on the other hand, went from being seen as a left-wing focused historian who criticized U.S. environmental policies, treatment of Native Americans and foreign policy with Mexico to one who came to appreciate more and more the good side of America and the great people who made it what it is today.

His later change to focus on presidents and the military struck some of his peers as "old-fashioned." He did gain immense popularity, though, with most of his books being *New York Times* bestsellers and selling millions of copies. He became so successful that he was able to write full time and became a household name through appearing in multiple documentaries and films. His consulting work with Spielberg was fruitful, and he helped promote *Saving Private Ryan* as well. He was later criticized for sloppy source citations, but it didn't hamper his influence or sales.

Years after those tumultuous days, Ambrose's publisher, Simon & Schuster, suggested that he embark on a three-volume biography of Nixon. He was initially unhappy about the idea and told his editor, "I don't even like the guy." Ambrose got to work on the project and eventually found

some positive qualities of Nixon that he never appreciated. Though he never actually spoke with the former president, Ambrose always chuckled at a line Nixon said to Charlie Rose during an interview from the early 1990s. When asked if he ever read Ambrose's biographies of him, Nixon replied that Ambrose was "just another left-wing historian." Ambrose always loved quoting that line to people, because in quoting it he could always add, "Eisenhower didn't think so!"

On April 19, 2001, Ambrose was the invited speaker at the 120th Landon Lecture. He said that it was surreal to come back to deliver an address at an event at which he once caused a self-inflicted professional injury on himself. His topic? A tribute to "American of the Twentieth Century" Dwight Eisenhower—Nixon's boss.

THE ANTIWAR MOTHER OF AMERICA'S GREATEST GENERAL

Dwight D. Eisenhower is arguably one of the most influential Americans of the twentieth century. Not only did he lead the most massive and complex land, sea and air force the world had ever seen against the Axis powers, but he had to do it across two continents, multiple seas and a major ocean and with multiple Allies. On top of that, he was a successful two-term president whose steady hand kept America safe, but competitive, with the USSR during the Cold War. Though he was a warrior, Ike never relished the role or gloried in it. It's likely that he got this trait from his pacifist parents back in Kansas.

Eisenhower's parents, Ida and Jacob, were transplants to Kansas from the East Coast, having married in Lecompton, Kansas, on September 23, 1885, on the campus of Lane University, their alma mater. Due to economic conditions, the family moved to Texas for a time, where Ike was born in 1890, before returning to Kansas. They settled in Abilene, with his father working as a railroad mechanic and later at a creamery. With seven boys, the Eisenhowers had a lot of young minds to influence.

The household was devoutly religious, with Eisenhower's mother setting aside times at breakfast and supper for Bible readings every day. Ike's parents were previously members of a Mennonite sect and later joined the International Bible Students Association, which became the Jehovah's Witnesses. Pacifism was strongly preached in the household, and the home served as the local meeting hall for their faith from 1896 to 1915.

Young Dwight Eisenhower, the future thirty-fourth president, in 1907. He grew up in Abilene. His decision years later to attend West Point saddened his mother. *Courtesy of the National Archives.*

Ike was more interested in reading mom's old history books—especially the ones covering military history. When he wasn't hunting, fishing or camping outdoors, he had his nose in a history book. Ike was athletic and did well in school, and to the great consternation of his mother, he was accepted to the U.S. Military Academy at West Point. She was deeply saddened that her son chose the art of war as a profession, thinking it to be "rather wicked." Though pacifists, they also promoted independence and didn't overrule Ike and he was allowed to go. Ike graduated in 1915, and his military career from then on was on an upward trajectory. Ike never joined any church or religious organization until being baptized into the Presbyterian Church in 1953.

It's likely that Ike's parents' pacifism influenced the way he conducted warfare. His small-town humility followed him and served him well later when he had to deal with peacocks such as George S. Patton and British field marshal Bernard Montgomery. He had the patience to put up with their egos and never forgot that his primary mission was to keep the Allies working together smoothly. Never feeling the need to show off like Douglas MacArthur, he had the rare quality of displaying quiet confidence and never resorted to posturing. He carried this cool-headed approach into the presidency, where he kept a skeptical eye on what he considered to be the Pentagon's reckless spending. In his farewell address to the nation in 1961,

he warned the nation that a "military-industrial complex" had grown in Washington and to be wary of its influence. No doubt his parents' distrust of war rubbed off on Ike. He was a warrior—but a calm and reluctant one at that. Having a hothead in the Oval Office during the 1950s height of the Cold War could have been disastrous. In one perfect anecdote, he was taken to a massive underground presidential fallout shelter and pressured to spend massive amounts on more nationwide. He remarked, "Good God, I didn't realize we were this scared." He subsequently used it as an indoor driving range and refused to get sucked into spending on the military simply through fear.

FROM KANSAS TERRITORY INDIAN RESERVATION TO VICE PRESIDENT

Maybe one of the most interesting biographies in American history belongs to Charles Curtis, the thirty-first vice president of the United States. As Herbert Hoover's vice president from 1928 to 1933, Curtis was the first person with significant Native American heritage elected to high office in the executive branch. Not bad for a guy born on an Indian reservation.

Curtis's mother Ellen Papin was of Kaw, Osage, Potawatomi and French ancestry and gave birth to him on January 25, 1860, on Kansa/Kaw land that would later become North Topeka. Kansas was named after the Kansa/Kaw tribe, which controlled vast territory across Kansas, Nebraska and even parts of Iowa, Missouri and South Dakota. His father, Orris, was an Indianan

Left: An 1857 Conference of Kaw Indians with the U.S. Commission of Indian Affairs. Wood engraving from the *Illustrated London News*, April 25, 1857. *Courtesy of the Library of Congress.*

Opposite: Mon-Chonsia, *A Kanza Chief* by McKenney & Hall, 1842. The federal government considered him the principal Kanza chief in the 1820s. *Courtesy of the Library of Congress.*

of English, Welsh and Scots descent. Curtis could trace his mother's lineage to Chief Mon-Chonsia (White Plume) of the Kaw and Chief Pawhuska of the Osage. So in essence, his mother was an Indian princess.

Though she died when he was three, he stayed at the Kaw reservation in his early years and spoke Kansa and French. Curtis's father was off and remarried, coming and going at times. He was even captured and imprisoned during the Civil War in 1863. Young Charles saw his own action

Charles Curtis, thirty-first vice president of the United States, 1929. Half Kaw, he was the first person of native ancestry in office in the executive branch. *Courtesy of the Library of Congress.*

back on the reservation, though. On June 1, 1868, one hundred horse-riding Cheyenne warriors stormed the Kaw reservation. The Kaw warriors rode out to meet them as the frightened white settlers retreated to Council Grove. The Cheyenne and Kaw traded bullets and arrows for a few hours, shouting war cries and facing off against each other. The Cheyenne left with a few stolen horses after merchants in Council Grove offered some sugar and coffee to broker a truce. Young Charles was there that day, riding with a Kaw interpreter sixty miles to Topeka to seek the governor's intervention in the rivals' dispute.

Curtis lived on the reservation with his maternal grandparents for much of his youth but later lived with his paternal grandparents in Topeka, where he graduated from Topeka High School. Curtis never denied his Native American roots and rose in the Topeka legal community after passing the bar in 1881 and acting as an attorney until 1889. At age thirty-two in 1893, he began his political career as a U.S. congressman. He later steadily worked his way up to U.S. Senator, majority whip and majority leader over the next three decades. When he was selected as Hoover's vice presidential running mate in 1928, he helped Hoover win a landslide election over New York governor Al Smith.

Curtis hadn't forgotten his roots, though, and had a Native American jazz band play at his inauguration. As the first Native American in elected high office, he decorated his office with native artifacts and was matter-of-fact about his background. There are even photos of him posing with a headdress. It's quite a life when you're born on a territorial reservation and you close out your days a heartbeat away from the highest office in the land.

9

CIVIL RIGHTS AND SOCIETAL PROGRESS

LANGSTON HUGHES AND HARPER'S FERRY

Many of us know of Langston Hughes as the famed African American poet, social activist, playwright and novelist who was a leader of the Harlem Renaissance in New York City. His work spanned decades and inspired many people to be proud of their culture and ancestry and to strive for the acceptance of people of all races and walks of life. Many are unaware, however, of his connection to Kansas—and to John Brown's raid on Harper's Ferry in 1859.

Born in Joplin, Missouri, in 1902, the young Langston Hughes was raised mainly in Lawrence, Kansas, following his parents' separation. His father, sick of racial discrimination and lack of opportunities, left the United States for Mexico, and his mother was often traveling seeking employment. In Lawrence, he was left in the care of his grandmother Mary Sampson Patterson Leary Langston, who was near seventy years old when he came to live with her. Mary Langston was a proud, lonely, elderly woman who seldom went out and instilled in Langston a pride in being black and refusing to accept a second-class status. Though she expressed little emotion, she wistfully told him many tales of days past when she worked on the Underground Railroad helping fugitive slaves and her marriage to Sheridan Leary—one of John Brown's raiders who led the assault on Harper's Ferry, Virginia.

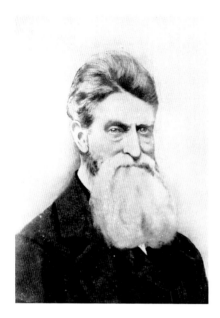

John Brown photographic print, 1859. Brown made national headlines for his violent retaliations against proslavery guerrillas in Kansas in the 1850s. *Courtesy of the Library of Congress.*

One of Mary Langston's most prized possessions was a shawl that belonged to Sheridan Leary. She told young Langston that this shawl was given to her after someone rode up to her door and told her that her husband was dead. She had no knowledge that Sheridan was involved in any plot at Harper's Ferry, but that event was a seminal moment in her life. The bullet-riddled shawl was sometimes laid over Langston on cold Kansas winter nights to keep him warm. Some historians have suggested that Sheridan was buried in his shawl and that this was a different one, but as with oral and family histories, the facts are impossible to corroborate.

Born in North Carolina in 1835, Leary was from a prosperous family of free blacks who traced their ancestry to an Irish veteran of the Revolutionary War named Jeremiah O'Leary. His parents, thanks to smart land investments and his father's artisanal skills, became affluent and raised him and his five siblings in a fine house. The children lived a life of advantage that most blacks in the antebellum South could only dream of. They were educated by private tutors, attended social dinners and even had black servants—some were even slaves. Leary's father would even purchase slaves at auction and allow them to work for their freedom.

Young Sheridan Leary, in contrast to his parents, disdained any accommodation with the institution of slavery, and this may have facilitated his departure from the South in 1854. Some family lore says that he left after a falling-out with his father; other tales say that he fled after beating a white man who was abusing a slave. Either way, his father disinherited him and two of his sisters for leaving for Ohio.

Hughes's grandmother Mary Sampson Patterson, also from North Carolina, was a free woman of African, Indian and French heritage—complex background not unlike Sheridan Leary's. She was vulnerable to attempts from whites to enslave her and, like many other southern blacks, left for the

North in 1857. Settling and going to school in Oberlin, Ohio, she met and married Sheridan on May 12, 1858. Not much is known of their courtship, but it is likely that they knew each other as youngsters in Fayetteville, North Carolina. They had a passionate belief in the liberation of the black race and together served as conductors on the Underground Railroad, sheltering fugitive slaves heading from the South up to Canada. She soon quit her studies and gave birth to their only child, a daughter named Loise (who would later become Hughes's aunt) in February 1859.

Having met fiery antislavery warrior John Brown in Cleveland, Sheridan was recruited (unbeknownst to his wife) as one of twenty men to partake in Brown's raid on the federal arsenal on Harper's Ferry, Virginia, on October 16, 1859. Their goal was to capture thousands of federal guns and march into the South, distributing them to enslaved blacks and starting a slave insurrection.

The raid on Harper's Ferry went fantastically awry, as two of Brown's men guarding a bridge shot a railroad bagging agent, alerting the town of their raid and soon causing church bells to ring in alarm. The local militia assembled, and Brown and his men were surrounded. U.S. Marines led by Colonel Robert E. Lee and Lieutenant J.E.B. Stuart arrived the next day. On October 19, the soldiers overran Brown and his followers, killing ten of his men and two of his sons.

Leary and two other men, having withheld several attacks on the rifle factory that they occupied, realized their situation was hopeless and their ammunition was low. They decided to make a run for it and fled through the factory's back door. The fast-flowing Shenandoah River was their only hope of escape, should they be able to swim across it. After firing a round, they plunged into the water. One man, Kagi, was killed by a shot to the head. Leary made it to a rock in the middle of the river as militiamen fired at them from the banks and was "shot through the body." Other militiamen waded in after them. The third man, Copeland, reached the rock and surrendered.

Leary was dragged to shore where an enraged crowd called for him to be lynched, but he was taken to a nearby building, where he died after suffering for ten to twelve hours from his wounds. His final wish was to tell a newspaper reporter to send word to Mary and Loise about how he had died. His remains and those of the other slain raiders were placed in two large wooden crates and buried in an unmarked grave half a mile outside of the town.

This takes us back to the story of the shawl. A few weeks before the raid, some sympathizers of Brown from Philadelphia sent "great blanket shawls"

to the Kennedy Farm, a farm where the raiders plotted their actions and prepared themselves for battle. On the night of the raid, each man in the group had taken a shawl and used them as overcoats. Langston Hughes said of the shawl that

> *Sheridan Leary wore this shawl when he went from Oberlin, Ohio, to join John Brown in order to help him create the slave revolt which they hoped might free the Negroes. At Harper's Ferry Leary was killed and left to lie for a long while in a muddy ditch, but some good person took his shawl and sent it back to Oberlin to his widow, Mary Sampson Patterson Leary, who later became Mrs. Langston, my grandmother.*

After Leary's death, Mary later married another abolitionist and a friend of Leary's, Charles Langston, who was the father of Langston Hughes's mother Caroline. Caroline married James Nathaniel Hughes, and they had one child: James Mercer Langston Hughes. Though his mother, Carrie, was not the daughter of Sheridan Leary, he had a special attachment to the shawl worn during the raid. He later wrote a poem, "Aunt Sue's Stories," inspired by what his grandmother told him when he was young:

Aunt Sue's Stories
By Langston Hughes

Aunt Sue has a head full of stories.
Aunt Sue has a whole heart full of stories.
Summer nights on the front porch
Aunt Sue cuddles a brown-faced child to her bosom
And tells him stories.
Black slaves
Working in the hot sun,
And black slaves
Walking in the dewy night,
And black slaves
Singing sorrow songs on the banks of a mighty river
Mingle themselves softly
In the flow of old Aunt Sue's voice,
Mingle themselves softly
In the dark shadows that cross and recross
Aunt Sue's stories.

And the dark-faced child, listening,
Knows that Aunt Sue's stories are real stories.
He knows that Aunt Sue never got her stories
out of any book at all,
But that they came
Right out of her own life
The dark-faced child is quiet
Of a summer night
Listening to Aunt Sue's stories.

Langston wasn't showered with affection by his grandmother, so he retreated into the world of books, which also later influenced his writing. He did, though, take her stories and her commitment to social justice from her. When Teddy Roosevelt came to Osawatomie, Kansas, on August 31, 1910, to dedicate John Brown Memorial Park and deliver his famous "New Nationalism" speech, Mary and Langston were seated on the dais, as she was a guest of honor, being the only surviving Harpers Ferry widow. That left an impression on young Langston. He also admired her commitment to her

Theodore Roosevelt speaking in Baldwin, 1910. He was in Kansas to promote his "new nationalism" ideas of human welfare central to his 1912 presidential campaign. *Courtesy of the Library of Congress.*

own dignity. Lawrence, Kansas, though founded by abolitionists, had slipped from its brave young days into a typical segregated town by the late nineteenth century. Mary even refused to go to church once they were segregated.

Mary died in 1915 when Langston was thirteen years old. He later wrote in *The Big Sea* that he didn't cry at her funeral. He didn't think that was appropriate for her: "Nobody ever cried in my grandmother's stories. They worked, or schemed, or fought. But no crying. When my grandmother died, I didn't cry, either." His grandmother was tough, and he knew she would want him to be that way as well.

He inherited the shawl and took it with him in the years after. He kept it in a safe deposit box in New York City. In 1930, his mother was in dire financial straits and suggested he sell it. She wrote to him, "Say here in Cleveland antiques are all the rage and I was just wondering if we could not sell the Harper's Ferry Shawl? I almost know we could and it would give us all a few dollars. Do you know where it is or do you have a receipt or anything for it. A man told me here last week I ought to get $500.00 for it. I have been in some of the antique shops here and they have old rugs, spreads, quilts, etc. I don't know just thought I'd ask about it."

The shawl was later kept in Harlem with some friends, and he was horrified to learn that a janitor was allowing water to drip into the basement storage area, ruining some of the cherished belongings that he stored there. The shawl was undamaged, but he decided it was time to properly save it for good. He donated it to the Ohio Historical Society, where it safely resides today. In his note to the society, he says he "thinks they would be safe in dating the shawl at thirty to forty years preceding John Brown's raid, certainly the first quarter of the 1800s." The history of this object and that moment in time came often to his mind. In 1931, he wrote a poem, "October the Sixteenth," in honor of the anniversary of the raid:

> *Perhaps*
> *You will remember*
> *John Brown.*
> *John Brown*
> *Who took his gun,*
> *Took twenty-one companions,*
> *White and Black*
> *Went to shoot your way to freedom.*

Kansas-raised poet Langston Hughes. Photo taken by friend and fellow Kansan, Gordon Parks, in 1943. *Courtesy of the Library of Congress.*

Though Hughes lived in several places around the Midwest during his youth, including Kansas, Illinois and Ohio, he always considered Kansas to be his home. He once came to Lawrence later in life and told an audience, "I sort of claim to be a Kansan because my whole childhood was spent here in Lawrence and Topeka, and sometimes in Kansas City." Though many of his childhood years were lonely, he was shaped by them and grew an affinity for black culture that he might not have gotten had he not lived with his grandmother. Some children in Lawrence to this day spend their school years at Langston Hughes Elementary School.

WILLIAM ALLEN WHITE VERSUS THE KKK

William Allen White (1868–1944) of Emporia was a nationally respected author, columnist, progressive political leader and editor of the *Emporia Gazette*. His editorials appeared in many newspapers across the nation, such

Alarmed by the rise of the KKK, *Emporia Gazette* editor William Allen White came in third for governor in 1924 on an anti-KKK platform. *Courtesy of the Library of Congress.*

as his famous article "What's the Matter with Kansas?" With his plainspoken outlook and his sense of humor, he came to represent the values of "middle America." He had enough of a pull that visitors to his home in Emporia included actor Douglas Fairbanks and Presidents Theodore Roosevelt, Herbert Hoover and Calvin Coolidge. Having won Pulitzers, hobnobbed with presidents and even earning acclaim through his many published books, White wasn't afraid to get off his rear end and take on a threat when he saw one.

He was alarmed, though, by the reemergence of the Ku Klux Klan in Kansas in the 1920s. The Klan had made a resurgence in the South in 1915 and spread to many rural states, inciting nativist violence against not just blacks but also Catholics, Jews, immigrants and anyone else that they deemed immoral or "Un-American." Many states outside the South had a huge Klan movement, even Indiana, where historians estimate that half of the state legislature under Klan-aligned Governor Edward L. Jackson were Klan members themselves. An estimated one-third of all men in that state were Klan members in the early 1920s.

By 1924, the mayor of Emporia, as well as the chief of police and the majority of his department, were Klan members. Reporters were often kicked out of town when attending their meetings, and thousands of men in the area were secretly joining the KKK. He received threats from them and refused to back down in articles about them. White wanted to draw attention to them, and urged political friends of his to run for governor of Kansas and expose the group. When nobody wanted to, he ran for the office himself. He was frustrated that the Republican candidate was courting the Klan vote and that the Democratic candidate, though anti-Klan personally, wouldn't speak out against them.

White had no political campaign war chest, but he was so respected that he easily got the ten thousand signatures needed to run. Running as an Independent, his son drove him around the state in their Dodge to speak. He passionately spoke of the rotting influence of a "secret society based upon

prejudice" and depended on supporters for food and a room while traveling. He received his share of death threats and even had a burning cross thrown at him during a speech in Cottonwood Falls.

On Election Day, White came in third with 149,811 votes. The Republican candidate, Ben Paulson, defeated Democratic incumbent governor Jonathan M. Davis 323,402 votes to 182,861. Though White knew he probably wouldn't win, he definitely raised awareness of the Klan and their slide into the state. Not long after, the Kansas legislature banned the Klan from conducting business in the state. The Klan soon after lost influence nationwide after a series of scandals, followed by published membership lists leaking to newspapers. White had the victory he wanted.

THE KANSAS HOUSEWIFE WHO SPARKED SCHOOL DESEGREGATION

When Esther Swirk Brown (1917–1970) heard how inferior the school was that her black maid's children went to, she was appalled. The community of South Park, in suburbanizing Johnson County, had recently built a brand new, modern school for the 222 local white children. The 44 local black children went to the Walker School, a school with subpar classroom materials, inferior heating, dirt floors and no indoor plumbing. There was not even a high school option for black children either. In 1947, Esther was a normal thirty-year-old Merriam, Kansas housewife. Her husband was an U.S. Army Air Corps veteran, and they had two small children. Being the daughter of Jewish Russian immigrants, though, Esther had felt the sting of discrimination before and empathized with the African American children of the county.

Raising the issue at an all-white school board meeting, she was met with jeers and name-calling and was even hit with an umbrella by an angry woman. Refusing to be intimidated, she told the crowded gymnasium, "Look, I'm just a Kansas housewife," she said nervously. "I don't represent these people, but I've seen the conditions of their school. I know none of you would want your children educated under such circumstances. They're not asking for integration, just a fair shake."

Soon after, Brown met with African American residents of the county and raised money for a legal case against the school district. Not only did she go door-to-door to raise funds, she also promoted the case at a Billie Holiday concert. The local chapter of the NAACP got involved, and they organized a boycott of the Walker School. Brown received backlash soon

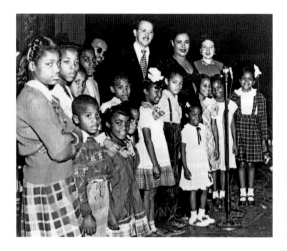

Billie Holiday with schoolchildren in Merriam, between 1940 and 1950. To her left is Esther Brown, an activist who spearheaded *Brown v. Board of Education.* *Courtesy of the Library of Congress.*

after, with a cross burned in her yard, her husband being fired from his job—by his own father—telephone threats and even an FBI investigation into whether she was a communist. The investigation charged that she had "actively agitated Negroes, getting them to assert right to send children to school for white children." Her bravery was contagious, and black families in the county were inspired to stand up as well. Being the late 1940s, this was unprecedented. The civil rights movement hadn't even reached nationwide levels of organization and *Brown v. Board of Education* wasn't until 1954.

Black attorney Elisha Scot Sr. represented the black families in the legal case against the school district. Both a lower court and the Kansas Supreme Court ruled that the Walker School facilities were inferior. The ruling in the 1949 case, *Webb v. School District No. 90*, was a victory, and the African American children were allowed to attend South Park Elementary without incident. Riding on this success, Brown helped the NAACP continue the push against school segregation during the next few years, culminating in the landmark *Brown v. Board of Education* ruling. She's not the namesake of the case, though, that would be plaintiff Oliver Brown, no relation.

Esther Brown continued her civil rights work in Wichita and Topeka and elsewhere until her death from cancer in 1970. Years later, Linda Todd, the secretary of the Topeka NAACP, said, "I don't know if we could have done it without her." Alfonso Webb, the father of the lead plaintiff, said that it took a white woman to step up to the system because blacks were too scared. "We were scared from history, scared from experience, scared from not enough experience," he said. Her activism was years ahead of its time, and she deserves more recognition for getting the ball rolling nationwide.

FIRST WOMAN ELECTED TO MAYOR IN THE UNITED STATES

It took decades for the women's suffrage movement to gain ultimate success in 1920, when women were finally granted the right to vote nationwide. Kansas was not immune to these movements and had its own local suffrage chapters. In 1877, women in Kansas had gained the right to vote in city municipal elections, and it didn't take long for their influence to be felt.

Susanna Madora Salter was a wife and mother of young children in Argonia (population five hundred), where she worked as an officer in the local Woman's Christian Temperance Union. Some of the men in town thought it would be funny to put her name on the Prohibition Party ticket, thinking she would lose. They were incensed at the intrusion of female voters into their domain. Little did they realize she would actually win with two-thirds of the vote on April 4, 1877. This election win came just weeks after women were enfranchised. Other local offices were won by women, showing the power of their vote.

Though not expecting to ever be mayor, and not even originally seeking the office, Susanna performed her duties admirably. She was also no fool—she was only six weeks shy of graduating college at Kansas State Agricultural College (Later Kansas State University) when she fell ill and had to drop out. She brooked no nonsense during meetings and was no novice to politics. Though she was just twenty-seven years old, her father was the town's first mayor and her father-in-law, Melville J. Salter, was once the lieutenant governor of Kansas. Her husband acted as city clerk as well, so she knew how things worked.

Some of the men who put her up for the nomination were city council members and were surprised when she opened the first meeting by saying, "Gentlemen, what is your pleasure? You are the duly elected officials of this town, I am merely your presiding officer." The men were surprised at how well she did and got along with everyone. She served an uneventful year as mayor and was an international sensation and curiosity. She received congratulatory mail from all over America and also from many European nations. Newspapermen from the coasts came to Argonia to write about her. One New York reporter wrote:

> *I asked Mrs. Salter if her ambition to act as a female politician or leader in woman suffrage circles had been aroused by her election. She quickly replied, "No, indeed, I shall be very glad when my term of office expires,*

Suffragettes in Kansas gained the franchise in municipal elections in 1887 after much campaigning. Argonia's Susanna Salter was the first female mayor elected in America. *Courtesy of the Library of Congress.*

> *and shall be only too happy to thereafter devote myself entirely, as I always have done heretofore, to the care of my family." And in conversation with a number of business men in Argonia I found a very general disposition to rest on the laurels now won as the only American town which ever tried the experiment of a woman Mayor.*

Once her term expired, Susanna declined to ever run for office again. The family relocated to Oklahoma, and she lived to the ripe old age of 101. She did return to Argonia, though, in 1933 to be honored with a bronze memorial plaque mounted on a stone base in the public square. America's first female mayor started as a joke and ended as a dignified success. In addition, she also gave birth to her fourth child while in office.

QUIRKY STORIES

BLIZZARD OF 1886

The most crippling and deadly succession of blizzards in Kansas happened at the start of January 1886. Heavy snows and unceasing prairie winds combined to bring the temperature to 30 degrees below zero. Snow drifts of up to six feet piled up across the state, and it is estimated that nearly one hundred Kansans died during the storms. Many people froze to death outside of their homes simply due to the whiteout conditions and the fact that they couldn't even see their hands in front of their faces. Others died in flimsily constructed homes that weren't insulated enough to keep out the cold. Cattle died by the thousands as they turned away from the whipping winds and walked continuously to escape it, often collapsing due to hunger or exhaustion. Sheep and pigs also froze to death by the thousands. Some counties reported over 80 percent of their livestock dead due to the blizzards.

Many of the stories of people frozen to death are hard to imagine. In Minneola, two young ladies and their mother left their house, which was filling with snow, to head to their brother's home to ride out the storm. The next morning, all three were found huddled together, the mother the only survivor and with frostbitten feet. Some people were found in their dugouts; others were found within fifty feet of home. One homesteader in northwest Kansas froze to death with his team of two horses less than one hundred feet from home. Near Oberlin in Decatur County, a farmer, his wife and

Interior of the last dugout home in Smoky Valley, 1909. Dugouts were a common sight in Kansas' first fifty years as a state and usually could protect people from the elements well. *Courtesy of the Library of Congress.*

their six children froze to death as well. Stories such as these were common, as weather reports at the time were often inaccurate or nonexistent. Couple that with the quick onset of some storms and even the most seasoned settler could be caught in whiteout conditions in a few moments' time.

Besides the tragedy of the blizzard, the day-to-day business of life was inconvenienced as well. Trains were snowbound by the dozens, and one even froze to the rails. On January 20, a passenger train full of tourists heading to California via Boston was stranded along with an Atchison, Topeka and Santa Fe passenger train near Kinsley, Kansas. Snowbound for three days and running out of food, they were fortunate to get a breakthrough with the snow and were taken to Kinsley. Luckily for the 270 people heading west, Kinsley was a town full of caring people. The townsfolk in the tiny town of 1,500 took all of the passengers into their homes and kept them warm and entertained for the next few days. The town put on games, plays and meals and soon made fast friends with many of the well-to-do travelers in their midst. In some cases, lifelong

friends were made, with townsfolk going to visit their "blizzard train friends" years later. They even published a special-edition newspaper called the *B-B-Blizzard*, recounting the goings-on that week. It was surely the most exciting thing that town had ever seen.

ROUTE 66

Route 66 is the most famous road in the United States, with its cultural significance long outlasting its use as an east–west route across the country. The road begins in Chicago, Illinois, and spans an incredible 2,448 miles across eight states before ending at Santa Monica, California. It was the first major highway and inspired the romantic "open road" mythos of freedom on wheels, which played out in many books, songs and films. What many people don't realize, though, is that Route 66 goes through Kansas. OK, it only goes through Kansas for thirteen miles, but it still counts. What people realize even less is that the town in the hit Pixar movie *Cars* was partially inspired by Baxter Springs, Kansas, and the character Tow Mater was based upon a real tow truck in Galena.

In John Steinbeck's classic *The Grapes of Wrath*, Route 66 is referred to as "The Mother Road." Over the years, others have dubbed it the "Main Street of America" or the "Will Rogers Highway." Whatever you want to call it, the highway was established on November 11, 1926, as one of the original highways within the U.S. Highway System. Early proponents (mainly Kentuckians who stood to profit) of a national road from east to west proposed a Virginia to California path. The Chicago to California plan won out in the end, though, as access to the West from one of the nation's major cities was a winning consideration. After the road passes St. Louis and the hills of southern Missouri, its wide-open, flat "endless landscape" vibe begins in Kansas in Cherokee County, the "corner" county at the extreme southeastern part of the state.

Route 66 exploded in popularity and use in the 1930s as the easiest way to head west. As traffic grew, the economies of the communities that it passed through thrived upon the traffic. American roadside culture took off in this era, with drive-through restaurants, motels, mom-and-pop service stations, souvenir stands and quirky attractions dotting the route. During the Dust Bowl and Great Depression of that decade, many tens of thousands of destitute farming families took the road from Kansas, Texas, Arkansas and

Oklahoma to head for economic opportunities on the West Coast. These "Okies" were the ones Steinbeck mentioned in *Grapes of Wrath*.

Kansas was the first state to completely pave over its section of Route 66, accomplishing the feat in 1929. OK, maybe it was only thirteen miles serving people driving across Cherokee County between Joplin, Missouri, and Miami, Oklahoma, but a win is a win. By this time, Cherokee County had seen a lot of history, from Civil War battles to cattle drives and the growth of a local mining industry that included significant coal and zinc deposits. With the decline of that industry, the highway still supplied economic lifeblood for the county, with many businesses based un serving the thousands of cross-country travelers passing through. Once construction of the Interstate Highway System commenced in the 1950s, many sections of US 66 began their slow decline. Traffic drained off and shifted to other places once the interstate was king. Many parts of the famous route were simply paved over by new interstate as well. Kansas was bypassed completely, though, with many people in the area fighting a losing battle to keep the road alive. By 1985, the highway was officially removed from the U.S. Highway System. Surviving portions of the road have been deemed "Historic Route 66" and others designated as National Scenic Byways.

With the thirteen-mile stretch of the famous highway that Kansas can lay claim to, it seems almost as if some highway planner was just planning a little joke by including the state. Heck, it's not even mentioned in the famous song "Route 66" popularized by Nat King Cole and the King Cole Trio:

> *Well it goes from St Louis, down to Missouri*
> *Oklahoma city looks oh so pretty*
> *You'll see Amarillo and Gallup, New Mexico*
> *Flagstaff, Arizona don't forget Winona*
> *Kingsman, Barstaw, San Bernadino*
> *Would you get hip to this kindly trip*
> *And take that California trip*
> *Get your kicks on Route 66*

Kansas is used to being passed over, but if you give the state thirteen miles, the people will make the most of it. The citizens of the three towns it passes through—Galena, Riverton and Baxter Springs—pack as much of the Route 66 experience in as they can, with signs and businesses touting the road's history. The three towns are proud of their connection to the highway, with Galena even having a refurbished Route 66–themed service

station that sells antiques and Route 66 merchandise. When John Lasseter, Pixar's creative director, took a cross-country road trip in 2000 with his family, he was inspired by the highway and took note. He later employed road historian Michael Wallis to lead the Pixar team on a fact-finding road trip across multiple states in preparation for the movie *Cars* (2006). Baxter Springs was one of the towns that inspired the fictional town of Radiator Springs in the movie, as it was a once-booming almost ghost town.

The team was also charmed by a neglected and rust-covered 1951 International boom truck, which directly inspired the major character Tow Mater from the film. The old truck had sat outside a former Kan-O-Tex gas station for years and, with 99,372 miles on it, had seen much in its day. With the success of *Cars*, the residents of Galena even threw a party for the old truck to celebrate the eightieth anniversary of Route 66. Tomato sandwiches and a birthday cake for the highway were served to attendees while they watched the film on a large-screen TV. A contest was held to name the truck, with a local child's suggestion of "Tow Tater" winning the honor. The old truck still had juice in it as well, even appearing in the Galena Christmas parade. With the attention of the film bringing renewed interest to Route 66, Galena has worked to get visitors to stop and take in the sights instead of just passing through. Vintage cars resembling other characters from the movie have been brought to town as well to join Tow Tater.

Kansans can be very thrifty people and know how to make a lot out of very little. It's that way with the tiny slice of Route 66 that barely nicks the state—Kansans will claim it and promote it. Nat King Cole and the 1960s hit TV series *Route 66* might never have given Kansas a mention, but Pixar came along and made up for that lack of recognition. Adventurous drivers still road trip the entire route, and now most make sure to stop in Kansas, as the locals have tried hard to promote the history of the road there. Tow Tater sits waiting for you if you decide to pass through.

THE FLYSWATTER

Flies, mosquitoes and other winged insects have been a nuisance to mankind since time immemorial. The ancient Egyptians, Greeks and Romans all used different types of fans, reeds and horsetail staffs to dispatch the pests. Not only are these creatures a mild bother, but they also bring diseases with them.

Sanitary washing and drinking basin on ATSF train, 1943. Kansas secretary of health Samuel J. Crumbine promoted public sanitation nationwide. *Courtesy of the Library of Congress.*

In 1900, an inventor named Robert R. Montgomery obtained an early patent on the design we are most familiar with—a handle roughly a foot long with a screened square at the end of it. He called his invention a "fly-killer." It was one of many fly-killing devices on the market at the time, though the term "flyswatter" had not yet been coined.

Just five years later, at a Topeka baseball game in 1905, Kansas Board of Health secretary Samuel Crumbine overheard enthusiastic fans yell "Swat the ball!" Crumbine was working on an anti-fly campaign at the time, as Kansas was in the throes of a plague of flies. Since flies spread communicable diseases, Crumbine titled one of his health bulletins "Swat the Fly." Kansans were instructed to swat the flies whenever they saw them, as their health was on the line.

Another big part of Crumbine's campaign was to encourage installation of window screens in homes across the state. In Weir City, a group of Boy Scouts led by Frank H. Rose were building window screens for the people of the town and attached the leftover squares to yardsticks as their version called "fly bats." Rose showed his new fly killer to Crumbine, who dubbed it a "flyswatter," and the name took off nationwide.

Crumbine's flyswatter campaign and other efforts earned him an international reputation as a health campaigner. He also promoted the use of throwaway paper cups for drinking water on trains, as opposed to everyone drinking from the same cup. Tuberculosis was a major concern at the time. Disposable paper towels were pushed by him as well, replacing a rolling towel that everyone used in bathrooms. Being ever so innovative, he

brilliantly encouraged many brick manufacturers to print the phrase "Don't spit on the sidewalk" on their bricks. You can still find bricks in old parts of towns across America that have this printed on them.

Now whenever you reach for that flyswatter, remember Dr. Crumbine and his efforts to make us all healthier. His legacy lives on after his death in 1954, and even Hollywood took notice of him. The character Doc Adams from the long-running television series *Gunsmoke* was based on Crumbine and portrayed by fellow Kansan Milburn Stone.

DENVER...KANSAS?

Kansas had mountains once upon a time. It's true—when Kansas Territory was established on May 30, 1854, with the passing of the Kansas-Nebraska Act, the territory extended from the Missouri border in the east all the way to the heights of the Rocky Mountains in the west. The new territory also extended from the 37th parallel north to the 40th parallel north, which would encompass eastern Colorado all the way west from Pueblo to the north of Boulder.

The first Kansans to head west and attempt to settle there left from Lawrence, Kansas, in 1858. A butcher named John Easter heard of gold near Pikes Peak from a Delaware Indian named Fall Leaf. Fall Leaf was living on a reservation near Lawrence and claimed to others that he had found gold while scouting in the area not two days from the mountain. Easter and around four dozen others left Lawrence in May 1858 to seek adventure and possible riches. Few in the group had any experience doing this sort of work, but one man had been a prospector in California and was the go-to expert for the party. A town was to be built for trading as well, should the project succeed.

Long story short, the panning for gold didn't work out. They had a fine time taking their eleven wagons across the Santa Fe Trail, visiting Bent's Fort, hunting buffalo and trading with Native Americans. However, once the prospecting work began in earnest near Pikes Peak, the idea of settling a community there was abandoned. No gold was to be found, and their site (near the present Garden of the Gods in Colorado Springs) was not going to suffice.

The group splintered from there, with some heading to New Mexico, others going to Fort Garland in southern Colorado and the rest heading

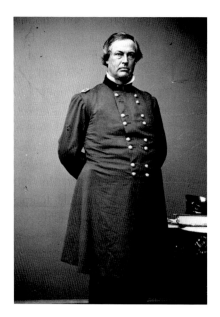

James W. Denver, fifth territorial governor of Kansas (1857–58) and namesake of Denver, Colorado. Photo taken between 1860 and 1870. *Courtesy of the Library of Congress.*

north to continue panning for gold and establishing a town. In what is now present-day Denver's Grant-Frontier Park, the group that headed north built rows of cabins east of the South Platte River. Naming their new community "Montana City," they named their rows of cabins Kansas Row, Leavenworth Row and Lawrence Row. These were the first structures built in the future Denver area. Gold wasn't found here either, and the Montana Town Company failed to make this a thriving community. Everyone abandoned the site, and the cabins were dismantled and moved to another site, a settlement called Auraria a few miles downstream.

Later that year, though, on November 22, 1858, another Kansas speculator arrived to settle a town of his own. General William Larimer staked his claim across Cherry Creek from the mining settlement of Auraria and named his new town site Denver City in order to win favor from Kansas Territorial governor James W. Denver. Unbeknownst to him, Denver had already resigned his office and could not make Denver City county seat as Larimer wanted. Denver City thrived as a frontier town, supplying nearby miners with goods, saloons, horses and tools. The city grew as a major hub for wagon routes and by 1863 as a Western Union terminus.

Kansas lost its far western territory and Denver on February 28, 1861, when the Territory of Colorado was created to govern it. Though the state lost its mountains, skiing and any rights to the future Denver Broncos, there is a funny postscript. Many years after the founding of Denver, the namesake of the city, former territorial governor of Kansas James W. Denver, visited the thriving town in 1875 and 1882. He complained that the locals didn't show him much affection. Maybe he expected a parade? Either way, his 1882 visit made him the only person in U.S. history to visit his namesake after it became a state capital. He can't complain too much, right? Besides, his great-great grandson was Gilligan Island's very own Bob Denver. Pretty cool legacy if you ask me.

DUST BOWL RAILROAD

After the Civil War, railroad growth exploded across the western frontiers of America. There was a great need for thousands of miles of new lines to supply the west and to help develop it for future settlers. Colorado and the Pacific coastal states were huge draws for immigrants coming through Kansas, and the days of wagons that went eleven miles per day weren't going to cut it anymore.

Kansas business leaders and politicians knew the necessity of developing railroads here as far back as the 1850s, but private investment and enterprise could not do it alone. Federal and state governments were the real movers and shakers in railroad development, and land grants, stocks, bonds and sometimes straight cash were used to get companies to build west. Early on, the Kansas-Pacific and the Atchison, Topeka and Santa Fe Railroads were the biggest developers of railroads in the state. The ATSF began laying its first tracks in 1868 and reached the Colorado border in 1872. By the end of the century, the state was crisscrossed with railroad lines in all directions, moving wheat, cattle, supplies and people speedily and efficiently within and out of the state. Some towns depended on a railroad hub being built there for the community's survival. Many towns even had celebrations with marching bands, speeches and massive community picnics to celebrate the arrival of the railroad.

Suffice it to say, many companies got in on the railroad business, and today over a dozen have lines of twenty miles or more in the state. Over one hundred defunct railroad companies have existed at one time or another in the state, though, such as the Lawrence, Emporia and Southwestern Railway, which lasted from 1887 to 1894. It's easy to forget that rail was about the only way to travel long distances for decades, unless you wanted to ride a horse hundreds of miles. People depended on railroads for everything entering and exiting their cities, and they were much more of a fixture in peoples' lives before the automobile. They were so crucial to the daily life and economy of the nation that laborers were needed to fill many empty positions. A series of Congressional Acts limiting immigration from Asia and Eastern Europe opened the door for the first of thousands of Mexican workers to head north to work for the railroads, among other industries. It was this railroad expansion environment that gave investors the confidence to start new lines in all sorts of places.

One such now-defunct railroad was the Wichita Northwestern Railroad (WNW), which served a one-hundred-mile line between Wichita and Hays

Left: Kansas-Pacific Railway map, 1869. The thick lines along the route indicate areas open to settlers. *Courtesy of The National Archives.*

Below: Mexican laborers in Newton, 1908. Mexican workers have filled Kansas labor shortages in mines, railroads, meatpacking and agriculture for generations. Many raised their families here. *Courtesy of the Library of Congress.*

between 1912 and 1940. This little railroad was created entirely to move farm products to markets. Regular travelers could get a pass, but the company didn't depend on them for profit. With the Dust Bowl and Great Depression hitting this railroad like a double-whammy, grain shipments fell 40 to 60 percent during the 1930s. It's a wonder that the company even stayed afloat to 1940, when falling revenues and competition from trucks was finally too much to overcome. Larger railroads like the ATSF had an easier time staying afloat due to their massive infrastructure and heavy traffic.

Though this railroad only served for twenty-eight years, many old-timers across the dozens of communities served have fond memories of it. Leonard Berglund, a farmer near the now-defunct ghost town of Ash Valley, tells of

Lifting an ATSF engine with eighty-ton crane, Topeka, 1943. The locomotive will be carried to another part of the shop to be wheeled. *Courtesy of the Library of Congress.*

a prank he and some other boys pulled on the railroad in the 1930s. At one point in the railroad's steep grade up one of the valley's rolling hills, the boys smeared axle grease all over the rails and hid nearby to watch the fun. When the WNW train made its approach at the designated time, it could not conquer the hill and spun its drivers in place, losing momentum and slipping backward down the hill. The engineer and his crew were not amused.

Though cars were slowly taking over railroads, people still found them handy to use back in the 1920s and '30s. Some needed to ride it to get to nearby towns, with ministers getting free passes. There were many occasions where the snow fell so deep that dirt roads were impassible, so locals took the WNW tracks to town. Since everyone knew the train

schedule, they were comfortable taking their Model Ts to town on the tracks that the train had already plowed free by coming through. It was a bumpy ride, but it got you to town. You don't see many cars bumping down the railroad tracks these days. It would probably get you arrested. Back then, though, that was no big deal.

Ernest Hemingway and *A Farewell to Arms*

If you do a quick Google search of the greatest writers of all time, you will undoubtedly find Ernest Hemingway on nearly every list, up there with Joyce, Shakespeare, Dostoevsky and Austen. But what made him so great? There are many opinions, but many can agree that he spoke directly and straight to the common person. You won't find lofty and flowery language in his writing. His style was factual, literal and to the point. Sometimes he didn't even take sides when describing something awful; he would just describe the way of the world as "the way it is." His connection to Kansas and Kansas City influenced his writing, and his experiences here are recounted in many of his works.

After finishing high school in Oak Park, Illinois, Hemingway came to Kansas City to work as a cub reporter for the *Kansas City Star* in 1917. Many other famous novelists got their starts as journalists as well, including Mark Twain and Sinclair Lewis. As a cub reporter, his job was to cover "short-stop runs" for the *Star*, which included scurrying all over town reporting on crime, fires, hospital admittances and the departures and arrivals of notable people at Union Station.

In this job, which only lasted six months, he used the newspaper's style guide as a personal guide to his writing from then on. The maxim was to "use short sentences. Use short first paragraphs. Use vigorous English. Be positive, not negative." Early in 1918, he signed up at a Red Cross recruitment drive and volunteered to become an ambulance driver on the Italian front. He was injured by mortar fire in July of that year, suffering shrapnel wounds to both legs. He remarked on that incident in his typically blunt style, "When you go to war as a boy you have a great illusion of immortality. Other people get killed; not you....Then when you are badly wounded the first time you lose that illusion and you know it can happen to you."

While recuperating from his injuries in a Red Cross hospital in Milan, he fell in love with an American nurse named Agnes von Kurowsky. They decided to marry when he returned stateside in 1919, but he was devastated

by a letter from her informing him that she was engaged to an Italian officer. The relationship that he had with Agnes haunted him for many years, with some people even suggesting that he would later abandon his wives before they could abandon him.

Fast forward ten years to 1928, and Ernest and his second wife, Pauline, were back in the Kansas City area, living in Mission Hills, Kansas. It was here that they stayed at the home of W. Malcolm and Ruth Lowry at 6435 Indian Lane while Pauline came to rest in the months leading up to the birth of their first son, Patrick. In that time, Ernest wrote *A Farewell to Arms*, arguably his best-known novel. He also wrote some in Pauline's hometown of Piggott, Arkansas. By June, when the baby was born, he had 311 pages completed. His wife gave birth by Caesarian section on June 28 after a marathon eighteen hours of labor. As his wife was in labor, he wrote the famous scene about Catherine Barkley's death during childbirth. Catherine was based on Agnes von Kurowsky.

To this day, you can drive all over Kansas City and see the places he lived, worked and stayed during different trips to the city. Maxims such as "The best way to find out if you can trust somebody is to trust them" and "We are all apprentices in a craft where no one ever becomes a master" keep generations of his fans coming to the area to follow in his footsteps. Among the leafy suburbs of Mission Hills, Kansas, though, the house where he wrote *A Farewell to Arms* still stands. It's not hard to imagine him next to some window up there tapping away a classic with a pipe in his mouth.

AMELIA EARHART'S FIRST FLIGHT

Amelia Earhart (1897–1937) is one of the most accomplished and famous Kansans that there ever was. Not only was she a great pilot, having been the first woman to fly solo across the Atlantic Ocean, but she was also instrumental in promoting and supporting other female pilots. She made other great feats as well, such as being the first woman to fly solo coast to coast across the United States, and the first person to solo over the Pacific—from Honolulu, Hawaii, to Oakland, California. Her daring attempt to fly twenty-nine thousand miles around the earth's equator is legendary, as is her disappearance. Still, she inspires generations of women that they, too, could follow their dreams. Fascination with her adventurous spirit continues to this day, and she might have got her first taste of flight in a rooftop stunt.

Born in Atchison, Kansas, on July 24, 1897, Amelia was the rambunctious daughter of German-descended Samuel "Edwin" Stanton Earhart and Amelia "Amy" Earhart. She and her younger sister Muriel (whom she nicknamed "Pidge") were inseparable tomboys. They reveled in climbing trees, riding horses, shooting rifles and collecting toads, worms and moths. Their mother didn't want to raise them as "proper" little girls and encouraged them to get outside and mix it up a bit. Amy even let them wear bloomers (a skirt over long trousers), which their maternal grandmother disapproved of. None of the other girls in town wore them, but these girls did. It was in this happy-go-lucky environment in small-town Kansas that Amelia tasted the freedom that influenced her later life.

Inspiration struck her soon after returning from a trip to the 1904 St. Louis World's Fair. Being fascinated by a roller coaster at the fair, she built her own model with her uncle's help. She decided it might be a great idea to just ride that thing off of a homemade ramp attached to the roof of her family's toolshed. This first flight of hers ended in chaos, as she and her car tipped over the edge of the roof and crashed to the ground. Though she tore her dress and got a nasty lip bruise, she felt exhilaration and told her sister, "Oh, Pidge, it's just like flying!" Little did she know at the time how much she would later enjoy real flight.

Amelia spent the formative early years of her life in Atchison before the family moved to Iowa in 1908. Though Earhart lived in Minnesota, Illinois, and other places, she always considered Kansas to be home. Small-town Kansas was the place where she was given the freedom to not be bottled up by society's expectations for her gender. Perhaps that spirit and her calamitous first "flight" gave her the spark she needed to become the pioneer we recognize today.

TAKE YOUR TIME, FELLAS

When the cornerstone was laid for the east wing of the Kansas State Capitol building in Topeka on October 17, 1866, the nation was barely a year out from the Civil War, Andrew Johnson was president and the young state of Kansas was only five years old. Due to a severe winter, the brown stone from a quarry southeast of Topeka crumbled, damaging the foundation and cornerstone of the wing. Back to the drawing board, harder limestone was brought in from Geary County and the wing continued construction.

Soldiers/sailors reunion at the unfinished Kansas State Capitol building, 1882. Construction on the statehouse took thirty-seven years, and it was finally completed in 1903. *Courtesy of the Library of Congress.*

Not that this mattered too much—Topeka was going to take its sweet time building this thing.

The west wing didn't begin construction until thirteen years later in 1879, and twenty years into the project, in 1886, a central building was begun to link the two wings. The north and south wings began in 1883. Throughout the 1890s, the dome was completed and the final touches were finished in the early years of the twentieth century, pulling the whole building together.

On March 24, 1903, the Kansas Statehouse was complete. Little did they know in 1866 when starting construction that it would take thirty-seven years to finish. To put it into perspective, Teddy Roosevelt was president and Ford's Model A came out the same year the building was done. It's an impressive structure, though, with its dome standing seventeen feet higher than the U.S. Capitol in Washington, D.C. They sure were in no hurry, though.

GOOD TIMING, VOLGA GERMANS

There's a lot of Volga Germans in Kansas, and it is thanks to the decisions of Russian monarchs in the eighteenth and nineteenth centuries. In 1763, Catherine the Great of Russia wished to develop empty lands along the Volga River, so she encouraged Germans to come east and improve Russian agriculture. In the next five years, over twenty-five thousand Germans paid heed to the call after being offered loans to travel there, with no taxes or military service required. Over one hundred colonies were settled, with the Germans living in relative isolation from the rest of Russia for the next one hundred years.

Ethnic Volga Germans welcome President Theodore Roosevelt in Victoria, 1903. Tens of thousands of Volga Germans came to Kansas from Russia. *Courtesy of the Library of Congress.*

Czar Alexander II changed the deal in 1871, though, when he removed the Volga Germans' military service exemption. Calling a conference among their leaders, they sent representatives to the United States to see if immigrating to the country would be a viable option. Upon their arrival in Topeka in 1875, the Kansas Pacific Railway encouraged them to head west to Ellis and Rush Counties on railroad land, as well as other communities in Kansas.

These new settlers sent word back to Russia that the deal was great, so thousands left Russia in the ensuing years and headed to Kansas. They brought with them their food, language and culture, which can still be felt in places like Hays, North Topeka and Russell. Many kept coming until World War I, when Russia cut off immigration after the fall of the Romanov dynasty.

Life wasn't always easy for the Volga Germans, with two world wars in the twentieth century against Germany casting suspicion on many of them by their fellow Americans. Still, getting out of Russia before the rise of the USSR was quite fortunate for them. The ones left behind in Russia had their own state, the Volga German ASSR in Soviet Russia, until 1941, when Nazi Germany invaded. Joseph Stalin considered them all potential enemies of the state and sent over 1 million Germans to inner exile in Siberia and Central Asia to forced labor camps and gulags. Somewhere between 200,000 to 300,000 of them died due to starvation, overwork or disease in the 1940s. Many never got to go back to the Volga.

The ones that made it to Kansas have been thanking their lucky stars ever since. Kansas has benefitted from their coming as well. They brought with them winter wheat, a strain of wheat that can be planted in the autumn that can grow into young plants, delay growth during winter and resume growth once spring arrives. This wheat is easy to manage, is tough against weeds and prevents soil erosion during the winter. The Germans' contributions helped turn Kansas into an agricultural powerhouse.

SPORTS

NAISMITH, THE LOSING COACH

Not many sports can trace their origin to a single verified inventor. Soccer, for example, was created independently and in different forms by the ancient Chinese, the Japanese, Greeks, Romans, parts of Central America and later England. Even the modern English-derived version developed over decades by thousands of different players. Ice hockey evolved similarly, being played with different kinds of balls and sticks on ice over the centuries. Basketball, though, has a simpler origin: James Naismith invented it in 1891. Want to see the original rules that he came up with? They are housed in a secure display case at the University of Kansas right next to Allen Fieldhouse, where the Jayhawks play basketball. The program has a glorious history, with many legendary players and championships. It is quite ironic, though, that James Naismith, the game's inventor, is the only Jayhawks coach to post an all-time losing record.

Born in Canada in 1861, Naismith invented the game in 1891 while teaching at the International YMCA Training School in Springfield, Massachusetts. Being the school's physical education teacher, he devised the game as a way to keep students active indoors during the winter months. The goal was to physically exert them so as to calm down their rowdiness as well as design a low contact game so as to not make it "too rough." He knew he needed a soft ball, a high un-guardable goal and

passing as a way to avoid injury and contact. He wrote up his thirteen basic rules, and the game was introduced. Using a soccer ball, two teams of nine players shot the ball into peach baskets, and the rest is history. Speaking of this first game, he commented:

> *I showed them two peach baskets I'd nailed up at each end of the gym, and I told them the idea was to throw the ball into the opposing team's peach basket. I blew a whistle, and the first game of basketball began.... The boys began tackling, kicking and punching in the clinches. They ended up in a free-for-all in the middle of the gym floor. (The result: numerous black eyes, a separated shoulder and one player knocked out.) It certainly was murder.*

With some tweaking of the rules, subsequent contests went better than the first one. It became an instant hit on campus by the next year, and the YMCA introduced it internationally in 1893. Naismith later commented, "The invention of basketball was not an accident. It was developed to meet a need. Those boys simply would not play 'Drop the Handkerchief'."

After receiving his medical degree in Denver, Naismith moved to Lawrence, Kansas, in 1898 to work for the University of Kansas as a physical education instructor and chapel director. He soon became the coach of the Jayhawks' first basketball team in 1898, just six years after he created the game. In that span, the YMCA had spread the game, and its popularity grew nationwide. These early squads played nearby YMCA teams, as well as nearby schools William Jewell College and Haskell Indian Nations University. They even played future rival Kansas State, with Naismith notching the win 54–39 on January 25, 1907. His tenure as coach wasn't incredibly memorable, though. In nine seasons, he coached the Jayhawks to a 55-60 record before passing the coaching job off to successor Forrest "Phog" Allen, a former player of his. Allen went on to have an incredible career as a coach, though Naismith once hilariously told him, "You can't coach basketball; you just play it." Allen went on to coach KU for thirty-nine seasons, winning national championships, starting the NCAA Tournament and coaching future legends Dean Smith and Adolph Rupp.

Naismith lived long enough to see basketball grow in such popularity that the game was played by youths all over the nation and the world. After stepping down as coach, though, he preferred to sit back and watch others do it. He saw wrestling, rugby and gymnastics as superior sports and his own game as a sort of curiosity. He was proud of his role as a physical education

instructor and molder of young men and never practiced self-promotion as the inventor. He was even concerned that professionalism of the sport would sully a game he invented for fun.

He served as KU's athletic director for many years, retiring in 1937 after almost forty years of service to the school. Never one to cash in on his invention, Naismith did take great pride though in 1936 when basketball was made an official Olympic sport at the 1936 Olympics. The National Association of Basketball Coaches raised money to send him there, and he handed out the medals to the three medal-winning teams, United States (gold), Canada (silver) and Mexico (bronze). Seeing his game played by so many nations was compensation enough for the humble PE instructor.

Naismith died in 1939 of a brain hemorrhage and is buried in Memorial Park Cemetery in Lawrence. His name adorns Naismith Drive on KU's campus, as well as Naismith Hall and Allen Firehouse's James Naismith Court. The Jayhawks basketball team has been known to take morning runs to his grave, touch it in remembrance and run back to campus. Many national and international awards and trophies bear his name. Fittingly, in 2017, the Naismith Award for best college player went to Jayhawk Frank Mason.

Naismith is never far from the minds of Jayhawks fans, and his connection to the school came full circle in 2010 when alumnus David Booth bought the original thirteen rules, typed onto two pages, for $4.3 million at a Sotheby's auction. This purchase was the most expensive sports memorabilia purchase in history. At a center court ceremony at a Jayhawks game in 2016, Booth and his children revealed the returned rules with Naismith's eighty-year-old grandson, James Pomeroy Naismith, standing with them. Booth said that his motivation for buying and donating the document to KU was that "they're incredibly important and should be at KU. Naismith invented basketball and was there for forty years. And Coach Phog Allen was one of the key figures in making it so popular." If you go to the DeBruce Center (right next to Allen Fieldhouse), the rules light up and a recording of Naismith's voice plays in which he explains how he invented the game. Not bad for a losing coach.

JOHN WOODEN WORKS THE CONCRETE AT KU

When most people think of Lawrence, Kansas, they think about the Kansas Jayhawks basketball team. Being a nationally renowned program with multiple national championships, it dwarfs every other activity in town—

even the football team. The Jayhawks football team has been a roughly .500 program with flashes of brilliance here and there. But one thing many people don't know about the football team is its connection to a college basketball legend: "The Wizard of Westwood" himself, John Wooden of UCLA fame.

Born in 1910, John Wooden grew up on a farm outside of Martinsville, Indiana, a town of roughly five thousand people situated thirty miles southwest of Indianapolis. He grew up with a strong work ethic, with parents who grew their own food in their garden, held multiple jobs and expected their kids to strive for greatness in everything they did. Young John worked many jobs as a teenager in the 1920s, from erecting telephone poles to garbage collection and working in a grocery store. He always had a paying gig and was up for anything.

John excelled in basketball as well, helping his high school team win the 1927 Indiana State Championship his junior year. Legendary Kansas coach Forrest "Phog" Allen had been in touch with Wooden, trying to recruit him to KU, and told him he could come out to Kansas in the summer if he ever needed work. John and a teammate of his decided to hitchhike to Lawrence that summer to work the wheat harvest. They wore their state championship letterman's jackets to boost the odds of them getting rides and hit the road.

On reaching Lawrence, though, they were surprised to realize that they had come too early and the crops weren't ready for harvest yet. Thinking they would have to head back home, Phog convinced them to stay, saying he'd find some work for them. Always conscious of talent acquisition (Phog being the man who recruited Wilt Chamberlain to KU), he wasn't about to let them go. He took them over to Memorial Stadium, KU's new football stadium, which had just been erected earlier in the decade. A project to add seating to the north end zone was in progress, and the boys were put to work

Memorial Stadium on the campus of the University of Kansas in Lawrence. Legendary UCLA basketball coach John Wooden helped build an expansion on the stadium. *Photo by the author.*

pouring cement. They were allowed to sleep on the floor of the campus gym at night. And to think of how recruits are treated like visiting gods at schools these days!

Wooden ended up playing basketball back in Indiana at Purdue University, where he had a great career and was named a consensus All-American three times. His 1931–32 squad went 17–1 that year and was retroactively named the Helms National Champion for that season. Though he went on to great fame, winning ten national titles at UCLA between 1964 and 1975, he never forgot his roots and the work ethic that got him there. Years ago in Kansas City at a Naismith Awards Banquet, James Allen, Phog's grandson, introduced himself to then long-retired Coach Wooden. Wooden regaled him with this story and said, "You see, I helped build that stadium of yours. I think I did an excellent job!" Lawrence has been touched by many basketball greats. Some even stopped to pour some cement.

THE TOWN NAMED AFTER A WORLD SERIES WINNER

An hour and a half drive west of Kansas City is a tiny almost ghost town named Bushong, in northern Lyon County. Like many small communities in Kansas, its population has dropped significantly over the years. Empty storefronts dot the old main street, and a derelict school reminds us of a busier past. Originally named Weeks after local farmer Joseph Weeks donated twenty acres to the Missouri Pacific Railroad Company, this community got its start as Kansas was opened up to railroad expansion. The company built its depot on part of this donated land, and Mr. Weeks sold another twenty platted acres as a town. Just like that, a town was born.

In the 1880s, baseball was the uncontested national sport, with the American Association and the National League facing each other in the World Series for the national baseball championship. This was a precursor to the modern World Series, with many interesting teams, such as the Brooklyn Bridegrooms, the Hartford Dark Blues, the New York Metropolitans and some familiar ones like the Cincinnati Red Stockings (Reds). Kansas City even had a team for a year: the Kansas City Cowboys.

Being as there was no NFL, NHL, Internet or television to compete with, baseball was king. Basketball wasn't even invented yet, and the rebirth of the Olympics was still yet to come. Cities prided themselves on the glories of their teams. St. Louis residents had immense pride in their local team, the

St. Louis Browns (which later became today's St. Louis Cardinals). The Browns had gone to the 1885 World Series, playing the Chicago White Stockings (now the Chicago Cubs) to the most hated sports outcome of all—a draw. Each team had won three games and tied one, with the World Series ending in dispute.

The 1886 season was a barn-burner, though, with the Browns posting a 93–46 record and beating the White Stockings 4 games to 2 in the World Series. The city of St. Louis and the whole state of Missouri were so proud of their team that the Missouri Pacific Railroad decided to honor members of the team by naming some towns along its route after Browns players. One such player was catcher Albert J. "Doc" Bushong. Bushong was an exciting player who was an integral part of the team, playing every game that series. He was also teammates with infielder Charles Comiskey—the future founder

The Missouri Pacific Railroad honored the 1886 World Series champion St. Louis Browns by naming towns after players. Bushong, Kansas, was named after Albert J. Bushong. *Courtesy of the Library of Congress.*

of the Chicago White Sox—and Tip O'Neal, whom Canadians refer to as their Babe Ruth. Comiskey got his own town named after him just a few miles down the tracks, also in Lyon County.

There is no record of what Bushong thought about a town being named after him, but you'd have to imagine it was a point of pride for him. He played for five more years and spent the rest of his life as a successful dentist in New Jersey. Perhaps he regaled his patients with stories of his baseball days and the Kansas community that bears his name.

At its height, Bushong boasted a population of around 150 people. There was a bank, a mechanic shop, a general store, a post office, a hotel, a grade school and even a high school. There's still around 30 people there, so it's not gone yet. Keep in mind that if you take a drive through the Kansas countryside and come across a forgotten little hamlet, it just might have a story or two to tell. And whatever happened to that railroad, you might

wonder? It's now part of the Flint Hills Nature Trail, a 117-mile hike/bike trail through the beautiful Flint Hills of Kansas. It was built after the railroad line was discontinued in 1980. Many cycling enthusiasts ride through Bushong as they cross the five counties it encompasses. The name Bushong survives, though, as a neat reminder of a baseball star from a century and a half ago.

KANSAS' LONE KENTUCKY DERBY–WINNING HORSE

If you've ever been to Prairie Village, Kansas, you'll recognize it as a typical, pleasant suburb of Kansas City. The schools, parks and neighborhoods are some of the best in the entire metro area and the well-manicured public spaces are quite attractive. Hugging the Missouri border roughly eight miles as the crow flies from downtown Kansas City, this community holds an interesting surprise. If you drive into a neighborhood not far from Corinth Library, you'll find the grave of a Kentucky Derby–winning horse and his sire in an island in the middle of the cul-de-sac at 59 Le Mans Court. Around the horse graves are neatly trimmed grass and bushes and a wrought-iron fence surrounding it. A sign atop the fence reads "Woolford Farms."

Born in 1935, Lawrin was raised at Woolford Farms, a two-hundred-acre Thoroughbred horse farm founded by department store owner Herbert M. Woolf of Woolf Brothers Clothing Stores. This farm was the site of many gatherings of the Kansas City elite, such as boss Tom Pendergast, as well as esteemed visitors such as Theodore Roosevelt. Wanting his own elite horse, Woolf paid $500 for one named Insco (1928–1939). Insco was the son of the famous sire Sir Gallahad III (1920–1949), a horse that had seven major wins and sired three Kentucky Derby winners, among many other champions. One of Insco's brothers, Gallant Fox, was the second horse to win the Triple Crown, pulling off the feat in 1930. Insco placed sixth in the 1931 Derby and, in 1935, sired Lawrin.

Lawrin was trained by Ben A. Jones, a hall of fame trainer who won six Kentucky Derbies and two Triple Crowns. In 1938, Jones led Lawrin and his jockey Eddie Arcaro to victory in the sixty-fourth Kentucky Derby. Lawrin lived at Woolford Farm until 1955, the same year that the farm was sold. Prairie Village had officially become a city four years earlier, and the neighborhoods and shopping centers weren't far behind. Lawrin was buried next to Insco, and their grave is the only remaining relic of the great farm that

once stood on that site. Today you can drive down the leafy neighborhoods not far from restaurants and shops and pull over in that cul-de-sac and take in a little piece of history that is modestly hiding in the suburbs. Kansas' only Kentucky Derby–winning horse will be there waiting for you.

Polo...but Played with Cars? What Could Possibly Go Wrong

The 1910s were an exciting time to be a vehicle enthusiast. Automobiles were quickly replacing the horse. Ford's Model T had just been released in 1908 and was well on its way to eventually selling fifteen million units during its nineteen-year run. Motorcycle companies such as Indian and Harley-Davidson were selling their products all over the nation, causing Americans to fall in love with the motorcycle. Kansas was not immune to the trend. Many car and motorcycle events and races entertained the public during the decade, including a record-breaking one-hundred-mile motorcycle race in Norton.

The wildest use of automobiles at that time—and likely ever—is the game of automobile polo, or, auto polo for short. Officially invented in 1911 by a Ford dealer in Topeka named Ralph Hankinson, he came up with the game as a publicity stunt to sell cars. In this promotion, he promised the game of polo—but with cars instead of horses. At the July 20, 1912 event, two teams squared off against each other: two cars per team with two men inside. In each car, the driver focused on getting to the ball and avoiding collisions while the malletman hit the ball. The tops of the Model T cars and doors were removed for better visibility and so the malletman could stand and swing the mallet. Over five thousand spectators came to a Wichita alfalfa field to witness the wild spectacle. The concept for the sport had likely been around for a few years, but Hankinson gets credit for the first widely publicized games. From then on, the sport exploded in popularity nationwide.

Roughly the length of a football field (three hundred feet) and half again as wide, the game could be played both outdoors and indoors. This gave the game a year-round audience, and it became common nationwide at fairs, exhibitions and even major arenas like Madison Square Garden. It was so damaging to the cars that Ralph Hankinson even patented the first roll bar on the back of the vehicle to prevent the players from being crushed. Though the game became popular coast-to-coast, it was described by many in the press as the "lunatic game." Cars would constantly throw riders out

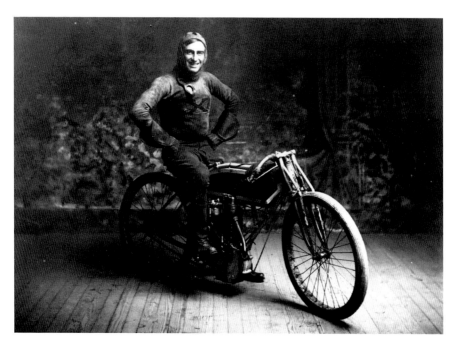

Racing champion Ray Weishaar set a world record on October 22, 1914, in Norton. He raced one hundred miles in two hours and one and a half minutes. *Courtesy of the Library of Congress.*

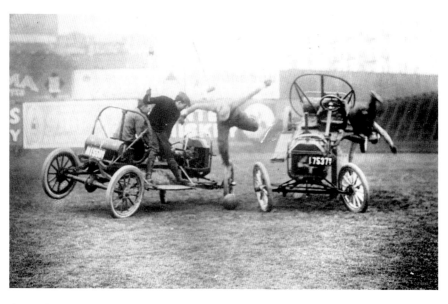

Auto polo was devised by a Topeka Ford dealer as a publicity stunt in 1911 to sell Model T cars. Pictured here is a contest between 1910 and 1915. *Courtesy of the Library of Congress.*

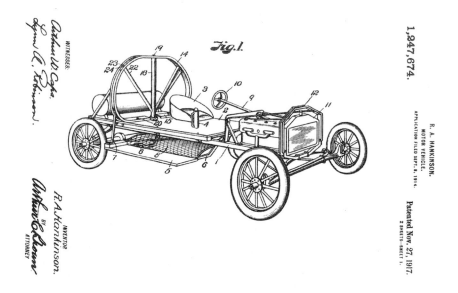

In 1917, R.A. Hankinson of DeSoto, Kansas, patented the roll bar for use in auto polo contests. The roll bar is common in many open-top vehicles today. *Courtesy of the Library of Congress.*

of them, roll over and repeatedly collide. Mostly riders had cuts and broken bones; deaths were rare, but they did happen.

Sponsored by Texaco, Hankinson traveled to the Philippines and the United Kingdom to promote the sport and recruit new teams. Teams from Wichita even toured Europe in 1913, to much fanfare. The game chugged on into the late 1920s, but the high cost of repairing and replacing the cars eventually did in the sport. The public had other avenues for entertainment now as well, with the rise of basketball, football and the cinema. Fewer auto polo promoters were willing to cough up the money for something so expensive. Hankinson's teams in 1924 reported 538 burst tires, 66 broken axles, 1,564 broken wheels, 10 cracked engines and 6 cars totally destroyed that had to be permanently retired. After World War II, the game made a small comeback in the Midwest, but it faded again.

The next time you see a demolition derby, Nascar race or monster trucks, just keep in mind that they are child's play compared to auto polo. Modern people tend to look at the past as stuffy and uptight, but this game showed that the opposite is true. You couldn't get an insurer to back this sport today, let alone the legal rights to do it in any arena. The old days were often much more fun than today.

BIBLIOGRAPHY

Ambrose, Stephen E. *Undaunted Courage: Meriwether Lewis, Thomas Jefferson and the Opening of the American West*. New York: Simon & Schuster, 1996.

Amidi, Amid. *The Art of Pixar: 25th Anniversary: The Complete Color Scripts and Select Art from 25 Years of Animation*. San Francisco: Chronicle Books, 2015.

Armstrong, John. *Reminiscences of Slave Days in Kansas*. Topeka: Kansas State Historical Society, 1895.

Barrow, Blanche Caldwell, and John Neal Phillips. *My Life with Bonnie & Clyde*. Norman: University of Oklahoma Press, 2004.

"The B-B-Blizzard." Kansas Memory. Accessed September 15, 2016. http://www.kansasmemory.org/item/211237.

Bennett, D.K. *Kansas Geology: An Introduction to Landscapes, Rocks, Minerals, and Fossils*. Lawrence: University Press of Kansas, 1983.

Bennett, Hugh Hammond. *Elements of Soil Conservation*. 2nd ed. New York: McGraw-Hill, 1955.

Berglund, Lee. *Wheat Belt Route: The Story of a Dust Bowl Railroad*. David City, NE: South Platte Press, 1998.

Brondfield, Jerry. *Rockne: The Coach, the Man, the Legend*. Lincoln, NE: Bison Books, 2009.

Brooks, Elizabeth. *History of Mission and Northeast Johnson County*. Mission, KS: Historic Old Mission Enthusiasts, 1992.

Brown, Daniel James. *The Indifferent Stars Above: The Harrowing Saga of the Donner Party*. New York: William Morrow, 2009.

Brown, William E. *The Santa Fe Trail*. St. Louis, MO: Patrice Press, 1988.

Bryant, Beverley. *Portraits of Kentucky Derby Winners: A 120-Year History*. Deerfield Beach, FL: HCI, 1995.

Burke, Diane Mutti, and Jonathan Earle. *Bleeding Kansas, Bleeding Missouri: The Long Civil War on the Border*. Lawrence: University Press of Kansas, 2013.

Burke, W.S. *Official Military History of Kansas Regiments During the War for the Suppression of the Great Rebellion* (1870). Ottawa: Kansas Heritage Press, 2005.

Burnes, Brian. "A Touch of Camelot in Kansas: Remembering the Night John F. Kennedy Came to Johnson County." *Wichita Eagle*, November 5, 2013.

Burns, Ken, and Dayton Duncan. *Lewis & Clark: The Journey of the Corps of Discovery*. New York: Knopf, 1997.

Butler, Susan. *East to the Dawn: The Life of Amelia Earhart*. Boston: De Capo Press, 2009.

Carleton, Lt. J. Henry. *The Prairie Logbooks: Dragoon Campaigns to the Pawnee Villages in 1844, and to the Rocky Mountains in 1845*. Lincoln: University of Nebraska Press, 1983.

Carpenter, Garrett R. "Silkville: A Kansas Attempt in the History of Fourierist Utopias, 1869–1892." Master's thesis, Emporia State University, 1951.

Cash, Jon David. *Before They Were Cardinals: Major League Baseball in Nineteenth-Century St. Louis*. Columbia: University of Missouri Press, 2011.

Castel, Albert. *A Frontier State at War: Kansas 1861–1865*. Lawrence: Kansas Heritage Press, 1958.

Clark, William, and Meriwether Lewis. "Journals of the Lewis and Clark Expedition." Accessed September 21, 2016. https://lewisandclarkjournals.unl.edu/journals.

Collins, Robert. *General James G. Blunt: Tarnished Glory*. Gretna, LA: Pelican Publishing, 2005.

Connelly, William E. *History of Kansas Newspapers: A History of the Newspapers and Magazines Published in Kansas from the Organization of Kansas Territory, 1854 to January 1, 1916*. Topeka: Kansas State Printing Plant, 1916.

Crawford, Samuel J. *Kansas in the Sixties*. Ottawa: Kansas Heritage Press, 1994.

Crumbine, Dr. Samuel J. *Frontier Doctor*. Pittsburgh, PA: Dorrance and Company, 1948.

Dary, David. *Entrepreneurs of the Old West*. Lincoln: University of Nebraska Press, 1986.

Davis, Kenneth S. *Kansas: A History*. New York: W.W. Norton & Company, 1984.

Davis, Seth. *Wooden: A Coach's Life*. New York: Times Books, 2014.

Dean, Virgil W., ed. *Kansas Territorial Reader*. Topeka: Kansas State Historical Society, 2005.

Dearborn, Mary V. *Ernest Hemingway: A Biography*. New York: Knopf, 2017.

Dykstra, Robert R. *The Cattle Towns*. Lincoln: University of Nebraska Press, 1968.

Earhart, Amelia. *The Fun of It*. New York: Harcourt, Brace and Company, 1933.

Etcheson, Nicole. *Bleeding Kansas: Contested Liberty in the Civil War Era*. Lawrence: University of Kansas Press, 2004.

Farrow, Lee A. *Alexis in America: A Russian Grand Duke's Tour, 1871–1872*. Baton Rouge: Louisiana State University Press, 2014.

Fitzgerald, Daniel. *Ghost Towns of Kansas: A Traveler's Guide*. Lawrence: University Press of Kansas, 1988.

Frost, Lawrence A. *The Court-Martial of General George Armstrong Custer*. Norman: University of Oklahoma Press, 1968.

Gaston, Herbert E. *The Nonpartisan League*. New York: Harcourt, Brace and Howe, 1920.

Gent, Frank. *Beneath the Surface of Tuttle Creek Reservoir: The Town of Garrison in Potawatomie County, Kansas, 1880–1959*. Manhattan, KS: Chapman Center for Rural Studies, 2011.

Goodrich, Thomas. *War to the Knife: Bleeding Kansas, 1854–1861*. Lincoln, NE: Bison Books, 2004.

Guinn, Jeff. *Go Down Together: The True, Untold Story of Bonnie and Clyde*. New York: Simon & Schuster, 2009.

Hall, Thomas B. *Medicine on the Santa Fe Trail*. Dayton, OH: Morningside Bookshop, 1971.

Hallberg, G.R. "Pre-Wisconsin Glacial Stratigraphy of the Central Plains Region in Iowa, Nebraska, Kansas, and Missouri." *Quaternary Science Reviews* 5 (1986): 11–15.

Harbaugh, John W., and Daniel F. Merriam. "Topographic Ellipses in Finney and Sedgwick Counties, Kansas May Signal Deep Structures in Precambrian Basement." *Transactions of the Kansas Academy of Science* 111, no. 3, 4 (Fall 2008): 269–74.

Hinton, Richard J. *Rebel Invasion of Missouri and Kansas, and the Campaign of the Army of the Border against General Sterling Price*. Chicago: Church & Goodman, 1865.

Hodge, P.W. "The Location and the Site of the Haviland Meteorite Crater." *Meteoritics* 14, no. 2 (1979): 233.

Hughes, Langston. *I Wonder as I Wander: An Autobiographical Journey*. New York: Hill and Wang, 2015.

Huntington, Samuel P. "The Election Tactics of the Nonpartisan League." *Mississippi Valley Historical Review* 36, no. 4 (March 1950): 613–32.

Huron, George A. "Ernest Valeton Boissiere," Address at annual meeting, Kansas State Historical Society, 1901.

Hutchisson, James M. *Ernest Hemingway: A New Life.* State College: Penn State University Press, 2016.

Jameson, Henry B. *Heroes by the Dozen: Abilene from Cattle Days to President Ike.* Abilene, KS: Shadinger-Wilson, 1961.

Johnson, Byron Berkeley. *Abraham Lincoln and Boston Corbett: With Personal Recollections of Each; John Wilkes Booth and Jefferson Davis, a True Story of Their Capture.* Self-published, 1914.

Johnson, Vance. *Heaven's Tableland: The Dust Bowl Story.* New York: Farrar, Straus and Giroux, 1947.

Kauffman, Michael W. *American Brutus: John Wilkes Booth and the Lincoln Conspiracies.* New York: Random House, 2004.

Kish, Bernie. "Remembering Knute Rockne and His Connections to Kansas." KPR. Accessed January 3, 2017. http://kansaspublicradio.org/kpr-news/remembering-knute-rockne-and-his-connections-kansas.

Lansing, Michael. *Insurgent Democracy: The Nonpartisan League in North American Politics.* Chicago: University of Chicago Press, 2015.

Larimer, William Henry Harrison. *Reminiscences of General William Larimer and of His Son William H.H. Larimer, Two of the Founders of Denver City.* Austin, TX: New Era Printing Company, 2014.

Lee, R. Alton. *From Snake Oil to Medicine: Pioneering Public Health.* Westport, CT: Praeger Publishing, 2007.

Lefebvre, Jim. *Coach for a Nation: The Life and Times of Knute Rockne.* Indianapolis, IN: Great Day Press, 2013.

Lefler, Dion, "Apollo 13 Crew Recalls Terrifying Trip." *Wichita Eagle,* April 18, 2010.

Leonard, Stephen J., and Thomas J. Noel. *A Short History of Denver.* Reno: University of Nevada Press, 2016.

Love, Mindi C. *Johnson County, Kansas: A Pictorial History, 1825–2005.* Marceline, MO: Walsworth Publishing, 2006.

Lovell, Mary S. *The Sound of Wings: The Life of Amelia Earhart.* New York: St. Martin's Griffin, 2014.

Lull, Robert W. *Civil War General and Indian Fighter James M. Williams: Leader of the 1st Kansas Colored Volunteer Infantry and the 8th U.S. Cavalry.* Denton: University of North Texas Press, 2013.

Mace, Kenneth D. "An Extract from Pioneer Airmen of Kansas," *Aviation Quarterly* 5, no. 2 (1979).

Manning, Carl, "Idea for Helicopter Was Born in Goodland in 1909." *Associated Press*, November 21, 1999.

Maugh, Thomas H. "Dig Gives Earlier Proof of People on the Plains." *Los Angeles Times*, February 26, 2005.

Mayer, Bill. "Wooden Connected to Memorial Stadium." *Lawrence Journal-World*, January 22, 2010.

McGlashan, C.F. *History of the Donner Party: A Tragedy of the Sierra*. Mineola, NY: Dover Publications, 2013.

McMurry, Linda O. *George Washington Carver: Scientist and Symbol*. New York: Oxford University Press, 1982.

Merriam, Daniel F., Jianghai Xia and John W. Harbaugh. "The Edgerton Structure, A Possible Meteorite Impact Feature in Eastern Kansas." *International Journal of Geophysics*, 2009.

Meyer, Philip E. "Tuttle Creek Dam: A Case Study in Local Opposition." Master's thesis, University of North Carolina, 1962.

Monaghan, Jay. *The Life of General George Armstrong Custer*. Boston: Little, Brown, 1959.

Mooney, Catherine M. *Phillipine Duchesne: A Woman with the Poor*. New York: Paulist Press, 1999.

Morlan, Robert L. *Political Prairie Fire: The Nonpartisan League 1915–1922*. St. Paul: Minnesota Historical Society Press, 1955.

Naismith, James. *Basketball: Its Origin and Development*. Lincoln, NE: Bison Books, 1940.

Nicholson, James C. *The Kentucky Derby: How the Run for the Roses Became America's Premier Sporting Event*. Lexington: University Press of Kentucky, 2012.

Nininger, H.H. "Further Notes on the Excavation of the Haviland, Kiowa County, Kansas, Meteorite Crater," Delivered at the joint symposium of the S.R.M. and Section E of the A.A.A.S. on "Meteorite Craters," at the Fifth Annual Meeting of the Society in June 1937.

Nininger, H.H., and J.D. Figgins. "The Excavation of a Meteorite Crater Near Haviland, Kiowa County, Kansas." *Proceedings of the Colorado Museum of Natural History*, no. 3 (1933): 9–16.

Nottingham, Theodore J. *The Curse of Cain: The Untold Story of John Wilkes Booth*. Indianapolis, IN: Theosis Books, 1997.

Pabst, Lettie Little. *Kansas Heritage*. New York: Vantage Press, 1956.

Parkinson, Jami. *Path to Glory: A Pictorial Celebration of the Santa Fe Trail*. Kansas City, MO: Highwater Editions, 1996.

Phillips, John Neal. *Running with Bonnie and Clyde*. Norman: University of Oklahoma Press, 1996.

Pielou, E.C. *After the Ice Age: The Return to Life to Glaciated North America*. Chicago: University of Chicago Press, 1991.

Pietrusza, David. *1960—LBJ vs. JFK vs. Nixon: The Epic Campaign That Forged Three Presidencies*. New York: Union Square Press, 2008.

Prentis, Noble L. *History of Kansas*. Topeka, KS: Caroline Prentis, 1899.

Rains, Rob. *James Naismith: The Man Who Invented Basketball*. Philadelphia: Temple University Press, 2009.

Rampersad, Arnold. *The Life of Langston Hughes: Volume I: 1902–1941, I, Too, Sing America*. New York: Oxford University Press, 2002.

Redpath, James. *Slavery in Kansas*. n.p.: Amazon Digital Services, 2015.

Richmond, Robert W. *Kansas, A Pictorial History*. Lawrence: University Press of Kansas, 1992.

Roper, Donna C. *The Whiteford Site, or Indian Burial Pit: A Smoky Hill Phase Cemetery in Saline County*. Topeka: Kansas Historical Society, 2006.

Rorabaugh, W.J. *The Real Making of the President: Kennedy, Nixon, and the 1960 Election*. Lawrence: University Press of Kansas, 2009.

Saloutos, Theodore. "The Expansion and Decline of the Nonpartisan League in the Western Middle West, 1917–1921," *Agricultural History* 20, no. 4 (October 1946): 235–52.

———. "The Rise of the Nonpartisan League in North Dakota, 1915–1917." *Agricultural History* 20, no. 1 (January 1946): 43–61.

Schultz, Ray S. *Murder, Massacre and Misfortune Near Walnut Creek Crossing*. Woodston, KS: Santa Fe Trail Association, 1996.

Scott, William Forse. *The Last Fight for Missouri: An Account of the Price Raid in September and October 1864*. Kansas City, MO: Civil War Roundtable of Kansas City, 1990.

Sears, Paul B. *Deserts on the March*. Norman: University of Oklahoma Press, 1947.

Shoemaker, Earl Arthur. *The Permanent Indian Frontier: The Reason for the Construction and Abandonment of Fort Scott, Kansas, During the Dragoon Era*. Washington, D.C.: National Park Service, 1966.

Smith, William E. "The Grave of Sarah Keyes on the Oregon Trail." *Kansas Historical Quarterly* 5, no. 2 (May 1936): 208–12.

Socolofsky, Homer E., and Huber Self. *Historical Atlas of Kansas*. Norman: University of Oklahoma Press, 1992.

Spurgeon, Ian Michael. *Soldiers in the Army of Freedom: The 1st Kansas Colored, the Civil War's First African American Combat Unit.* Norman: University of Oklahoma Press, 2014.

Stephens, Ken. "Fruition of a Mission: At 50, Space Center Lauds Founder, 'Spark'," *Hutchinson News,* April 25, 2012.

Sternberg, Charles H. *Hunting Dinosaurs in the Badlands of the Red Deer River, Alberta, Canada.* Lawrence, KS: self-published, 1917.

———. *The Life of a Fossil Hunter.* New York: Henry Holt and Company, 1909.

———. *The Story of the Past: Or, The Romance of Science.* Boston: Sherman, French & Company, 1911.

Strate, David K., ed. *West by Southwest: Letters of Joseph Pratt Allyn, A Traveller Along the Santa Fe Trail, 1863.* Spearville, KS: Spearville News Inc., 1984.

Svobida, Lawrence. *An Empire of Dust.* Caldwell, ID: Caxton Printers, 1940.

Tefertiller, Casey. *Wyatt Earp: The Life Behind the Legend.* Hoboken, NJ: Wiley, 2009.

Thorn, John. *Baseball in the Garden of Eden: The Secret History of the Early Game.* New York: Simon & Schuster, 2011.

Todd, J.E. "History of Kaw Lake," *Transactions of the Kansas Academy of Science* 28 (January 14, 1916–January 13, 1917): 187–99.

Tuttle, Albert B., and Mary T. Tuttle, eds. *History and Heritage of Gove County, Kansas.* Gove, KS: Gove County Historical Association, 1976.

Ulrich, Barbara C. *The Carey Salt Mine.* Mount Pleasant, SC: Arcadia Publishing, 2008.

Vecsey, George. *Baseball: A History of America's Favorite Game.* New York: Modern Library, 2008.

Vella, Christina. *George Washington Carver: A Life.* Baton Rouge: Louisiana State University Press, 2015.

Wallis, Michael. *Route 66: The Mother Road 75th Anniversary Edition.* London: St. Martin's Griffin, 2001.

Walton, George. *Sentinel of the Plains: Fort Leavenworth and the American West.* Englewood Cliffs, NJ: Prentice-Hall Inc., 1973.

War Department. The Office of the Judge Advocate General. Court Martial Case Files 1809–1894. Record Group 153: Records of the Office the Judge Advocate General–Army. National Archives and Records Administration, National Archives Building, Washington, D.C. online at fold3.com. Publication: Custer's Court Martial. Section: Court Documents. Subject: Proceedings, 159–60.

Welch, G. Murlin. *Border Warfare in Southeastern Kansas, 1856–1859.* Shawnee Mission, KS: Fowler Printing, 1977.

Wexler, Bruce. *Route 66: Ghost Towns and Roadside Relics*. London: Chartwell Books, 2016.

Whittaker, Frederick. *A Complete Life of General George A. Custer*. New York: Sheldon & Company, 1876.

Wilkins, Robert P. "The Nonpartisan League and Upper Midwest Isolationism." *Agricultural History* 39, no. 2 (April 1965), 102–9.

Williams, Burton J., ed. *Essays on Kansas History*. Lawrence, KS: Coronado Press, 1977.

Williams, Pat, and Bill Walton. *How to Be Like Coach Wooden: Life Lessons from Basketball's Greatest Leader*. New York: HCI, 2010.

Wilson, R. Michael. *Legal Executions in Nebraska, Kansas and Oklahoma Including the Indian Territory: A Comprehensive History*. Jefferson, MO: McFarland Books, 2012.

"With the Devil's Help." *Iola Register*, April 24, 1970, 49.

Wooden, John, and Steve Jamison. *My Personal Best: Life Lessons from an All-American Journey*. Los Angeles, CA: McGraw-Hill Education, 2004.

Wright, Marshall D. *Nineteenth Century Baseball: Year-by-Year Statistics for the Major League Teams, 1871 Through 1900*. Jefferson, NC: McFarland & Company, 2004.

INDEX

ABOUT THE AUTHOR

Adrian Zink is a native Kansan who has worked in the history profession for over fifteen years at a variety of museums, universities, archives and historic sites. Born and raised in Larned, he holds bachelor of arts degrees in history and political science from the University of Kansas, a master's of library science from the University of Maryland and a master's in history from the University of Wisconsin–Milwaukee. He currently works at the National Archives–Kansas City. He has previously worked at the Kansas Historical Society, UW–Milwaukee Archives, the National Press Club Library and Archives in Washington, D.C., and at the University of Kansas Natural History Museum. Adrian and his wife, Toni, have two children and live in Overland Park, Kansas. This is his first book.